NAUGHTY BASTARDS

A big thank you to: all the Diamond Geezers for being so open and honest;
Bailey for the blinding photos; Iain Mills, Bailey's assistant; my editor Adam Parfitt;
and Leo O'Reilly – my Diamond Geezer for risking life and limb to look after me.

Dedicated to Joan Bentley at St.Bernard's Animal Sanctuary.

'We who are about to die, salute you.'

(Gladiator's greeting at the start of the Games in ancient Rome – A.D. 50)

KATE KRAY
pictures by David Bailey

NAUGHTY BASTARDS

TWENTY-ONE TRUE STORIES

JOHN BLAKE

Published by John Blake Publishing Ltd,
3 Bramber Court, 2 Bramber Road,
London W14 9PB, England

www.blake.co.uk

First published in paperback in 2008

ISBN: 978 1 84454 513 1

British Library Cataloguing-in-Publication Data:

A catalogue record for this book is available from the British Library.

Design by www.envydesign.co.uk

Printed in the UK by CPI William Clowes Beccles NR34 7TL

5 7 9 10 8 6 4

Papers used by John Blake Publishing are natural, recyclable products made from
wood grown in sustainable forests. The manufacturing processes conform to the
environmental regulations of the country of origin.

Every attempt has been made to contact the relevant copyright-holders, but some
were unobtainable. We would be grateful if the appropriate people could contact us.

FOREWORD

With no other weapon available, the clenched fist is one of the best we have. Whether it's self-defence or going to war, battles, rucks and rows are as old as mankind itself. And whether it's hand-to-hand combat, a grudge fight or sparring for a wager, the tough guy with fire in his belly and a passion in his soul has always been set apart from other men. Like it or not, he's the guy who can do the business.

Roman gladiators were among the original hardcore fighting men. The gladiatorial games were the first professional circuit, although the matches didn't usually last very long. The gladiators' problems were over when one beat the other to death. The history of the world has been written in blood. From press gangs, the soldiers taking the King's shilling and sharpshooters in the Old West scrapping for land, gold and freedom, to the ultimate carnage of the wars in the 20th century, man has punched, gouged, axed and shot his way through every blood-soaked minute.

I don't think anyone knows what makes one man capable of going the distance while another bloke backs off or runs away from it in the first place. It's not over till it's over, but

the man who does see it through is different from the rest –
he will go that extra inch. It's more than a coincidence that
the guys I have talked about in this book all had a tough life
when they were kids. Broken homes, poverty, crime and
hard times were what it was all about. For these youngsters
there was a simple choice – stand up and fight or lie down
and get trampled. They all have one thing in common – they
did survive. Not only that, but they made it, no matter what
it took, to the top of their own particular muddy hill. But did
they like what they saw when they got there?

These men have all been on the reputation roller coaster,
riding high one minute and then spinning dizzily down
the black hole the next. Can villains really become good
guys? Here's your chance to make your own mind up. Read
about Hugh Collins, one of the most violent inmates of
Barlinnie Prison. Hugh is a murderer who spent twenty-four
years in jail. Now he has been released and has found his
niche in life. He is a happily married man and a world-
acclaimed sculptor.

Esmond Kaitell drifted into a life of crime and violence,
setting himself up as judge, jury and executioner. When he
hit rock bottom and was left for dead in a grudge fight it
looked like the end of the story. But Esmond is now a
changed individual who, by the grace of God and with the
help of friends, has not only survived but has made a success
of his life.

Alan Mortlock is an inspirational character. For seventeen
years, violence, drugs and alcohol were his daily bread until,
one day, the power of prayer managed to achieve what no
amount of crime and punishment could do. In a truly
miraculous turnaround, Alan found Jesus and almost
overnight gave up everything he had ever known. He is now
a born-again Christian who has found peace and success in
his life.

There are so many more of these stories. Joe Smith has gone from being a gypsy bare-knuckle fighter to a championship pro golfer. Noel Ennis is a non-violent successful businessman – a far cry from the old days of shoot-outs on the Costa del Sol and years spent languishing in Spanish jails. He's faced up to it, took a long hard look at himself and turned his life around – his way. All these men have come from a dangerous, shadowy world where life is cheap and violence is commonplace. Punching and stabbing, knives and shooters have long been part of their everyday existence. A lot of them still train at the gym and they always will. Being fit and hard and keen is all that's between them and a trip to casualty or the city morgue. For many of them, when it's six o'clock it's time for their sharp strides. They shine their shoes, put on a crisp white shirt and adjust their dickey bow, ready for whatever the night is going to throw at them. Whether it's doing security, protecting the rich and famous or standing on the door at China White's, their beat is the pubs, the clubs and the back streets. Their brief is to deal with punters who are off their heads on booze or drugs – the testosterone-filled hard men who are spoiling for a fight. Like the gladiators going into the arena all those centuries ago, these men face it without flinching, again and again.

I'm not making any excuses for these men; they know what they are doing and what is the bottom line. Guilt is something they don't understand. They couldn't handle it if they did. And the regrets are mostly for lost opportunities … And yet in spite of this, the men you are about to meet have all turned their lives around magnificently in one way or another. Somehow they've made something of themselves, they've turned a corner. No more waiting for the knock on the door. Just a sense of feeling good – a buzz all right, but nothing like the old days.

Is it knowing that you can't put a price on peace of mind? Whatever it is, they've cracked it. Don't get me wrong. These guys will never soften up. There is a look in their eyes that you don't see anywhere else. It's a look they never lose. What they have gone through sears the soul. Those that have been in prison have left a big part of themselves inside. They are geezers who always make you wary – in appearance alone, their size, their fists, and the flash super status that goes with having a reputation sets them apart. Ordinary people will go on stepping aside when they walk by. It may be that these fighting machines from the back streets are a dying breed. An endangered species. In our super-civilised world, with better education, housing and spy-in-the-sky, it's a high-tech future. The fighting tigers from the concrete jungle just won't be there any more. All the scrapping now is done on a computer screen. Bam! Smash! Pow! Game Boy is king. Kids have TVs in their bedroom, holidays in the sun. The bad times won't ever come punching back. Will they? But what if it isn't axe-carrying raiders this time? What if another, more sinister challenger jumps into the ring? Will there be any shockproof hard guys left? Will anyone have the fire and the fury to take the blows? The nerve and the stamina to go the distance?

The blokes in this book have all done things that would make the average person curl up and crawl into a hole. They have been involved in the sorts of things that you don't even want to know about. Ask them to tell you a secret and they pull up the shutters, batten down the hatches and clam right up. And yet in a strange sort of way, they have their own code of honour. They have strong beliefs, morals and principles. Believe it or not, they're kind, funny, family men who help kids and like animals. They've gone from being tough shit, rock bottom with not a penny to their name, to successful entrepreneurs with pockets full of dosh. Not only that,

they've had a conscience upgrade along with their status, and in the process discovered an eternal truth: the best way to get through life is to treat other people as you'd like to be treated yourself. When they are in the right, they never back off. Even when they are wrong, they never give in. These men have walked into danger without flinching. They are Bad Guys who, for many different reasons, have crossed an invisible line and – against all the odds – have made themselves up into Good Guys. Proper diamond geezers. Here are their stories; you can judge them for yourself ...

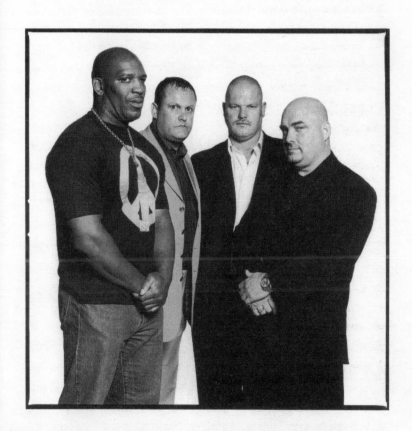

CONTENTS

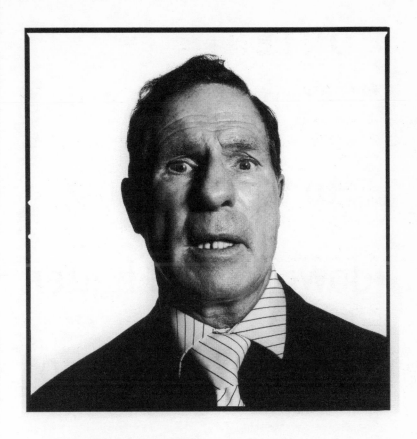

ROY SHAW
'A WALKING, TALKING, KILLING MACHINE'

NAME: Roy 'Pretty Boy' Shaw

DATE OF BIRTH: You're as old as the woman you feel!

OCCUPATION: Whatever he wants!

STAR SIGN: Pisces

'If someone is going to try to put me down, they'd better make sure they do it, because they won't get a second chance.'

ROY SHAW

'I'M A NICE PERSON, TILL YOU TREAD ON MY TOES.'

I was on millionaire's row, a leafy lane where every house is set in its own grounds with a sweeping drive up to the front door. Roy's gaff was easy to spot. The heavily barred wrought-iron gates were firmly closed. Was it to keep the Rottweilers in, or visitors out? I pressed the bell and waited. I could see the unblinking eyes of security video cameras monitoring my every move. Was Roy at home? Was he in bed? There was a shiny red Bentley Corniche parked up in front of the house. Roy is a party animal who is making up for lost time; he might be recovering from the night before. His pets, two black-and-tan hounds from hell, were growling and slavering through the bars. I was a bit early and there was no way I was going any further while they were loose. Eventually, both the dogs and me heard

a loud whistle. The Rottweilers pelted back up the drive and the main gates opened. I was in.

If Roy had been on the razzle, it didn't show. He looked keen and sharp, dressed in a designer tracksuit. His small, piercing blue eyes were staring at me with an unnerving intensity as he showed me into the sitting room. Roy is 15 stone of squat, solid muscle that knots and pops when he moves. Not a man anyone would want to mess with. He showed me into a large kitchen overlooking the lawn and we talked about houses, gardens and dogs, while Roy made coffee for himself and herb tea for me.

Everything around him was the best – even the cups were finest china with gold edging and his own monogram – R.S. He seemed very much the high-powered businessman relaxing at home, though I was always conscious that Roy has an awesome reputation and is used to living in a secret world of hostility and hatred. But at the same time he is a man with strict principles and morals. When he's good, he's very, very good, and when he's bad, you don't want to know. I took a sip of camomile and honey and asked him about his background.

'Where were you born, Roy?'

The cockney accent is a dead giveaway.

'In Stepney, east London.'

'The sound of Bow Bells?'

Roy smiled. 'A Londoner through and through. I was a street urchin, a ragamuffin, and it was the war years so times were hard.'

'What about your family?'

'We didn't have much money, but there was a lot of love.'

'You grew up using your fists. Did you learn to box when you were just a kid?'

'That's right, Kate. I was ten when I discovered God's gift to

me – the power of the punch. From then on I became a rascal, I was getting myself into all sorts of trouble. I knew that I could fight my way out of it. I was a man on a mission with nothing to lose and a lot to prove.'

'When did you start boxing professionally?'

'In my late teens. When I turned pro, I trained under the guidance of Mickey Duff. I had ten professional fights with ten wins, six of them knock-outs.'

'What about fighting Lenny McLean? That was unlicensed, wasn't it?'

Roy nodded. 'Yes, I'd been in a bit of bother with the law and the Boxing Board of Control wouldn't give me my licence, so I went unlicensed.'

'Is that tougher?'

'Yeah. Basically the rules are just the same.'

'Beating Lenny made you the Unlicensed British Champion?'

'Yeah. McLean was a huge man, the size of a house. Nobody thought I could beat him because of his size and his reputation. I didn't care how fucking big he was, the bigger they are the harder they fall.'

Everything about Roy spells violence. Touch him and he feels like granite. His eyes are cold and expressionless. Think about a man-eating shark and you've got it.

'What about prison, Roy? How long have you spent inside?'

'Too long. In 1963 I was sentenced to eighteen years.'

'What was that for?'

'Armed robbery and grievous bodily harm. All in all, I've spent twenty-four years inside. Borstal, just about every prison in the country, including Broadmoor.'

'You're a survivor.'

'I've had to be.'

'Has your life ever been threatened?'

'If someone is going to try to put me down, they'd

better make sure they do it, because they won't get a second chance.'

'What's the most violent thing you've ever done?'

'I've been accused of murder.'

'But that was never proved?'

'No.'

'What's the most violent thing that's ever been done to you?'

Roy's eyes narrowed.

'When I was in the dungeons.'

'Is that when you were in Broadmoor?'

'Yeah, I was given drug treatment, the liquid cosh, and it fries your brain, makes you hallucinate. It's one of the worst feelings in the world.'

'What did they do?'

'I was in the punishment block – the dungeons we called it, because it was underground. The nurses were doping me up all the time. My perception of time deteriorated. I didn't have any visitors for six months. The worst was when they experimented on me.'

'Why did they do that?'

Roy shook his head. 'I was too violent.' They said it was to investigate my brain patterns. Two male nurses held me down and the doctor picked up a huge, long syringe. I asked him what it was for, but he didn't answer. I knew it wasn't going to be anything good. So I spat and cursed at them. I was already doped up so there wasn't much I could do. The doctor pushed the needle up through my cheekbone into my head. He told me they were going to investigate the movement in my brain. The nurses held my head so tight I thought they were crushing my skull. I could

'The doctor pushed the needle up through my cheekbone, into my head.'

feel the needle go through the gristle and behind my eyeball. Before that, a doctor had ordered me to have ECT – Electroconvulsive Therapy. I was strapped down and given electric shocks without an anaesthetic. The pain was indescribable.'

'Horrific.' I watched Roy's face; he was expressionless, staring into space. 'Was it to try to make you more calm?'

'It didn't work.'

'You've fought all your life. If you had to face someone in a bad situation, what would be the weapon of your choice?'

Roy held up his iron fists. 'These. Never let me down.'

He walked over to the window. Roy is a successful businessman, he has it made now. But the past won't go away. Although he has a string of girlfriends, I know he lives all alone in this grand, plush bungalow.

'Is there anyone special, Roy? Who do you love most in the world?'

'My mum.'

'She's always been there for you.'

'Of course.'

'What's your happiest memory?'

Roy came and sat down again, he thought about this for a moment.

'When I was a kid. Going out with my dad on his motorbike.'

'And your worst memory?'

'There's been plenty. But it has to be when my dad died. I was ten years old and I was in bed. I heard my mum scream. My dad had gone out on his bike. I was supposed to go with him that night but for some reason he hadn't taken me. If I had gone, I wouldn't be here now. He'd been in an accident with a lorry, it had swerved out of control and that was it. My dad was killed instantly.' Roy's eyes had filled. This is something that will never go away.

'Does anything frighten you?'

He shook his head. 'Nothing.'

'What about feeling guilty?'

I thought he might tell me something about his violent lifestyle. But it was romance that left regrets.

'If I've gone with a girl just for the sake of going with her.'

'Not because you really like her?'

'Yes. That would make me feel guilty.'

I knew that Roy was a dapper dresser, so how much did his appearance matter to him?

'How would you change your looks if you could?'

'I wouldn't. I'm all right as I am.'

'You wouldn't have plastic surgery?'

'No.'

'Everyone wants another chance. If you were eighteen again, is there anything you'd do differently?'

'Not really. I might have picked my partners a bit more carefully.'

'If you had to sum yourself up in one word or sentence, what would it be?'

'I'm a nice person, till you tread on my toes.'

I thought that everyone who's ever come into contact with Roy would agree with this. By now Roy was getting restless and pacing about the room. He has a high energy level and always wants to be on the move. But he is always polite and a true gentleman. I stood up and headed for the door.

'Before I go, will you tell me a secret, Roy?'

He took some persuading. 'No, I haven't got any secrets, Kate.'

'You must have one. Tell me how old you are?'

Roy gave me one of his famous grins, his face going from your man-eating predator to your favourite uncle.

'OK then, I'm thirty-eight. Will that do?'

Roy has a wicked sense of humour.

He walked with me to my car. The Rotties were running around, wanting to be fussed. They are a bit like Roy. The dogs look fierce and they can sure as hell bite, but when they want to be, they're calm and nice!

'I just wanted to ask you one more thing,' I told him as I got into the motor. 'Do you know any good jokes?'

Roy is always up for a laugh. 'Yeah, sure.' He thought for a minute. 'Did you hear about the two convicts in America who were about to be executed? The Warden says to the first one, "Do you have a last request?" The convict says, "Yes, I'd like to hear the song 'Achy Breaky Heart' one last time." The Warden says, "OK, I think we can arrange that." Then he says to the second convict, "How about you?" The second convict says, "Yeah, kill me first."'

'Brilliant,' I told him when I stopped laughing.

I started the motor and waved goodbye to this awesome man who has turned his life around and re-invented himself as a successful businessman. They say you can never beat the system, but although it threw the lot at Roy, it never beat him. The whole of his past has been fight, fight and fight, but not any longer. Roy has achieved celebrity status. There are books about him, TV programmes and now a film is being made about his life. He's never asked for his reputation, it came with the territory.

This is a man who's been to hell and back, and took more than a few unlucky punters with him. But he is a straightforward man with strict principles and morals. He has the respect of everyone who knows him. The sun was shining as I left Roy – a rich man or a poor man, who knows? Tons of money but still all alone in his luxurious bungalow on millionaire's row. Everything seemed to have come right for him ... except that he still comes home to an empty house.

I thought about this as I drove back to London. We all

need a soul mate, someone to love. There used to be a girl he was mad about. He told me once that he'd always regretted splitting up with her, that he'd give anything to get back with her. I tried to remember her name. Yes, that was it: Dorothy. If I could only track her down. It would be playing cupid, but I do like a happy ending. I wonder ...

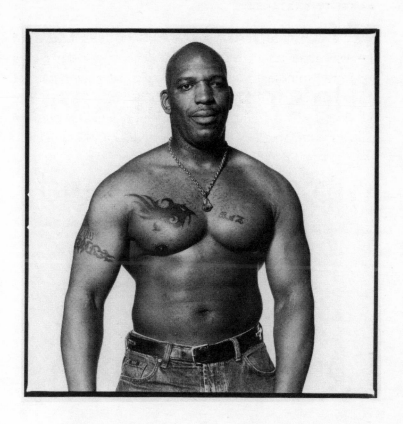

BARRINGTON PATTERSON
'A HELL FIGHTER'

NAME: Barrington Patterson

DATE OF BIRTH: 25.8.65

OCCUPATION: Entrepreneur

STAR SIGN: Virgo

'He's dared to stand up against me and I'm going to annihilate him. In those minutes, I want to knock his fucking head off.'

BARRINGTON PATTERSON

'WHEN PEOPLE LOOK AT ME THEY THINK, FUCKING HELL, I DON'T WANT TO TALK TO THAT BASTARD. BUT I DO WHAT I HAVE TO DO. I AM WHAT I AM.'

The Chase Hotel is an upmarket seventeenth-century coaching inn set in some of the most beautiful countryside in Warwickshire. It's the loadsamoney stockbroker belt. There are oak beams, log fires, four-poster beds, the works. It was mid-morning and me and my fiancé, Leo, were sitting at a table by the window, admiring the view. There was a dovecote on the lawn, a slow-moving trout stream and rolling fields as far as you could see. It had been a long drive and the Danish pastries and caffeine shot of high-altitude Colombian were hitting the spot. The dining room was very posh – china cups, silver coffee pots and crisp white tablecloths. In the courtyard outside rows of expensive motors were parked up in front of the entrance – Land Cruisers loaded with

saddles, Mercs and Volvos complete with tack, gun dogs and golf clubs. We were in green wellie-sporting country and it was a geezer from the world of physical excellence that we were waiting to meet.

But Barrington Patterson is not your everyday sports-man – he's one of the hardest and most vicious professional free fighters in the world, the Darth Vader of the deadly cage-fighting and kick-boxing circuit and a remorseless opponent without fear or feelings. In cage fighting, two men go into a four-sided iron pen and go on beating the life out of each other until one of them goes down and stays down. No rules, no preliminaries and no pleasantries. This is Barrington's game and when he's fighting he's mean, nasty and never knows when to stop. His reputation as a hell fighter has spread from Moscow to Manila. He'll go up against anyone, any time, anywhere. So when a £60,000 black BMW with tinted windows scrunched up the gravel drive and a huge black guy got out and casually flicked the remote door lock, I leaned over to have a better look. Shoulders a mile wide, closely shaven head, seriously menacing face, and his one eye giving it the entire once-over. It could only be the man himself. Barrington had arrived.

It was interesting to watch the reactions as he came through the hotel. This self-assured man mountain makes heads turn wherever he goes. People were scurrying out of his way and pressing themselves up against the walls as he strolled past. Did they sense his blatant menace? Nobody was taking any chances – they were giving him oceans of space. In spite of his size, Barrington moves quickly, light on his feet. He saw me and came across,

towering over the table and turning on the charm, a wide smile showing a gold tooth as big as a cricket bat. 'Kate, how are you?' he growled, holding out a hand like a dinner plate. My fingers were swallowed up in his fist but I needn't have worried – his handshake was as soft as a kitten. I gave him the once-over. He looked the business all right. Seventeen stone of steel muscles draped in a cashmere Armani suit, with a pale blue silk shirt, tasteful navy-and-cream designer tie and highly polished shoes. I caught a hint of discreet after-shave, maybe Paco Rabanne. There was a chunky old gold ring set with a sparkling diamond on his little finger. Wow! Money and style. Whatever the shadowy air of threat hanging over him, Barrington is one hell of an imposing guy.

Sometimes I can get a handle on a bloke just by looking at him, but in spite of his classy strides, Barrington has an air of just having stepped from the gates of hell. I felt as though he was weighing me up too. This was one careful, measured geezer. I decided that first off I'd ask him to tell me about his background.

'Tell me a bit about yourself. Where do you come from?' He sipped his freshly squeezed orange juice. For the moment he was calm and very respectful.

'I was born in Burton-on-Trent in Derbyshire. My family moved to Birmingham when I was two years old and then we moved to Coventry in 1988. I've been there ever since.' His voice is deep and husky, but level, without emotion. This was his life we were talking about but he gave the impression of being a bit remote.

'Do you come from a big family?'

He nodded. 'Yes, there are eight of us.'

'Eight children?'

'We were brought up by our mum.' Barrington was matter of fact, but the shutters were down. He fixed me with his

one eye. I tried not to focus on the injured one. Was I going to ask about his dad? He sat there like a coiled-up spring. No way.

Barrington seemed a mass of contradictions. One minute he was polite and thoughtful, the next I caught a glimpse of the pent-up fury ready to explode just below the surface. There was no way I could second-guess this man. So far he wasn't giving much away.

'Have you ever been to prison?'

He nodded. 'Yes.'

'For what?' It might have been fighting, GBH, whatever. Barrington could squidge anybody like a ripe tomato with just his meaty hands. He is one cool, cool geezer. Nothing would have surprised me. Except his answer ...

'Football violence.' I hadn't imagined him as a football supporter – but then, the Sky Blues and the Villains, it went with the territory.

'How much time did you do?'

'Three months. No problem. I've put it behind me.' He leaned back in his chair. I hoped it wouldn't break.

'Has your life ever been threatened?'

Again, Barrington was matter of fact. 'Recently, or ...'

'Any time.' Maybe threats were routine.

'It happens.' Barrington is a man who picks his words carefully.

I waited. He decided to tell me.

'The last time was about three weeks ago. In London.'

'Whereabouts?'

'I was outside a club. The Ministry of Sound. A guy pulled a gun on me.'

'Were you working?'

'Yes. I was standing there, talking to another doorman, a friend from Birmingham, and this man came up to me and started being abusive.'

'What did he say?'

'He was mouthing off, yelling and shouting, "You Birmingham blokes are full of shit." I'd never seen this guy before in my life.'

'What did you do?'

Barrington shrugged his massive shoulders.

'I don't want to hurt no one if I can help it. So I said, "Go fuck yourself." And he said, "Go suck your mum," and then I said, "Go suck your mum, you half-breed bastard, you're not even black so fuck off."'

OK. That was telling him. The language came as a bit of a surprise. So far Barrington had behaved like the perfect gentleman, but I'd asked him what went off and he was telling me the tale. His voice never changed, the same deadpan tone.

'What happened next?'

'There was a black crowd outside and they all began to laugh and this made the bloke mad and that's when he pulled out a bloody gun. I shit myself. I admit, I was that scared. But I put him down on the floor before he could think about it.'

'So, you're facing a hyper-maniac with a gun and you just go for it and put him down?'

Barrington nodded.

'Didn't you think he might pull the trigger?'

'It's a chance you take. I'm never taking that shit from anyone.'

'You could have been killed.' I was thinking this geezer was either incredibly brave or incredibly, barking mad.

Barrington flashed me one of his sudden smiles.

'I did have a bullet-proof vest on and the police came and they were on him within seconds.'

A sense of humour. Still, it took some bottle.

'Have you ever been hurt yourself? Stabbed or shot?'

Barrington shook his head.

'No.' It was hard to imagine that anyone would dare to attack this mountain of a man.

'Have you ever stabbed or shot anyone yourself?'

He reflected on this for a minute or two.

'I've never shot anyone,' he said slowly, 'but I have ...'

I wanted to ask, 'Tell me more: what, how, who,' but one look at his face ... He tensed, just a fraction. It was enough. I had to move on.

'What is the most violent thing that has ever been done to you?'

Barrington didn't hesitate. 'I haven't really had anything violent done to me. I've been in clashes but I've always come out on top.'

That figured.

'What's the most violent thing that you have ever done?'

Barrington didn't like this line.

'That's a nice question to ask, isn't it?' Maybe I was rattling his cage, but in the same expressionless, matter-of-fact voice, he told me anyway. 'The most violent thing I've ever done is when I was bashing someone with a baseball bat. I was just smashing his face in. I broke his nose and his jaw. It was a mess. There was blood splattering all over. It was on his shirt, on the floor. His bones were cracking, it was him or me, and he had it coming. He'd have done it to me if he could have got up. But I was pulping him.'

Barrington leaned back from the table and downed the rest of his juice, fixed me with his good eye and stared at me without blinking. I could picture him doing it. I ordered another coffee; Barrington stuck to his juice. He wasn't relishing what he'd done; it was just a fact, it happened.

So what was he like when he was in the ring? 'Tell me a bit about your fighting. Is it what you do for a living?'

'That and other things. Mainly the security business.'

'Working the doors?'

'Yes. And personal security.'

'Do you get paid for fighting?' What was the motivation behind it?

'Sure I do.'

'So come on Barrington, what's it all about, is it the money or the fame and fortune? Or winning the prize-fight belts?'

'You win money and belts. I'm only there for the money.'

I might have guessed. This man is the ultimate hard bastard.

'How long have you been fighting?'

'I've been fighting and kick-boxing on the professional circuit for over fifteen years. I've fought all over the world: Brazil, Hawaii, Moscow, Siberia, Ukraine. Championships, World Title fights. I fought a double world champion in the Ukraine.'

'What sort of fighting was that?'

'That was kick boxing. I'm into free fighting now.'

'Free fighting? You do what you want?'

Barrington's big meaty fists were clenched hard. I was getting through to him.

'There's no rule. Anything goes. Anything at all. Biting, scratching, gouging; you can knee, elbow. The only thing you can't do is punch your opponent on the face while he's on the floor.'

'Do you like doing this?'

The big man gave me a chilling wide gold-toothed grin. 'Yes, I enjoy it. I really do.'

There was no doubting it. 'But, isn't it a bit ... ' – I chose my words carefully – ' ... well, let's say "naughty", going to beat somebody up in their own country? Don't they think you're a maniac?'

He shrugged. 'It makes it better. I'm fighting them in their own backyard, on their territory and I'm still beating them. When I come out and win,' he punched his arms up in the air, 'I'm on top of the world, it's like nothing else.'

I didn't know whether to ask the next question. Would he take it the wrong way? But Barrington's answer surprised me. 'What about when you're getting ready for the fight. Do you feel nervous?'

'Yes. I'm always nervous. If you're not nervous before a fight, there's something wrong with you. Every time I come up against anyone, even if it's someone smaller than me, I'm always shitting myself. But it makes me a better fighter. When I'm scared, that's what makes me aggressive.'

I made a mental note that I would never, ever do anything to alarm this man. 'When did you face your last opponent?'

'A week ago, in Holland.'

'What happened?'

'They sent this guy over from Greece, told me he was a complete nutter, man of iron, couldn't be beat, all that shit, but they were bulling it up, trying to put the wind up me. They said he'd gone twenties, he'd gone fives, and he hadn't been knocked down. They give you all this caper. Try to freak you out.'

'Does it work?'

Barrington gave me a half grin and shook his head.

'You won then?'

'It was all bullshit. I went out there and played with him for four rounds. No problems. I stopped him in the fifth.'

'You're really well known in the rest of the world?'

'On the European circuit and the world circuit I'm ranked fourth and I'm also fourth in the Wackers. I'm going to be number one this year, if I get a crack at the titles. I have to travel to do it. If I go and fight abroad I do good. If I went to live abroad I'd be world champion.'

'What about in this country?'

Barrington leaned forward, drumming his fingers on the table. 'No. I don't like fighting over here. The promoters pay crap money and the crowd don't appreciate a good fight. It's different overseas. Here it gets driven underground by boxing.'

'How do you get to know about the fights?' Barrington was the most animated I'd seen him so far. Beating the shit out of someone and getting paid for it is what life is all about for him.

'I have a coach in England and a promoter in Holland. They fix fights up for me, but at the end of the day it's all about money. I ain't doing anything for the fun of it. When I'm fighting in front of sixty or seventy thousand people I want a good pay day.'

'And do you get it?'

Barrington nodded. 'Sure. Yes. I'm off to Japan in July; the top ten guys in the world are there. Knock-out bouts. Every one a cage fight.' The mask slipped and I caught a glimpse of the hellfire inside Mr Barrington Patterson. 'I'm looking forward to it,' he snarled. 'I wish it was tomorrow.' This man is a volcano: he looks cool on the outside, but inside there's a seething mass of violent aggression waiting to erupt out like a ball of fire. Would I like to see him fight? I don't know. I don't think so. I wasn't sure exactly what the hell cage fighting is all about.

'We'll be locked in a steel cage, it's about the size of a boxing ring. There's no way out, bars all the way round, even over the top.'

Just thinking about it made my blood run cold.

'Do you fight to the death?'

Barrington shook his head.

'No. But it's possible. One of you is going to get seriously

hurt. You can get strangled, knocked out, chewed up. Till either the referee decides one of you has taken too much punishment or someone submits.'

'Like being thrown into the lion's den.'

'Yes. You have to do what you have to do to fight your way out.'

'How do you cope with that? Beating someone up to within an inch of their life? Or them doing it to you?'

He shrugged. 'By keeping cool, staying one step ahead. In a fight you can't afford to lose your temper. If you do, you lose the fight.'

'Have you ever submitted?'

Barrington looked at me as though I was mad.

'Never,' he growled.

'Do you think there would ever be a circumstance when you would submit?'

'I've never been at that stage. I don't ever want to get there. I've never been knocked out and I don't intend to be. I wouldn't like it.' The menace in his voice was convincing enough.

'Do you have to psyche yourself up for a fight?'

'I do. Before I go into the ring or the cage, whatever, I stay on my own for at least five minutes. I need to be on my own, to think about things. Every time I fight, I dedicate the fight to someone – my brother or one of my daughters or my grandmother. That's what's going through my mind. I see the person I'm fighting as though it's him stopping me getting what I want. I don't allow anyone to do that. I want it more than him. I'm hungry for it. I mean to have it. I was born a fighter and at the end of the day, I'll always be a fighter.'

When he was telling me this, Barrington's one good eye flashed like a fury from hell. He has that unique element that makes him unstoppable,

whether it's sheer guts, a tiger-eye hunger for victory or bloody mindedness.

I felt sorry for whoever went in a cage with Barrington; it must take some bottle to face him.

'Do you know when to stop?' Surely there must be a point when he pulls back. 'If you were fighting someone and you could tell he'd had enough, would you ease off?'

He shook his head. 'No. It's up to the referee to stop the fight. I'll beat a guy until he falls on the floor. Until he's completely knocked out. I don't stop till I'm pulled off. It's not over till it's over.'

'We'll be locked in a steel cage. It's about the size of a boxing ring.'

'Will you ever retire?'

'Age or getting knocked out would make me. If I were seriously hurt, I would. But I've never been near that stage.'

I couldn't imagine that he ever would be.

'So what goes through your mind, when that bell goes and you're in a metal box and the crowd's screaming and there's no way out? There's just you and your opponent standing there, growling at each other. What are you thinking at that moment?'

'That he's in my way. I want him out of it. I'm going to destroy him. I'm going to rip his head off. He's dared to stand up against me and I'm going to annihilate him.' Barrington licked his lips. 'In those minutes, I want more than anything else in the world to knock his fucking head off.'

It was like talking to a testosterone-filled fighting machine. But Barrington's opponents were the best in the world, so what gave him the edge? How did he keep on top of the game?

'Your life must depend on it. How do you stay ahead?'

Barrington is a shrewd man; he has it all sussed out.

'By thinking. I consider everything I'm going to do first. I

weigh everything up, pros and cons. Then it's instincts. And if you have quick reactions, that's a big advantage.'

'And do you?'

He smiled. Of course he did.

'Anything else? Luck, charms, superstitions?'

He shook his head. 'I make my own luck.'

'How?'

'I don't drink alcohol.'

'Never?'

'No. And I don't take drugs. When you're working the door, doing security work, you've always got to out-think your opponent, be one step ahead. That's why training, being fit, not smoking, is what keeps you alive. And you have to have confidence – in yourself, and the ability to make the right decision.'

'And if you had to choose a weapon?'

'My fists.' Barrington held up his massive hands. 'These never let me down.'

'Is there anything makes you angry?'

'It takes a lot to get me worked up. It's real hard. People see me and they think I'm a big meanie, but I'm a softie at heart.' I had to look away. Tell that to the guy in the cage.

So far, all we'd talked about was his aggression, but everybody has a weak point. What was Barrington's? I wanted to know if there was any way to get to the real man. Was he scared of anything or anybody?

'Is there anything at all that frightens you?' I asked. 'What's the most scary thing that's ever happened to you?'

He paused, reflective. I thought he was going to say 'nothing', but again this man was full of surprises. 'What frightens me is death. I've had two car crashes. I've seen death staring me in the face, I just don't want to go there.'

Good answer. Barrington had relaxed back in his chair. He

struck me as a man who was going to take whatever life threw at him without flinching.

'What about happiness?'

'My happiest memory is seeing my first daughter born.'

'And your worst?'

'Losing my grandmother and my brother.'

'How did your brother die?'

'A broken heart. He hanged himself, over a girl.'

'How old was he?'

'Twenty-five.'

His voice was choked. I could feel the pain. He keeps his emotions well under wraps, but inside Barrington is a deeply sensitive human being. He'd told me about the grief in his life. What about the other side?

'What makes you happy? Who do you love most in the world?'

This was easy. Barrington flashed a wide smile and reached inside his pocket for a leather wallet. Not money, not a weapon. Family photos.

'That's my mother, these are my daughters.' His face was lit up.

I studied the snapshots; they were real pretty. 'How many children do you have?'

'I have four girls.'

The next questions were on my lips. A girlfriend? Wife? But Barrington saw it coming and side-stepped with years of practice. That was getting too near. The snaps and the wallet slid out of sight and with a growl the fighting man was back. He had closed the subject down. There was no way I was going to step in his corner. A fighter and a devoted family man – was there a conflict here?
What did the future hold?

'If you went to see a fortune teller, what would she say about your life?'

'I'd like her to tell me that I'm going to be a happy man. That I'll settle down with a wife and kids. That's what I'd like to hear.'

'What do you think you would hear?'

'Probably that I'm going to be on my own.'

'No way, not with that sparkle in your eye. What about the past though, any regrets?'

'No. There's nothing I'd change. I've enjoyed life to the full. I'd do it all again.'

'Isn't there anything, say you were eighteen again, that you'd like to do differently?'

'Maybe I'd have lived abroad.'

'Where?'

'Anywhere. I've been to so many countries because of the kick boxing, and I've enjoyed them all. If I had to choose, I would probably like to live in the Bahamas or Jamaica, because I have family over there.'

Barrington is one of the toughest blokes I've met. I wanted to know who he respects. 'What makes a hard bastard? Can you name one?'

Barrington thought about this before answering. 'People would call me a hard bastard. Although I'm not. You're only as hard as your last opponent. I don't see anyone being harder than anyone else. And life is full of change.'

'Does anything make you feel guilty?'

'Nothing. I never feel guilty. What I've done is done. I can't alter it.'

'Are you happy with yourself, your looks? Would you change if you could?'

'No.' An emphatic reply. 'I wouldn't be Barrington, would I? I would never have plastic surgery. I am what I am. Who I am. When people look at me, they think, Fucking hell, I don't want to talk to that bastard. I look in the mirror and I've got one eye big and the other small.'

'Did you do that fighting?'

Barrington grinned. 'Only with my sister. And she won. When I was eight she threw a cup at me. Didn't mean to get me. The only time she'd ever aimed straight.'

Every one of the men I'd talked to seemed to have a different way of enjoying themselves. What turned Barrington on?

'Come on, are you going tell me what gives you a buzz?' I thought he was going to say it was the fight game, violence, winning. But no, unpredictable as ever:

'Seeing people happy. That's what does it for me. I teach kick boxing and I take the kids to tournaments and when I see the kids win, it's a great feeling. I've taught someone and they're doing well. That's what I like.'

Barrington was fiddling with his key ring, BMW on a silver chain. 'What about possessions? Are they important to you?' I'd been told that he has TV sets in the back of his car seats and shows videos of his most brutal fights.

'I like my motor.'

'What about pets?' I'd heard a whisper that Barrington has a very tame parrot and that it takes grapes from his mouth. 'They're all right.' The gentle giant wasn't talking. Back to macho stuff.

'What makes a man? Being the best? The winner? Unbeatable?' Again, his answer was unexpected. 'Being a father. Looking after your kids. Being honest, truthful. Respect.' Can't argue with that.

'And if you weren't you, who would you like to be?'

I guessed right with Barrington's answer this time.

'Nobody. I'm totally happy being myself.'

Barrington pushed his chair back and stood up – a busy schedule, another appointment, he had to leave. I walked with him to his car. He is a truly complex geezer and, like

the sparkling stone he wears on his finger, he has many different facets to his character. With deep feelings and demanding respect, he has strict rules and lives by a strong, unbending code. There is no tolerance in his professional career and it is his unpredictability that makes him such a forbidding and formidable opponent. He pressed the remote and beeped open the car door.

'Barrington, before you go, will you tell me something else? What about a secret?'

He shook his head.

'I can't, because it wouldn't be a secret if I told it you.'

All right. 'Will you tell me a joke, then?'

No problem here. He came straight out with it. 'An Irishman went into a bar. He went, "Aaaargh!" It was an iron bar.'

His deep belly laugh set me off straight away. When I managed to stop laughing I asked him one last question.

'Sum yourself up in one word or sentence.' Barrington slid into the leather seat and turned the ignition. He thought for a few seconds.

'Nice, pleasant, charming.' His face cracked up again. 'And fucking funny as well.' He waved as he drove away.

I had to agree. This bloke is a real comedian.

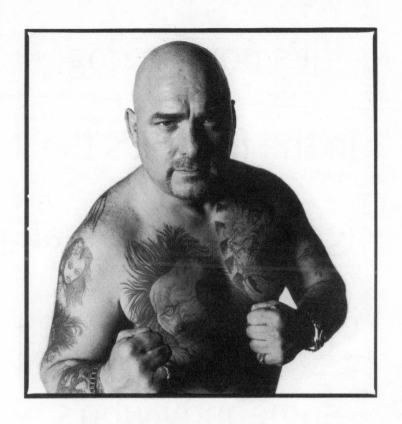

KEVIN HOUSTON
'NAUGHTY BUT NICE'

NAME: Kevin Houston

DATE OF BIRTH: 8.5.61

OCCUPATION: Boxing promoter;
Tattoo artist; Entrepreneur

STAR SIGN: Taurus

'It's not the dog in the fight, it's the fight in the dog that counts. When I see somebody who's going to fuck me off, there's no going back. I get in first.'

KEVIN HOUSTON

'ONCE YOU'RE KNOCKED DOWN, YOU STAY DOWN.'

I was in Coventry on a rainy Friday afternoon. I was standing outside a gym on Longford Road in a rough-justice part of the city. I looked around. Graffiti, boarded-up doors and iron bars across the windows. The gym was a big, square brick-built building with video cameras, security signs and a black-and-white painted sign over the entrance. It read 'CAPITAL PROMOTIONS UK' and underneath was the title 'Kevin Houston Boxing Promoter'. I already knew the name. There were plenty of gritty tales about the man who 'runs' Coventry: that he's one of the biggest boxing promoters in the UK, a wheeler and dealer who is respected and ranked with the most dangerous and hardest blokes in the country and with a temper like a slipping clutch. The street was

deserted but in a yard at the side of the gym, and looking fairly out of place, was £60,000 worth of high-revving Mercedes SL-Class. Metallic silver and with a personalised number plate – KEV 1. The rain was pissing it down and my hair was starting to frizz. But at least it looked as though the man was at home. I pressed the bell.

I could hear bolts being drawn back, a key turning in the lock and the door opened wide. Filling the doorway was a stocky British bulldog of a bloke. It was the man himself: Kevin Houston.

Solid bulging muscles, wearing a black T-shirt, black jeans and black leather shoes with thick soles and silver buckles. A Cartier bracelet on one wrist, a gold Rolex on the other. A chunky gold signet ring set with a diamond on his pinkie finger. His head was completely shaved and although he had the most fantastic cornflower blue eyes, the look of absolute menace made me shiver. I'd seen that look before and I recognised it. Danger. Still unsmiling, he gave me the once-over and then must have decided I was OK, because his expression changed.

'It's Kate, isn't it?' He stepped back and gestured for me to go inside. Kevin ushered me towards his office, past blokes sparring, boxers trying to knock the hell out of each other and meaty mean machines doing their fitness training. I edged past sweaty twenty-somethings pumping iron and beating the pulp out of punch bags. The place was full of testosterone and macho aggression. 'Come on in.' He pulled out a chair in a surprisingly hi-tech office. 'Sit

'I'd seen that look before and I recognised it. Danger.'

yourself down. I'm Kevin Houston.' He shook my hand in a grip like iron. I'd already guessed. Who else could it be but the Midlands boxer-turned-hard man-turned-world-famous boxing promoter? I looked around the office. There were photographs wall-to-wall of famous actors, sportsmen and, of course, boxers, all posing with Kevin. There was Jack Nicholson, Kirk Douglas, Tom Jones and Marvin Hagler. But the man Kevin was photographed with most was Don King, the famous boxing promoter. Was it a coincidence or were they really buddies?

'Good friends, you and Don?' I asked, pointing to the photos.

Kev gave me a wicked grin. 'So-so.' It was obvious by the look on his face that he was reluctant to talk about his dealings with Don King. Kevin offered me a choice of mineral water from the self-serve dispenser in a giant-sized silver American refrigerator, or a cappuccino from a snazzy coffee-making machine. I needed caffeine and I sipped it slowly while he spoke on the intercom to Noel, his right-hand man, took a call from LA and adjusted the channel on a fight-night plasma video screen. His office was state of the art, money no object, everything the very latest and best.

'Right, I'm all yours,' he said at last. I wasn't sure about this. What did it mean? Was he going to give me an interview? I'd been trying for years to pin down this man without getting a flicker of response. Kevin doesn't talk to anyone unless it's about business, the fight game or money. But for some reason he was in a good mood and today was the day. He settled himself back in his leather chair.

'Do you want to make a start?' Yes. Yes. Yes. This was it. One of the Midlands' toughest and richest geezers, with fists like iron and a reputation from hell – what makes him tick?

'Tell me a bit about yourself, Kevin. Where do you come from?'

'I was brought up on one of the roughest council estates in Coventry. Willenhall it's called, and when I say rough I mean diabolical.'

'What about your family?'

'There were six kids. Three brothers, two sisters and me.'

'So it was a tough childhood?'

Kevin nodded. 'It was. I had to fend for myself. You didn't get anything unless you got it for yourself. You had to clothe yourself, feed yourself and look after yourself. Don't get me wrong, my mum fed us and she did her best, but she had her hands full looking after six kids.'

'Were you a bit of a tearaway?'

He grinned. 'I was a right little bugger. I don't know how my mum put up with me. I did what I wanted, when I wanted. I never went to school. I couldn't see the point. Shutting you up in a classroom when you could be out doing something else. It wasn't for me. I could run rings round them when I was eight. It was a learning process, though – the school of life. When I was growing up I was a little bit out on the edge.'

'What do you mean?'

'I always knew that I had that little bit of something over the rest of them. The edge. Maybe because I was always looking out for the Old Bill!'

Kevin has the look of danger in his eyes but he also has a great sense of humour and when he cracks one of his jokes, it's easy to forget what sort of a man this is.

'Did you get in trouble a lot?' I could visualise a street-wise tough little kid.

'Even from being a kid I always knew the way I wanted things to go. I could suss people out – you know, when you're talking to someone, I knew what I had to do and say

to get the better of them. I knew what was coming. I had the edge over them. Anyway, we didn't have anything unless I fetched it. So that's what I did. I used to go down to the station and when the goods train came in, I waited on the wrong side of the track where nobody could see me and I waited my moment and when it slowed down enough I jumped on and helped myself. Never got anything much. It was devilment mostly.'

'What about your brothers, did you get on with them?'

'Sure. But I was a bit different from them. They were always mouthing off, arguing. Me, I never argued with anybody. I could think – like, He's a wanker or a fucker – and I'd be right. I'd leave it at that. It's like a gift I've been given. Call it instinct, if you like. It meant that I could do what I wanted. I could do a deal when I was five. I'd get anybody a fight if they paid well enough. I used to fix fights up between the other kids when I was eleven. I had more trouble and hassle before I was fourteen than most people know in a lifetime. It taught me a lot. I knew that I didn't want to be a mathematician or an office waller, or work any nine-to-five routine. I wanted to be somebody, make something of my life, do you know what I mean?'

'And have you done it?' I asked him.

'Yeah.'

Kevin is a quietly spoken man, very direct, and his manner is a bit deceptive. What you see definitely isn't what you get. His eyes give it away: laughing one minute, then like a shark the next – hard, cold, expressionless. They look through you, make you shiver, a ruthless, unemotional, pitiless stare. This man treads his own path. It would be a cold day in hell before he changed track. Maybe this was the defence mechanism of a man who lived with danger. I could always ask him.

'Has your life ever been threatened?'

'Many a time.'

'In what way? Give me an instance.'

'Mainly when I worked the doors. People come through and they want to have a go. I might have upset somebody and they'd want to give me a battering. I've been threatened with shooting, contracts put on my life.'

'They wanted to kill you?'

'Yes.' Kevin shrugged, so what. 'It's all bollocks. I mean, it's something to think about but these things can't be carried out.'

'Why?'

'Because the people that have threatened me have realised that if anything did happen to me, they'd be worse off.'

'What about being stabbed or shot?'

Kevin shook his head. 'I've been shot and stabbed at, but I haven't actually been hit.'

'Too quick on your feet.'

He smiled. 'Look, I'll show you.' Kevin was a top-ranking boxer when he was in his twenties. He was known for knocking his opponents out in five rounds – 'Once you're knocked down, you stay down' – and also for being a fast mover. He put his fists up, shadow boxing and doing some fancy footwork that wouldn't have been out of place in Riverdance. 'See that?' His feet moved so fast it was a blur. 'That's the Coventry shuffle.' I was impressed. 'I can usually get out of the way.' A solid bloke and light as a feather on his feet.

'What about trouble? Getting hurt. Does anything frighten you?'

Kevin yawned. 'Nothing.'

'Most people are deep down scared of something.'

He thought for a minute or two.

'Well, I suppose, when you're off your usual patch, it's

a bit different.' He fetched himself a glass of water. 'To be honest, something did get me spooked once. Late one night I once went rough shooting with a mate – pheasants, that sort of thing – and we were geared up with all the camouflage and there I was with my twelve-bore shotgun. The beaters were driving the game towards us – and it went very quiet and I was

'If someone is going to try to put me down, they'd better make sure they do it,'

in a spot on my own, just waiting, and all of a sudden a voice right behind me says, "All right, mate", and there's this bloke there, geared up with a balaclava just like me. Fucking hell, I jumped out of my skin, I nearly shit myself. It hit me that he'd crept up on me and I'd never heard a thing. Because he was on his territory. He knew the terrain. Then he says, "Are you with the club?" It turned out that it was his fucking gun club and his land and his pheasants and I wasn't supposed to be there. I'm shooting pheasants and they ain't even mine.'

'What did you do?'

'I went yeah, yeah, yeah and I fucking walked off. Oh my God that shit me up. It could have been anyone wanting to put a bullet in my nut.'

'You didn't lose your rag?'

'Not that time.'

'What does make you see the red mist?'

'Quite a lot of things. The gift I've got is that I see the red mist before anybody else does, do you know what I mean?' (This is one of Kevin's fave sayings.) 'I don't argue. I get in first. That's a big advantage in life.'

I didn't think that everyone would agree with him.

'Has anything violent ever been done to you?'

'No. I've never really been beat up in my life. I can't say that a lot of violence has happened to me. Around me, though.'

'You attract violence?'

'Not at all. I don't run from it, though.'

'What's the most violent thing that you've done?'

He nearly told me. Not quite, though. 'It was when ...' He stopped in time. 'Well, I don't use weapons. I might have smacked somebody, my fists or my knuckles.'

'Would they be your weapons of choice?'

'My fists, definitely.'

He was fiddling with the heavy gold bracelet on his right wrist and I thought he was getting a bit edgy. So far all I had seen was his tough side. It was time to change the subject.

'Who do you love most in the world?'

Without hesitating, he told me. 'My daughters, Tiffany and Stacey.'

'Are you an indulgent dad?'

Kevin looked pleased with himself. 'Yeah. If I can get it, they can have it.'

'Lucky girls. Wife? Girlfriend?'

He scowled.

'Animals? Dogs? Cats?' Well, you never know. Anyway, I was nearly right. Kevin has a hobby. His dad keeps racing pigeons and Kevin is as much into this as his old dad. Strange to think of a man with fists like iron looking after birds.

'And what's your happiest memory?' I thought he was going to share a treasured moment from his childhood or his kids' lives. His answer was a bit sad.

'To tell you the truth, I can't recall.'

Like a lot of other extremely tough men, with Kevin emotions are sometimes close to the surface and they can't be allowed to show. Maybe he wasn't going to let me that far in.

'What about your worst memory?'

This was much easier.

'When my twin brother was knifed.'

'What happened?'

Kevin leaned forward; this was as fresh in his mind as the day it happened.

'Well, my bro was going out with this girl and her ex-boyfriend was a bit of a lunatic. They'd been to the pub and she was giving him a load of grief one night and they split up and my brother went home on his own. He never thought any more about it. There was nothing to suggest that this night was ever going to be anything out of the ordinary. He just locked up and was going to bed. Then somebody came to the door and knocked and he went and opened it, like you would, and this ex of hers was standing there with a machete. He just lunged at him and gilleted him like a fish – sliced him straight up his stomach.'

Kevin's voice was still low, but his eyes were shooting darts of ice; the look of menace was awesome.

'Was it a bad cut?'

He nodded. 'Ten inches long, spilling his guts out. Anyway, he fell down and this maniac jumps on him and stabs him again. Somebody called for the ambulance. When it came he was as good as dead. In fact, he died while he was in the ambulance. The medics pulled him back.'

'Revived him?'

'Yes. Then he had a four-hour operation at the hospital and he died again on the operating table. I was there with my dad and we were waiting and waiting, it was absolute agony. Eventually the doctor came and he took me out of the room and told me what was happening and I thought, Fucking hell, how do I deal with this? My mind was racing. I felt breathless. Weak. I could hear someone screaming and

I wanted him or her to shut up. But it was me. I was the one who was screaming that he had to live. I willed him to live. He couldn't die, he was my twin brother. I put all my energy into it. Giving life back to him. I knew I could will him back to life.'

'And ...?'

Kevin leaned back, his arms folded.

'Yes. He lived.'

'And the man with the machete?'

He looked up at the ceiling; his voice was barely a whisper.

'It's funny, because he's never been seen again.'

This led me straight into my next question.

'What makes you feel guilty?'

The reply snapped back. 'Nothing.'

'There must be something?' Everybody has something on his or her conscience.

Kevin gave in. 'Women. My love life.'

'Are you going to tell me?' Did I sense an achy breaky heart?

'No way.'

If there was one, he wasn't going to let on. Kevin is a sharp but casual dresser. Designer gear, imaged up to the hilt. Is he happy with himself? Money is obviously no object.

'Is there anything you'd change about your looks?'

'No.'

'What gives you a buzz?'

His answer revealed an unexpected side to his personality.

'Doing a good tattoo.' Creative and artistic. This is so much at odds with the rest of his life.

'You don't have any tattoos, do you? He pulled his shirt up and showed me his stomach. Wow! A full-size lion's head. On the rest of his body are dragons, roses, Celtic

crosses, all where they won't show under a suit. Everything's hidden away under the surface, like the rest of his personality.

'What makes a man?'

'He has to be hard. Real and serious. And a nice guy.'

'So, if you weren't you, who would you like to be?'

There was no hesitation.

'World champion boxer. The best sport of all and there you are, in the ring, the two of you, one wins one loses, on your own, winning the world title. That would be it. '

'If you had to liken yourself to a boxer, who would it be?'

'Well, I admire Marvin Hagler because he's tough, he fights all the time and he has respect. I like respect. And he doesn't talk any showman bollocks. He's a real professional.'

'And if you had to name a hard bastard, who would it be?'

Kevin thought for a while about this.

'A boxer. They have to give it and take it. And they're on their own. I think the hardest fighter would be Rocky Marciano, he was only a small guy but he took it and he was hard. I think a lot of it is grit, it comes from the heart. It's not how physical you are or how big you are, it's more about guts and determination. It's like a pit bull terrier. Now, he'll beat an Alsatian who's twice his size, because he has more heart for the fight. It's not the dog in the fight, it's the fight in the dog.'

I could see where he was coming from. 'How do you stay one step ahead?'

'By having the edge on everybody else. If I see somebody who's going to fuck me off, there's no going back. I go in first and finish it as quick as I can.'

'No matter what it takes?'

'Whatever.'

So, what does the future hold for this truly diamond

geezer? I'd give it a whirl. 'If you went to see a fortune teller, what would she tell you about the past and what would you like her to tell you about the future?'

His answer made me jump.

'First off,' he spat the words out. 'I'd never see a fortune teller. It's the biggest load of bollocks. People go to see them because they're wishing they could hear something to make their life a little better. They really believe what these con artists say. But the fortune teller isn't doing them any good, she's putting a spell on them.'

'You've had a bad experience?'

'I have. My ex-wife believed everything they told her. It's a waste of a life. A fortune teller who didn't know anything about her took money off her and told her a load of rubbish.'

'You're divorced, then?'

Kevin frowned. He didn't want to talk about relationships. 'I'm a bit of a psychologist myself and I look at people and I weigh them up. And that's what a fortune teller does, she'd look at their shoes and the way they dress, the talk and the attitude. They can sense weak people at ten metres. They tell them what they want to hear. Which is bollocks, because they don't know fuck all about them. They'd have to be God to know that. And a lot of people are so weak that they believe in this rubbish so much that it ruins their life.'

'What do you believe in?' He became thoughtful.

'I do believe there's a spiritual side to things.'

'Such as?'

'When you're dead and gone, you still have a soul, there is something more to life.'

I liked that. 'Come on, Kevin, tell me, if you were eighteen again, what would you do differently?'

'Nothing, really. I was very naive then but I don't think I'd

change anything. I've learnt a lot since then. I wouldn't like to be that young again.'

'What advice would you give anyone that age?'

'Eighteen-year-olds are all mad; you're off your head at that stage, aren't you? But the advice I'd give them would be: "Think before you speak."'

'Good words.'

'"And have a look round before you do anything."'

The phone kept ringing. He was having a hard time. 'Tell Frank I'll ring him back.' 'I can't get to Copenhagen till Tues.' 'If Lennox is willing to meet us halfway ...' The boxing game is his life and the calls were piling up.

'Can you sum yourself up in one word or one sentence?'

He thought quickly. 'A tough guy, but a nice guy. Naughty but nice.' Yes, I could go with that. Maybe more naughty. A man of extremes, though.

'Are you going to tell me a secret?'

'I've only got one.'

'And that is?'

'My cashpoint number.'

'Tell us then. I bet there's lots and lots and lots of dosh in there?'

I'd heard that he didn't own just one house but streets of them; there was the Merc, the clothes, the holidays, his famous generosity. He lavishes money on his daughters and his hospitality is legendary. No guest of Kevin's ever has to pay for anything: they get the best hotels and fabulous meals.

Kevin laughed. 'Eight-five-six-one. The only other person that knows that is my twin brother, because it's our date of birth'

'As if. Tell me a joke.'

'All right. There was this priest, right, and he was having a wank at the back of the Vatican and he hears a click –

and there's a tourist who is taking a picture of him. So he says, "Oh, you have a camera," and the tourist says, "Yes, I take picture of you." The priest says, "How much do you want for camera?" He says, "A thousand dollars." The priest says, "OK, I give you a thousand dollars for camera." So he gives him the thousand dollars and gets the fucking camera from him and walks round the corner and sees the Monsignor. The Monsignor says "Oh, you have camera, where you get camera from?" The priest says, "I get camera from tourist." The Monsignor says, "How much you pay for camera?" The priest says, "I pay a thousand dollars for camera." The Monsignor says, "He must have seen you coming!"'

Kevin's face cracked into a big grin, but it was a bit rude for me. I coloured up and made for the door. I'd been asking him a lot of questions, but he'd turned the tables easily. They say you can never judge a book by its cover and with this man it's true. Kevin Houston is one of the toughest guys I've ever met and a 10 carat diamond geezer. He was like a brick wall; I felt as though nothing would get to him. If you punched him with all your might in his solar plexus, you'd just break your fingers. If my questions got to him, he kept it well hidden. I think he sussed me out as much as I was trying to suss out him. I left in a hurry. He had the edge all right.

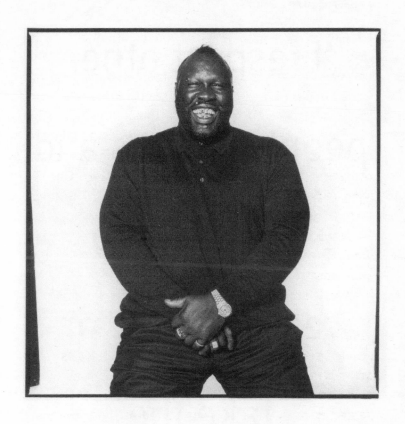

BILL

'IT'S NOT OVER TILL IT'S OVER'

NAME: Bill

DATE OF BIRTH: 15.12.61

OCCUPATION: Personal security

STAR SIGN: Sagittarius

'I respect other people's views and they have to respect mine or take the consequences. And murder is a fucking messy business.'

BILL

'THERE WERE TWELVE ARMED SHERIFFS WAITING FOR ME,
I WAS IN TROUBLE – BIG FUCKING TROUBLE.'

The Hare And Hounds is one of the plushest pubs in
upmarket Blackheath. It's the place to be seen –
Victorian posh and packed with city executives
wheeling and dealing on their mobile phones,
accessing the internet and checking their share
prices as they slurp Chianti and munch ciabatta. I
saw Bill as soon as I arrived. There was no missing
him. A huge monster of a guy standing by the
entrance, his feet plonked apart, he looked as solid
as a hunk of ironwood and as immovable as a huge
silver-backed gorilla. At his feet was one of his
Rottweilers, his constant companion. They say that
dogs get to look like their owners – or is it the other
way round? Either way, the dog had a similar
menacing expression. People were arriving all the
time but these city suits and regular punters edged

away when they saw Bill, making impromptu decisions to use the other doors. Bill spotted me and gave me one of his rare smiles.

'How are you, Kate?' We shook hands. He had huge chunky gold rings on every finger, a gold bracelet an inch thick on his wrist, a yellow gold earring and several thick close-linked old gold chains hanging round his neck.

'Brought your bank with you?' I kidded.

'Little bit,' he said, fingering at least an ounce of 22 carat gold ring on his middle finger.

We wandered over to a table on the terrace overlooking the sprawling lawns. Bill didn't want to go inside, he wanted the dog to stay with him. 'Is he friendly?' I put a hand out to pat him. The dog bared his teeth. Grrrrr. Bill snapped, 'Down, Drax.' The Rottweiler slumped to the floor instantly.

'What did you call him?'

'Drax. Dracula,' Bill explained. 'Feeds on human blood.' For a moment I thought he was serious. Then he laughed. 'Only kidding'.

'You could put him in the car, couldn't you?' Bill had parked his black long-wheelbase Shogun near to the exit. But Bill is a dog fanatic, especially Rottweilers. His fierce-faced mutts get the five-star treatment, and putting his dog in the car was not going to happen.

It was like a royal procession: the crowds parted in front of us. Both Bill and his dog were totally intimidating, there was nothing to choose between them. If there'd been anyone sitting down at the table we were heading for, I swear they'd have got up and scurried away.

In a beautifully cleared space we ordered our drinks – sparkling water, ice and lime for me, Italian mineral water for Bill. 'Why do you wear so much gold?' I asked him. A saddle ring, a dealer ring, a showman's ring – Bill had them

all; not for nothing is he known as the Mr. Bo-Jangles of London. 'I like the feel of gold, it's powerful,' he told me. It looks good on him too: he has the size and presence to carry it off. Bill has a style of his own: short spiky hair, chunky boots, designer street cred strides, the jewellery, it says it all: hip-hop, macho man, loaded.

'Do you still have the jewellery shop in the East End?'

He shook his head. 'Nah. But I still do a bit of buying and selling. New stuff, antique pieces, sovereigns, medals, Art Nouveau.'

It was hard to visualise this human mean machine being knowledgeable about the merits of a platinum pendant or the clarity of a Sri Lankan sapphire, but from diamonds to bullion, Bill is an expert. He is clued up about everything to do with precious metals – whether it's the price of ingots, gold testing or value per ounce, you want to know what it's fetching in Tokyo or Dubai – he's the man. 'You'll not be worried about muggers, will you?'

That made him smile. No, that wasn't going to happen. In fact, whoever saw him coming towards them with that chiller-killer look on his face and wearing the big who-knows-what's-in-the-pockets coat would step aside. Best to let him pass. And be glad when he did. Let's face it, who wouldn't want to keep out of his way? Anyone meeting Bill walking his dog on a dark street at night would be out of there pronto. We may as well say it like it is. The good is well hidden, what comes over is the bad and the no-so ugly. With a track record straight from the gates of hell, this bloke is one mean motherfucker.

I'd met him once before and knew that he was a friend of my former husband Ronnie Kray. Bill used to visit Ron in Broadmoor. I didn't have to ask to know that they wouldn't have been social visits. Murderers, bank

robbers, yardies and villains of all kind visited Ron. If they were on his VO list they were up to no good and involved in some kind of 'naughty business'! They wouldn't have been straight-up geezers.

'With a track record straight from the gates of hell, this bloke is one mean motherfucker.'

I had been told on the highest authority that Bill was still one of the 'hardest bastards' in the country. It was only when he knew who I was that he had agreed to talk to me. It still took some doing to get him to relax and open up. Bill looks hostile, secretive and mistrustful. But he had spoken warmly about Ron and had been a good friend to him. To be honest, how Bill looks, and how he actually is, is a contradiction. In reality he is a charming, laid-back, cool dude.

I asked him to tell me a bit about his background.

'I was brought up in Whitechapel, east London, to start with. Then we moved to south London.'

'Were you a bit of a tearaway?'

It was hard to imagine this solid muscle man as a little lad.

'My parents were fairly strict but I had a good upbringing – not over privileged or anything like that. I expect I gave them a hard time; my mum was always up at school trying to sort things out. I was a bit of a nuisance, but at that stage, nothing too bad. It was the area we lived in. You were part of it or you didn't exist. I was always going to be part of it.'

'Do you have brothers and sisters?'

'Yes, two of each. I'm the eldest. I suppose from day one I was always getting myself into mischief.'

'So how did you sort yourself out?'

'I started training and bodybuilding. My dad encouraged

me – they thought it would keep me off the streets more than anything.'

'Did you go in for competitions?'

'No, I wasn't bothered about that side of it. I'm not into collecting trophies or winning prizes. It was for the sake of keeping fit to start with, and then it was for work. If I'm not fit, I can't do my job.' Bill is totally single-minded about his commitments. He is a truly massive man-mountain, as solid as the rock of Gibraltar. If you punched him, you'd break your knuckles and the blows would just bounce off. Smash a bottle across his head, he'd blink and keep coming. Clunk him with a baseball bat, he'd take it from you and snap it in two.

'How much do you weigh?'

'Twenty-three stone now. I went up to 28 stone when I stopped training, but I didn't like the feeling. I've never stopped training since. I go down to the gym several times a week. I'm fitter and more agile at my present weight.'

'What about weapons?'

Bill frowned. 'I use whatever the situation warrants. I never commit violence unless it's justified. I'm not one of those people who use the position to bully people.'

'But if the occasion calls for it ...?'

He shrugged. 'I'm not afraid to use tools. I have done in the past. But that's occasionally. It's my fists mainly.' He clenched them and held them up. I shivered. 'They're good enough,' he snarled.

The thought of these meat plates, loaded with rings, smashing into anyone was serious. Bill's manner is fairly level, he's not loud or brash, but I wanted to know whether he flares up or not.

'You're fairly laid-back,' I told him. 'How quickly do you see the red mist when you're having a row?'

So far he'd answered my questions straight off, but now he became a bit cagey.

'I do have a bit of temper, unfortunately,' he admitted. 'And that's when anything can happen.'

'And when you lose it ...?'

'There's no going back.' He looked down at his hands. 'It's like *Mastermind* – once I've started I'll have to finish it.'

'No stopping you?'

'Not till it's over.'

'What's the most violent thing you've ever had done to you?'

'Nothing.'

'You've never been hurt?' This was surprising. In the rough, tough world in which these geezers live, most of them have a battle scar or two.

'Of course I've been hurt, but nothing that's made any difference. I've had guns pulled on me, but when it comes down to it, and you keep coming, you find that they don't have the bottle. Nobody's put me down – so far, anyway. I've had them hit me over the head with a bat and I've not even slowed down. I think the adrenaline takes over.'

'Have you been stabbed?'

'Yeah, a couple of times. I've had blokes bring out machetes and have a go. I've had cuts and slashings – but that's part and parcel. It's not been any big deal. I'd

'Nobody's put me down —

so far, anyway.'

have hurt myself more doing DIY.' He almost laughed. 'I've just been down and got myself stitched up.'

'And what's the worst thing you've ever done?'

Bill shifted a bit, looking very uncom-fortable. I thought for a minute he was going to get up and walk out. He gave me a very direct stare.

'There's not a lot I can tell you. Nothing I can talk about.

Let's just say I deal with things when I have to. Like working on the door at a club: half the time, they don't know what they're doing; they're out of their head for one reason or another. When I bop them, it might be a little tap for me, but it'll break their jaw or pop their nose.'

'You don't know your own strength.'

He shook his head. 'Believe me Kate, I do.'

OK. 'What about your reputation?' I'd heard lots of stories about Bill and retribution. He seemed to be watching me carefully while we were talking about this. Was he gauging my reaction? I tried to be as non-committal as him.

'Go on, what have you heard?'

'That when it's pay-back time, you go on till it's finished. That you aren't afraid to do anything.'

'You heard right. I'm not backing off from any fucking trouble. And if I come after anyone I stay with it till they've got what's coming to them.'

'No matter what it takes?'

Bill nodded.

'Whatever. People have got to accept that. If they don't, you lose respect. I respect other people's views and they have to respect mine. And if they don't they have to take the consequences.'

Bill bent down to pat his dog. He clicked a finger at a waiter and ordered a large chicken sandwich. 'Would you like anything to eat, Kate?' he asked me politely.

But I shook my head. I'd lost my appetite completely. When the sandwich came he waved it in front of the dog, which began to lick its lips. Bill threw the chicken up in the air; Drax caught it and wolfed it down. What a kind, thoughtful, dog-loving man. But ...

'Have you ever been to prison?'

'Yes, I've done a bit of bird and that was enough for me.'

Would he tell me what he was banged up for?

'Ironically, it was for a relatively minor offence. A policeman was taking pictures of me and all I did was take the film out of his camera!'

That didn't sound too bad.

'Is that all you've done?'

Bill stared through me, his eyes unfathomable. Was I asking him too many questions? I don't know what he's angry at but whatever it is, he brings it with him all the time.

'I've done lots of bad things,' he growled. 'Now I'm careful. When I got banged up I thought, This is not a clever place to be. No matter what it takes, I'm not doing any more bird.'

'Was it was a bad experience?'

He nodded. 'I felt like a caged animal. The screws are the worst. They're all fucking bullies.' Bill hates bullies. That was obvious. 'In my view they always come unstuck. The man who's frightened is the man you've got to watch. He knows he's got to take you out of the game because if he doesn't, he knows he's going to die. Simple as that.'

I'd heard about Bill's reputation as a 'minder' for the stars. 'Is it true that you've worked for lots of film stars?'

'Quite a few. I handle the security at a club where most of them go when they're in town – they get Kevin Costner in there, Tom Cruise, Tom Jones, Nicole Kidman. I look after a lot of foreign businessmen, princes, and sheikhs. When they want someone to watch their back, make sure they're all right, they ask me. They want to be able to relax, know that some nutter isn't going to bother them.'

'They wouldn't with you around.' Bill sure looks the part.

'I've flown all over the world on assignments. If someone's moving money or it's something they want to keep safe, or a personal problem, I handle it for them.'

Bill's office is plastered with signed photos of the rich and famous. It's a busy life.

So, what drives this workaholic who is always rushing about from one job to the next? Bill is also totally dedicated to his family and children.

'Who do you love most in the world?'

He replied without hesitation. 'My son.' For a moment his face changed and his eyes lit up, making him look totally different. Bill is a man who has, over the years, built up a hard shell in order to protect himself. There is layer upon layer of animosity and anger. But when he talks about his family, he is no longer hostile. There is another side to him. And Bill is a spot-on lookalike for Mr T – the American *A-Team* TV star. He seems happy to go along with this.

'Do you get mistaken for him often?'

'Yes. It saved my life once. When I was in the Deep South on a 'gator safari and I realised too late that they were still living *Gone with the Wind*.'

'What do you mean?'

'Well, I was on holiday with my girlfriend and we were having a terrific time. We'd been to the Cayman Islands, then we did Disney and we finished up in New Orleans for the Mardi Gras.'

'Sounds pretty good.'

'Until my fascination with alligators got the better of me. We bought two tickets for a ride on an airboat out into the swamps. What I didn't notice was that the guy running the show had KKK tattooed on the back of his hand.'

'What does that mean?'

'Hard to believe, isn't it? Ku Klux Klan. The guys running the swamp boats were "good ol' boys" and I was the nigger. I looked round and saw that everybody else there was white. Then I heard the ranger talking into a little radio.'

'What was he saying?'

'"We got a nigger on board." By now it was getting a bit tense. They still make their own rules in that part of the world.'

'What happened?'

'I was getting bad vibes and we were setting off out into the middle of nowhere. But I thought, Fuck it, I've paid my money I'm going to see those alligators. I didn't realise at first what sort of danger I was in. We got out into the first lake and it was sure full of 'gators – you could see their eyes just above the surface of the water and you could tell how big they were from their eyes to the point of their nose. If it was a few inches, it was a little 'gator. But if it was a foot and a half, that was one gigantic head. It made me think. If you got tipped in the water you wouldn't stand a chance. You'd be gone in seconds. It was a scary thought.'

Bill realised that he was in a very serious situation. 'When I had eye contact with the ranger, I think he knew that I was not going to back down. He turned the boat round and headed back for the shore.'

'I could feel their hatred and that they all wanted a slice of my black ass.'

'You went on your way.'

'No chance. There were twelve armed sheriffs waiting for me. I was in big fucking trouble. I wasn't in London, this was America's Deep South where black men are still lynched or tied up to the back of trucks and dragged to death. It was looking like me in the slammer and a midnight party with the Ku Klux Klan. I could feel their hatred and that they all wanted a slice of my black ass.'

'You couldn't fight your way out of this.' Twelve armed men were too much even for Bill.

'No, they were wanting me to make a move. I was thinking it was all over, when a kid piped up that I was

Mr T.' Bill flexed his arms, with a bit of a quirky smile. 'Then one of the sheriffs said to me, "Hey, are you really that nigger on the telly?" "Oh yeah," I told him, "yeah, that's right, I'm Mr. T ...!"'

'Close call. Did they ask you for your autograph?'

'No. They thought I was the film star all right, but they still chucked me out.'

'A scary experience.'

Bill was laid-back about it. 'I was lucky I didn't end up as 'gator bait!'

'Do you often get mistaken for Mr T?'

'Yes, but I don't mind. I do a lot of charity work, opening clubs and pubs, whatever they want – so long as it's in a good cause. Mostly I like to raise money for under-privileged or sick children. And they want to see Mr T – so that's what I give them.'

This was a different side to Bill. 'You're known as a tough guy. And here you are raising money for charity, helping kids. Why do you do this?'

'It makes me feel good. It gives me a buzz to think that I'm making a difference to some kid's life. Giving them a chance.'

'The chance you never had?'

'Maybe.'

Bill is like an iceberg. On the surface he's ice – cold, sharp and jagged – but you still don't get what's lurking under the water unless you dive in and look for it.

'Does anything frighten you?'

Bill was serious for a moment.

'God,' he said in a low voice. 'The thought of God frightens me.'

'Why?'

'The inevitability of life. That you can't take back

anything you've done and one day you'll have to account for it.'

A profound thought.

'What makes you feel guilty?' I thought his answer might relate to what he'd just told me, and in a way it did.

'Unnecessary suffering.' He paused for a moment. 'Nothing I've done has ever been planned. It just happened. I do what I have to do. It's survival.'

'What do you think makes a man?'

'A man is a bloke who avoids violence if he can and doesn't use unnecessary force. I believe in warning people first. Even then, I think to myself, In the name of God, man, you don't want this. I always quote God's name.'

'And a hard bastard?'

'Being able to deal with whatever comes up. Going forward all the time, never looking back. There's always one who wants to push it. I can't help that. I have to have respect – if a man hasn't got that, he's got fuck all. If there's no other way, I take him out.'

'Who do you think of as a hard bastard?'

'It's got to be Roy Shaw.'

'Why?'

'For what he's gone through. He means it. No messing, no backing down. He's his own man and he's survived.'

'And how have you survived? How do you stay one step ahead?'

'My reputation, I suppose. I never back down. I suss out the situation and weigh it up as much as I can, then I go in. My motto is – it's not over till it's over.'

'If you could change your looks, would you?'

Bill shook his head.

'No way. I've always been fucking ugly. That's why I stand out.' His striking appearance is his trademark.

'Would you have plastic surgery?'

'No.' He was definite about that.

Bill is a deep thinker. So, is he planning any changes in his life? What lies ahead? 'If you went to see a fortune teller, what do you think she'd tell you about the future and what would she tell you about the past?'

'I haven't got a clue. Probably things I wouldn't want to hear.'

'What would you like her to tell you?' Did Bill envisage a time when he wouldn't be in the same business?

'I'd like to think that I would go on being successful and respected and having a happy life. And that I'd never be in another police station or prison again.'

'Not retire to the country and breed dogs?'

He half smiled. 'Who knows, Kate?'

'Would you do things differently if you were eighteen again?'

There was no doubt this time. 'Definitely. I think it's harder to back off than it is to take someone's life. They've got families; it leaves a trail of shit behind. Murder is a messy business; it's not just you it affects. Taking someone's life isn't an easy thing, no matter how fucking hard anybody is. What I'd do differently is get an education.'

'Good answer. Why?'

'That way, you have choices in life.'

'So, if a youngster came to you and you could see he was going down the wrong road, what would you say to him?'

'Go to college, study and get some qualifications. And be very careful who you trust and who you talk to.'

'If you were to sum yourself up in one word, what would it be?'

'Dangerous.' Bang on.

The dog had begun whining, he was getting fed up. 'Sit,' Bill growled. Three blokes were getting up from the next table; they heard him and sat down as well.

'Will you tell me a secret?' I asked. I didn't think for a minute that he would. But he had a ripe one all ready.

'There's not many know what I'm going to tell you ... and it's a bit personal. Sure you're ready for it?'

'Go ahead.'

'All right. I've had my "you know what" pierced. That's my secret.' It certainly was. I couldn't think of anything to say. Bill burst out laughing.

I asked him one more question. 'Will you tell me a joke?'

He came straight out with it. 'What do you call an Indian lesbian?'

'No idea.'

'A ... mingeater.'

He grabbed the dog lead and stood up. Places to go, people to see. This is a powder keg of a man, slow to fire up, but once the touch paper is lit, get ready to run. With the dog at his heels, Bill was on his toes and away, back to the black motor with its tinted windows and his shadowy, dangerous world. The joke had made me laugh but I hadn't a clue whether Bill was smiling or not. There were no goodbyes.

ESMOND KAITELL
'THE SKYSCRAPER'

NAME: Esmond Kaitell

DATE OF BIRTH: 27.4.59

OCCUPATION: Managing Director, WK Security

STAR SIGN: Taurus

'Outside, there were three of the biggest men I'd ever seen in my life. They were body builders and they all had these duster coats on. I saw a baseball bat peeking out. I knew I was in the shit.'

ESMOND KAITELL

'I SET MYSELF UP AS JUDGE, JURY AND EXECUTIONER'

The sky was blue, the sun was shining, a gentle breeze rustled through the trees and Hyde Park in central London was packed. There were families, kids, sweethearts, more than a few tourists and I was there with a man who used to be one of London's scariest geezers: Big E, also known as 'The Skyscraper'. More than a few heads were turning – Esmond Kaitell is 6ft 5in in his bare feet and with a brutal and violent life behind him, the scars show. We were having a stroll past the lakes and fountains while he talked about his upbringing and mis-spent youth.

'What sort of life did you have as a child?' I asked him.

Esmond is a good talker. We sat down on a bench while he told me all about it.

'I was brought up by English people. My foster parents were cockneys and they were a wonderful couple. They

came to see me in the foster home, but when they heard there were three of us, they offered to take my brother and sister as well. We couldn't have had more affection from anyone, they loved us so much.'

'So it was a happy childhood?'

Esmond shook his head. 'Not entirely. It was great at home, I felt loved indoors with my foster mum and dad, but at school it was different. It was like being in a zoo. The kids could be nasty, but kids are kids. The parents were the worst, they just stood and gawped. From a young age I was made aware constantly that I was a different colour, that I didn't fit in. It made me shy and introverted. I was picked on. It was either sink or swim. When I was at school I decided that I wasn't going to be a pushover. That's how it all started.'

'How did that make you feel?'

Esmond has an expressive face and the pain was still written on it in large print. 'Mean. Aggressive. I was insecure. That's how I got started.'

'You became a hard bastard?'

'And some. In my heart I still loved people, and I wanted deep inside to help everybody, but instead of that I became more and more involved in violence. In the end, I set myself up as judge, jury and executioner.'

'What sort of a life were you living?'

'I started off boxing, at Dagenham Boxing Club. And then I did kick boxing and street fighting. I built up a reputation. As you do. Eventually I was working the doors and then I started my security firm.'

'Are you still looking after the doors?'

'Yes, I began fifteen years ago. But I have people working for me now. It's still a hard business.'

'Has your life ever been threatened?'

'Yes. Many times. I have to admit that I've always been

given to violent tendencies and it's got me into a lot of trouble.'

'Have you ever been to prison.'

Esmond didn't want to answer this. 'Whatever I've done wrong, I've paid my dues. I'm not proud of it but I'm not ashamed either.'

Esmond has a reputation on the street for having been involved in some heavy violence. 'What's the worst thing you've ever done?' I didn't know whether he would tell me.

'There's been so much. It was everything, a way of life, survival. I did what I had to do. It's like being the last gunfighter in a cowboy film. Once you're in it, there's no way out.' He thought for a moment, picking his words carefully, before deciding what he was going to say. 'I'm ashamed to say that people crossed the street when they saw me coming. And at that time they were right, because if there was trouble, I was usually in the middle. But it couldn't go on forever and it didn't. In the end, I came unstuck.'

'What happened?'

'An ex-doorman of mine was a scouser called Pete and I hadn't seen him for a couple of years. Then I heard on the grapevine that he'd come back down to London and was training to be a publican. He was taking on a pub in my area. So one night, when

'He was a frightened man when he saw me jump out of nowhere straight at him.'

I was out for a drink, I happened to pal up with two blokes who were the opposite of the types I usually meet. They were regular guys, quiet and a bit shy. We were having a beer and my scouse pal came in and he was fuming and raging. He said that the bouncers at a club in the Ilford

area had insulted him and his wife. They'd searched her and taken too long over it, tipped the contents of her handbag on the floor and then eight of them had come round him, chucked him out and told him to take his slag with him.

This was out of order. Pete had come to tell me. Well, I hardly stopped for breath.'

'You went over there to sort it?'

'Right. Without thinking. My new pals came with me, for the ride and to see a side of life they'd never dreamt about. I knew the club because I'd used to do the door there. Anyway, the bouncers are on the front steps and the manager and me and Pete and everybody's shouting at once. So I called my boys away and we retired to our HQ to think about our strategy, which was the back room of a kebab shop in Ilford. While they're all eating, I slipped back on my own. I know the place like the back of my hand, so I go upstairs and confront the geezer who mouthed off at Pete. He was a frightened man when he saw me jump out of nowhere straight at him and when he put his hand in his pocket, I knew something was coming and that it wasn't going to be good.'

'A shooter?'

'That's what I thought. I literally leapt at him and got him by the lapels and pushed him back through the double doors and put him on his backside. "Tomorrow you go and apologise to Pete and his wife, right?" And the guy's saying, "No I ain't doing that." So I tweaked it up a bit and he's screaming and then he said, "I'll go and apologise to her." I thought, That's about the best, I'm going to get. I got up, dusted myself off and walked through the doors, on my way. But outside, there were three of the biggest men I'd ever seen in my life waiting for me. I'm six foot

five but these topped me. They were body builders and they all had these dust coats on. I saw a baseball bat peeking out, and now the other guy's got up and he's behind me. I knew I was in the shit. Nothing for it but to try to make for the door.'

'Did they catch you?'

Esmond nodded. 'I'd no chance. They beat the hell out of me and left me for dead. I was in hospital for three weeks, I couldn't eat for six months, my wife had to liquidise my food. I had to drink through a straw and it got progressively worse. The pain in my head was excruciating. I was under three different hospitals, I'd gone deaf in one ear, I'd got plates in my head and was losing the sight in one eye. I'd never had sympathy with suicides before, but now I knew what it was like. I couldn't eat, I couldn't talk, and I couldn't close my jaw. I wanted to die.'

He fingered a puckered blue line running down his jaw. The scars were still there.

'What about the blokes who beat you up. Did they get away with what they did to you?'

Esmond pulled a face. 'People, well-known people, were coming round, asking me if I wanted it sorting.'

'They meant ...'

'Yes, that they'd take them out. But I told them no, I'd sort it myself when I was better. I felt very vengeful. The Old Bill had me under surveillance so I had to be careful and I was putting it about that nothing was going to happen. I was going to make sure that the Old Bill wouldn't pin anything on me.'

'Did you know where they were?'

'Yes. I knew who they were and where they were. The only thing that was keeping me alive at that time was the thought of who'd look after my kids if I topped myself or

went down for the big one. That and vengeance. In my mind it was an eye for an eye. It was eating me up.'

'What did you do?'

'One of my doormen came round to my house and, seeing how bad I was, he asked as he was leaving if I wanted to go to church with him. Now he knew what I was like, that I thought the church was all nonsense. Normally I would have told him to fuck off. Well, instead of that, don't ask me why, I just said, "OK, I'll come." He was fairly shocked and amazed but he came and picked me up on the Sunday and took me to a church in Canning Town.'

'How long ago is this?'

'Ten years. I went in and I didn't understand a word that anyone was saying, but the smiles and the handshakes were real and genuine. When I came out I felt a lot lighter. I had been feeling hatred for everyone but it had subsided. This went on for three weeks. The emotional side of me was easing off a bit.'

'Were your injuries getting better as well?'

'No, they were worse. They'd told me I had to go back into hospital for an operation to re-break my jaw. It might not be successful. No one could tell what I was feeling like inside. The external injuries were terrible and inside I was just as bad. I decided that these guys who had done this to me would be dead. I had some pals in Sunderland, the idea was that I'd call them, they'd come down and do the business, I'd be sitting in my flat in Ilford, no problems.'

Esmond's voice was totally unemotional.

'That's a desperate step,' I told him.

'My mate knew what was in my mind, and when we were going to church the next week, he told me that I had to forgive them. Every time he mentioned the word "forgive" it was as though he was putting a hammer in my head as well. He'd

asked me if I'd go to a prophetic conference with him at Kensington Temple and I'd agreed, but by the end of the journey I felt ready to kill him as well.'

'There was all this rage in you.'

'It was like, this was all my life had come to mean.' Esmond was drumming his fingers on the bench, oblivious to the ducks on the pond, the kids round the ice cream van, the sweethearts strolling arm-in-arm. 'By the time we got to this Temple

'I couldn't eat, I couldn't talk, and I couldn't close my jaw. I wanted to die.'

place I was in a rage and I was telling him what I thought. He said to me, "If you can't forgive them, God can't forgive you."'

'What did you say to that?'

'"If there is a God, he probably won't forgive me for some of the things I've done." Anyway, we went in. The place was packed and there was this American preacher and his wife, I've never seen them before, and there's maybe a thousand people there, all praising God, putting their hands up.'

'What did you do?'

'I thought to myself, I'm in a loony bin. I hadn't been anywhere like this in my life. I'm thinking, I'm getting out of here. This ain't me at all. Then it was just like a little voice saying to me in my head, "Stay where you are." And the music stops and the preacher starts talking, he says, "Lord, there are people here tonight who have been injured and need healing. There's a guy who has had a motorbike accident. The Lord's going to heal him. There's a woman who needs a new hip. The Lord's going to heal her. There's a man who was beaten up six months ago, he has head pains and

blurred vision and he can't eat. The Lord's going to heal him tonight."'

The way Esmond was telling me this sent shivers down my spine. His body had tensed, his voice was bubbling with emotion.

'The preacher was saying the Lord can heal you. Now I've been to Harley Street, I've seen top consultants, surgeons, and they can't do anything for me. Then the man said, "Those with injuries, stand up."'

'And did you?'

'Straight away. This was something I wouldn't normally do. I'm full of crime, bravado – I mix with villains, and this isn't my world. I felt stupid. Then I started shaking, first my right leg, then the rest of my body. The more I tried to stop it, the more I shook. It was as though I was plugged into the electrical supply.

'Were you scared?'

'Yes. People thought I was always in control. I had forty doormen working for me. Now something was happening that I had no control over. Then from above came this intense heat. I had light blue jeans on and a black polo shirt and I was soaked with sweat right through. It was awesome. The last thing I felt was totally peaceful. It was like an out-of-body experience; I've never felt anything like it before or since. Then I sat down before I fell down. Then it was over.'

'Did you feel different?'

'I told my wife I needed a coffee, so we went out to the lobby where there was a vending machine. She fetched me a coffee and herself a packet of biscuits. I'd not been able to eat anything like a biscuit for nearly a year. But for some reason she handed me one and without thinking I bit into it and chewed it and swallowed it. I had no pain. Now the pains in my head started to subside. My eye

opened up, I had perfect sight. I could hear clearly. And inside of me, something was going on that I couldn't explain. I felt eighteen again. All these good things were happening and I went back in the hall with everyone else, raising my hands and believing with everybody else. By the end of the service all the pains in my body had gone. From that day to this I've never had a pain.'

'What about the anger you'd felt for the men who attacked you?'

'I have to be honest. I didn't purposely forgive them, but gradually all my thoughts of revenge left me. People talk to me and they think I've gone soft. But hold on, I'm not having this: I've got a second chance here and I'm not going to blow it.'

Esmond's account of his 'miracle' had given me goose bumps.

'What did your doctor say to you?'

'They couldn't believe it.'

'Do you think that you were touched by some power?'

'It's the only explanation. Before the healing, the preacher walked up to me and said, "The Lord thanks you for forgiving." I hadn't told anyone that I had forgiven anyone.'

'Was this the most frightening experience in your life?'

'It was. I was frightened of the unknown because I'd always rejected it. I had never before taken on board the concept of God. I'd never questioned existence. Or a spiritual entity. But I was confronted with it. I know they're real now. I would never have forgiven anyone before. Suddenly I had forgiven the men who had ruined my life, but not through my own choice. I had been in lots of frightening confrontations. Once, in an office, there were two of us and six of them and one bloke had a gun to my temple and they all had swords and guns and we

had to blast our way out. That was nothing. It was more frightening meeting God.'

'If you could go back, what would you do differently? Do you think the life you lived was wrong?'

'The way I did it was wrong. But I'd still step in if I saw someone having a go. I couldn't help it.'

'You've turned your life around completely. Do you think you wanted it so much that you made it happen?'

Esmond thought about this for a moment. 'I think that we're all searching for the truth. We go down different roads to find it. Just as you think you're on the right road, something will come along and let you down and it becomes a falsehood. I believe I have now found the right road in Jesus. I was hurting from a young age, from being a boy. Some of my actions were wrong. People don't understand why this happens. I was misunderstood. You are judged on appearance and reputation.'

I agreed with him. This is so true. 'When you look back, are you embarrassed about some of the things you've done?'

'Sure,' he said slowly, 'but what I'm most embarrassed about is my foolishness.'

I gulped. There were tears in my eyes. This man's humility is inspirational. He went on.

'It was the fact that I had a brain and didn't use it. On the spur of the moment I made rash decisions and impulsive actions.'

'So if you were eighteen again, what would you do differently?'

Esmond looked me straight in the eye.

'I would sit back and take things on board. Assess and evaluate rather than seeing something and reacting

straight away. By the grace of God I've survived, but there's a consequence for all your actions. There is always a price to pay, but I've been given another chance.'

'After all you've been through, is there anything that still frightens you?'

Esmond nodded.

'These days the only thing that frightens me is the thought of heaven and hell. I worry about people going to hell. Although I'm not afraid of dying.'

'What makes a man?'

'It has to be someone who admits his mistakes. Looks after his family first.'

'Who do you think of as a hard bastard?' Esmond didn't care for this. Maybe this is a world he is trying to leave behind. 'I know a lot of hard men. I couldn't pick anyone out. They do what they have to do.'

'If you weren't you, who would you like to be?'

'Pele, the footballer.' Yes, I could imagine it. Esmond in a different life, different place.

'How would you sum yourself up – in one word or sentence.'

'Passionate in what I believe in.' There was no doubt about that.

'Tell me a secret.'

'I wear my heart on my sleeve.' An open secret and one hundred per cent true.

'And will you tell me a joke?'

'I was misunderstood. You are judged on appearance and reputation.'

'I'll have a go.' Esmond has a great laugh and he set himself off before he'd got the words out. 'There were two eggs in a saucepan and they were boiling away. One says to the

other, "Cor it's hot in here" and the other says, "That's nothing, when we get out we're going to get our heads smashed in!"' He was still chuckling as we walked to the park gates and went our separate ways. He hailed a cab, half turning to give me a big smile and a wave goodbye. What a smashing bloke.

This fantastic geezer has turned his life around of his own accord. I leaned against the park railings as I waited for Leo to come and pick me up. There was only one thought running through my head, that if anyone deserves to find a place in the sun, it is definitely Big E, 'The Born-Again Skyscraper', Esmond Kaitell.

ALAN MORTLOCK
'ONE OF THE TOUGHEST GEEZERS IN THE BUSINESS'

NAME: Alan Mortlock

DATE OF BIRTH: 12.10.55

OCCUPATION: Independent Boxing Promoter

STAR SIGN: Libra

'I had busted ribs, my nose broke, my jaw, I was slashed. And you should have seen the other guy!'

ALAN MORTLOCK

'THE POLICE RAIDED THE HOUSE WITH GUNS.'

Going into an unfamiliar church is a bit like going into a party where you don't know anyone. I was standing outside a modern-brick Tabernacle. It was nothing much to look at. There was a rather plain stained-glass window, a notice board and a small car park, all edged by a plot of grass that was struggling hard but failing dismally to survive. I tiptoed up the steps. The solid oak doors were firmly closed. I put my hand on the iron handle and looked around to see if there was anyone else approaching. No such luck. The street was deserted. I hesitated. It felt a bit like dying: I didn't know what was on the other side and I didn't want to go in on my own. I could hear a faint waft of organ music and angel voices in harmonious crescendo: 'From sinking sands,

he lifted me ... from shades of night to plains of light ...' It made me think of weddings. And funerals.

I'd been trying to track down Alan Mortlock for a few weeks, but he's a busy man. A boxing promoter with a million things on his mind and an appointment book that's chocker till the middle of next year. So when he suggested we could have a meet at his local place of worship I was surprised to say the least. I was still wondering what to do, when a side door opened.

'Kate, there you are.' Alan beckoned me down a narrow entry. The choir were still going full steam, but he took me into a sort of vestibule. There were coat racks, tables and chairs and a drinks machine.

'Shouldn't you be inside, doing the hymns?' I asked. I was OK to wait till they had finished. Alan smiled. 'No, I'm not much of a singer, Kate. I come down on Thursdays to do a bit of training with the kids.'

'Up-and-coming boxers?'

'You never know.' He pulled a couple of plastic chairs out of the pile stacked up against the wall. 'Here you are, have a seat.'

It all felt strange, a bit of déjà vu. There is a special kind of smell to a church. Is it the odour of sanctity or grubby cassocks, dead flowers, incense and dust? Suddenly I was fifteen again and bopping away at our local church hall youth club ... 'Knowing me knowing you – ah-ah – There is nothing we can do ...' If only. But this time around I was chatting to a streetwise fighter, a boxing promoter who is one of the toughest geezers in the business. He slotted

'I didn't do anything with my life except violence and drugs.'

some coins into the machine. 'Cup of tea?' Why not. Alan pushed a Styrofoam cuppa across the grey Formica-topped table and we were ready to begin.

'You're a London boy made good, aren't you?'

'I hope so, Kate. It wasn't always that way.'

'You're on the BBC website.'

Alan smiled. 'I must have made it, then.'

'What does independent boxing promoter mean?'

Alan explained. 'People in the past, such as the Boxing Board of Control, have called me the pirate promoter. I promote non-Boxing Board of Control shows. We're not professional. We're what the world and the Boxing Board of Control call unlicensed boxers. We do our own thing with our own sets of rules. We have medics and referees, but it's more exciting, the guys are evenly matched and it's tear-ups.'

'Blood and guts?'

He nodded. 'Going that way.'

'You're known as a tough guy and you've had a violent life. Have you ever been to prison?'

'Only once and that was in Africa.'

'What are the jails like there?'

Alan shook his head. 'You don't want to know about it. They think it's bad in prison in England, but over there is something else entirely.'

'But you survived.'

'I got out, and I came home. I don't even want to think about it again.'

OK, we'll not go there. 'Has your life ever been threatened?'

'Not really. But I've had plenty of close encounters. For years I was involved in fighting. I didn't do anything with my life except violence and drugs. You're always getting

threatened. It was by the grace of God that I wasn't killed or that I didn't kill someone else.'

'Have you ever been stabbed or shot?

'I've been stabbed. Shot at but, thank God, they missed. I lost a finger in a bad fight once and a pal picked it up and took it to casualty with me. It was actually sewn back on.'

'Is that the most violent thing that's ever been done to you?'

Alan shook his head.

'No. There was a fight in 1977 that was a lot worse. I had busted ribs, my nose broke, my jaw, I was slashed. And you should have seen the other guy!'

He can still have a joke about it. I'd seen Alan before at boxing tournaments. I knew that he was a devoted family man, so his answer to my next question surprised me.

'Who do you love most in all the world?' His answer came without any hesitation. 'The Lord Jesus Christ.'

'Tell me about it. Are you a born-again Christian?'

'Yes. Eleven years ago I had a miracle in my life. I didn't believe in God. If there was ever a complete atheist, it was me. My mother died in my arms when I was fifteen years old. She had a brain haemorrhage and a stroke and I brought her back to life by mouth-to-mouth resuscitation and heart massage and I called out to God, "Please don't let her die." I was nothing but a kid. And I was a skinhead at the time and I was down on my knees praying for my mother to be saved.'

'Was she?'

'No. She still died, so I cracked up, I didn't believe there was a God. After that, I sort of went on the rampage. I didn't really care too much about who was hurt and what was what. I just thought of going out and having lots of battles on the street, that's what I used to enjoy more than anything else. I was never a thief or

anything like that. Plenty of my mates were but they used to love fighting and I ended up in some real battles. About eleven years ago I was out of control. I'd been on the gear for seventeen years, I was using amphetamine sulphate and I was a hundred-pints-a-week alcoholic.'

'A downward spiral?'

'You could say that, Kate. Then a man who was a friend of mine, who had been a drug smuggler, came along and told me that Jesus could sort me out. To be truthful, I laughed at him. But I thought Jesus would be a good excuse – I could use him as a moody on my wife. Our married life was going down the tubes. I was in terrible trouble with her, and basically she'd had enough.

'She'd stuck by me through thick and thin, when I was in the nick and when the police raided the house with guns and all sorts, she was always there for me. And she couldn't take any more. But one night I had come to the end, I couldn't go on and there was no way forward for me.'

'Was that your lowest point?'

Alan's eyes were focused and intent. 'It was just a moody to get out of trouble, but I asked Jesus to come into my life. I woke up next morning and I wasn't an alcoholic any more.'

'You stopped?'

'I didn't want to drink any more. And I gave up a lot of the bad things I'd been doing. Don't get me wrong, I'm not perfect. I still do things wrong like any other person, any man who tells you he doesn't is a liar.'

'What had happened that morning?'

'My friend came and talked to me; he'd already been saved. He'd given up drugs and the whole lifestyle that went with it. He wanted to help me and we asked Jesus to come into our lives. He prayed with me. My wife was ready to have a nervous breakdown. She was physically and

mentally ill. She's Jewish and she says she doesn't believe in Jesus but she was prayed for and a man laid hands on her and Jesus was asked to give her peace.'

'What happened?'

'Do you believe in miracles?'

I told Alan the truth. 'I don't know.'

'That day was a miracle. She was trans-formed in front of my very eyes, from a person who was ready for the nut house to a person who had found peace. She was able to relax for the first time in years. I asked Jesus to come into my life and that day he did. He came into my room and ever since then I've turned my life around.'

'That's an amazing story.'

'I go out of my way to help people now. I go to prison and I go to young offenders' units, anywhere if they want to listen. I'm not a Bible-basher, though; I simply try to help them. I have friends, Jimmy Tibbs and Frankie Sims, they're all with me, they've turned to Jesus as well.

'All sorts of different people have found their faith through you?'

'Through Jesus.'

'Was that your happiest memory?'

'Yes. It was the night that Jesus came into my life. The very next day I just felt different.'

'What is your worst memory?'

'The very worst was when I got my bit of bird. It was just at the time that my boy was going to be born. His birth was while I was away. When I heard about it, this should have been like the best moment – an anniversary, birthday, Christmas all rolled into one – and I remember standing in the Scrubs thinking, I've missed it. That was probably one of the worst times for me.'

'Did it make you angry?'

'Sad.'

'What does make you see the red mist?'

'I'm a lot better than I used to be, I don't get so ruffled. But people being cruel to children. I can't stand it. The way that the authorities let it go and nothing gets done.'

'What frightens you?'

'I suppose it's thinking about how I used to be. I wouldn't want to go back to how my life was then. I rely on Jesus every day because all of us can slide downhill. It's so easy to do, and the thought of slipping back would terrify me.'

'What makes you feel guilty?'

'Thinking back on certain aspects of my life is a heavy trip for me. Now I do things differently. I tell myself that no man or woman is perfect. If I make a mistake − which wouldn't be the sort I used to make − but if I do go wrong in any way, I think of it and I feel guilty. I need to keep strong. I need to pray and read the Bible, like a boxer needs to fight. If a boxer's going to fight, he needs to train; he needs to be in the gym. A Christian needs to read the Bible and pray. If I'm not doing that, I can feel myself going under. That would make me feel guilty.

'You put effort into your way of life.'

'Yes, I don't want to be a hypocrite. I don't go and judge people, I have no right to go and say you should do this, you shouldn't do that. I'm not like that. But I try my best in everything that I do.'

I have to admire Alan for the tremendous way he's turned his life around. His old world is long gone. What about his appearance? Would he like to alter this as well?

'Would you like to change how you look? Plastic surgery, that sort of thing?'

'I wouldn't have plastic surgery, but I would have the tattoos taken off my hands. I'm covered in tattoos.'

'Would you have all of them removed?'

'Only the ones on my hands. I can cover the others up.'

'Now you're a boxing promoter, up there with your name in lights, does it give you a buzz?'

Alan got up and started to walk about the room. 'I get a buzz when a man or a woman gives their life to Jesus.'

You can't go wrong with that.

'Is this what makes a man?'

'Yes. A man is somebody who looks after his family, his wife and kids. And helping somebody who's in trouble, that makes a man. Helping people who need a bit of help.'

'If you weren't you, who would you want to be?'

Alan thought about this. 'In the old days it would have been Oliver Reed. But not now. I don't think there is anyone, Kate. I'm happy with myself now.'

'You liked Oliver because he was a wild man?'

'Yes. He was a hell-raiser, one of my idols.'

'You've known a lot of hard nuts. Who would you say is the one that stands out?'

'It would be Roy Shaw. And the reason why I say Roy is because I'm involved in unlicensed boxing and out of all the people I've met along the way, all the boxers and all the guys that I know and I respect, Roy is different. To me, he is the epitome of unlicensed fighting. He is just one cool hard man. And the other thing I like about him: one minute he can be looking at you with a stare and you think, Hold on a minute – and the next it'll turn into a great big smile.'

I agreed. I'd seen Roy's face light up with a smile, just when you were getting seriously worried by the scowl. 'You have an action-packed life. Travelling all over the world, mixing and fixing your boxing matches. I don't suppose that everyone you come across is Mr Nice Guy. How do you stay one step ahead?'

Alan folded his arms across his chest. He has given his

life to Jesus but he still survives in a dog-eat-dog world. How has he got it all sussed?

'By being shrewd. Using my wits. I'm streetwise, after all. I'll give you a little quote from the Bible: You need to be as wise as a serpent and gentle as a dove.'

'That's profound.'

So what is coming in the future for this man with a past as murky as an East End sewer? 'If you went to see a fortune teller to ask her about what lies ahead, what do you think she'd tell you and what would you want her to tell you?'

Alan gave me a hard look.

'Years ago I used to be involved in all that kind of stuff, before I came to know Jesus. I thought there was nothing wrong in spiritualism, but now I know better. I wouldn't go to fortune tellers or have anything to do with that sort of thing.'

'You need to be wise as a serpent and gentle as a dove.'

'If you had to sum yourself up in one word or sentence, what would it be?'

'Treat others as you wish to be treated yourself.'

Alan had given me a pretty good answer. But would he spill the beans about anything he shouldn't?

'Tell me a secret.'

'I can't.'

'Go on, there must be something.'

'All right then. I'm actually a member of parliament.' I had to smile. That would make him a proper villain.

'Tell me a joke.' He had one right off.

'Two young kids were talking to each other. They were both little liars and one says, "I jumped off that 100-foot cliff yesterday", and the other says, "I know you did, I saw you."' He cracked up laughing. I had to join him. 'That was brilliant.'

Alan glanced at a schoolroom clock on the wall above the door. The music had stopped and we could hear chairs scraping and sounds of conversation. 'I have to go now, Kate, it's been lovely meeting you.' Alan shook my hand and walked outside with me and back on to the street.

'Are you staying on?'

'Only briefly.'

I turned to go, then Alan called me back. 'Here you are, Kate, have a read at this. You never know.' He pushed a leaflet in my hand. 'You'd be very welcome.' The door closed and I flicked through the pages as I walked slowly on down the High Street. Times of Service. Morning Prayers. Evensong. Praise the Lord. Amen.

I thought about it as I walked back to the multi-storey car park, past the supermarkets, the betting shops, the made-up babes and good-time guys on their way to another night's escapism in the pubs and clubs. An evangelical experience? Well, it had transformed Alan's life. You never know. I put 'The Way to Jesus' in my pocket. I might just give it a whirl.

BRIAN McCUE
'A DIPLOMAT NOT A DOORMAT'

NAME: Brian McCue

DATE OF BIRTH: 28.8.62

OCCUPATION: Bouncer

STAR SIGN: Virgo

'I thought the guy had just punched me, but he had a flick knife and he brought it up the inside of my thigh. As deep as hell.'

BRIAN 'THE BULL' McCUE

'I KNOW THAT WHATEVER HAPPENS THE
LORD IS ON MY SIDE.'

I met Brian outside an industrial estate on the
way to the docks in Liverpool. He was on his way
to catch the ferry back to Ireland and he had a
tight schedule. But the sun was shining, a crisp
fresh breeze was blowing up from the Irish Sea
and Brian said he was hungry. 'What about it,
Kate? Do you fancy a burger?' There was a hot dog
trailer cafe on the car park and it looked busy,
always a good sign.

'Why not.' Brian had to be on the two o'clock sailing,
there wasn't time for anything else. We found a bench
near a few spindly trees and sat down. My appetite was
leaving me rapidly but Brian was tucking into his
hot-dickety-dog with enthusiasm. Mustard was dripping
down his chin and I had to resist the impulse to wipe
it away.

'Tell me a bit about your background. Where do you
come from?'

'I come from Scotland originally. I'm living in Belfast at the moment, so that's home. And I lived in Blackpool for seventeen years, that was before I moved to Ireland. I liked Blackpool, I'm aiming to go back to live there one day.'

'You grew up north of the border. Was it a tough area? What was it like?'

'Yes, it was pretty rough. There was a lot of poverty. I was always fighting; I was involved in one scrap after another. That was because of the area we lived in. If you couldn't fight, you was nothing. It was what we all did. You learned to take the rough with the smooth.'

'So it was a natural progression to working in the security business?'

Brian nodded. 'What else was I going to do? I was good with my fists. I had a reputation before I left school. Everybody knew they had to watch out for me. I wasn't going to back down for anyone, even when I was a kid.'

'What about your education?'

Brian laughed. 'What education? The only learning I got was in the school of hard knocks. I wish it had been different, but you can't change what and who you are.'

Brian is an unlicensed boxer with over a hundred prizefights to his name, and when he's not in the ring he's doing security work in the pubs and clubs.

'Being a bouncer is a pretty dangerous way to make a living. Has your life ever been threatened?'

Brian nodded. 'Loads of times. When you're on the door it's an occupational hazard. You never know what to expect, every time you go out there's someone wanting to try it on.'

'Is it something that just happens, or do they plan to do it?'

'No, it's spur of the moment, they've had too much gear or booze and they're off their heads. I doubt if they even know what they're doing.'

'Have you ever been stabbed or shot?'

'I've never been shot. I've been stabbed a few times.' Brian takes it all in his stride. It's no big deal.

'Whereabouts were you stabbed?'

'I was stabbed in my eye. And in my arm. My stomach was slashed. Another time I was stabbed in my leg.'

'So it's off to casualty and get stitched up?'

'Something like that.'

'Good grief. Is that the most violent thing that's ever happened to you?'

'The time when I was stabbed in the leg was pretty bad. It was a pub fight. I thought the guy had just punched me, but he had a flick knife and he brought it up the inside of my thigh. As deep as hell. I went down and my leg just came away from me. There was blood everywhere. It was like my leg was dead. I'd kept hold of him and I managed to get a last punch at him. I heard his nose break and that was it. The ambulance was coming and he legged it. I'd lost two pints of blood and I nearly went to meet my maker that time.'

'But you're a tough geezer.'

'I pulled through.'

'You get guys with knives coming at you, but what's the weapon of your choice?'

No hesitation. 'My hands. They never let me down.'

Brian can look after himself and it takes a lot to put him out of action. But what's it all for – is there anyone waiting at home for him?

'Who do you love most in all the world?'

'I ought to say my girlfriend Kathleen,' he laughed. 'She's a lovely girl, and she'll kill me for not saying it, but it has to be my daughter, Stacey.'

'What are your happiest and your worst memories?

He leaned back in the chair and looked up at the sky. 'The worst one is easy. It was when my dad died.'

'How long ago was that?'

'Eight years ago.'

'What did he die of?'

'It was cancer. Slow and painful. It still chokes me up when I think about it.'

'You were close to your dad?'

'Yes.'

'And your happiest memory?'

'Was when my baby daughter was born. An unforgettable experience.'

'Why?'

'There's this little human being. And it's a part of you. You're wishing that everything will go smooth for her and that she won't have to have a hard life.'

'You've had to take the rough with the smooth?'

'A lot of rough. I've done a lot of things I wish I could have avoided. But there's been no other way.'

'What makes you see the red mist?'

Brian's face set in a hard expression. 'People letting me down. That makes my blood boil. And telling me lies. Why do they do it? They always get found out.'

'What happens then?'

'They get what's coming to them.'

'And has that happened often?'

'I suppose quite a few times. Yes. But I don't actually like violence. I like to think of myself as a diplomat, not a doormat.'

'Talk first and act later?'

'Yes, that's right, Kate.'

'Does anything frighten you? Do you ever think that one day you'll come up against someone who won't back off?'

'No. Nothing frightens me.'

'Does anything make you feel guilty?'

'Yes. Not being able to do what I've said I would do.'

Brian is on a straight track: he knows what he wants and where he's going. If anyone lets him down or does a double cross, watch out. He's a tough guy. But is he vain?

'If you could change your looks, would you? And would you have plastic surgery?'

'Well, I shave my hair off, so I'm bald.'

'Would you change that, let your hair grow, have a transplant maybe?'

'No. I'm not giving anyone anything to get a hold of.'

'What about your tattoos? Do you keep them covered up?'

Brian thought for a moment. 'Yes, I do keep them out of sight. And I suppose I'd like to have them all removed.'

'Why is that?'

'Well, I had them done when I was younger and I was plastered. I wish I hadn't done them because people judge you by what they see, and if they see a bloke covered in tattoos they make a certain judgement. But you should never judge a book by its cover.'

'That's so true.'

'I like to think that I'm very different now from the young kid who had the tattoos done when he'd had a bit too much to drink. So, yes, I would have plastic surgery to have them taken off.'

'What gives you a buzz nowadays?'

'There's only one thing. Winning. It means everything to me. I have to be the best.'

'Is that when you're fighting?'

'Yes, I have to come out on top. I go into the ring with that in mind. It's all I'm focused on.'

'Is this unlicensed fighting?'

'Yes.'

'And do you psyche yourself up for it?'

'I can't not win. And I have the Lord on my side. '

'I've heard people say that you have something written on your shorts?'

He nodded. 'A verse from the Old Testament. Samuel 35, v 1: "Contend O Lord with those who contend with me and fight against those who fight against me."'

'That's brilliant.'

'It's how I look at it.'

'And why did you decide to put that on?'

'Because the Lord gives me strength. And it's nice to show some appreciation.'

'Just a bit. And that's the buzz?'

'That's it.'

'Do you say a prayer before you go in the ring?'

'Always.'

Brian is a deeply spiritual human being. A million miles from the young tearaway clawing his way up the ladder of success.

'What makes a man?'

'Someone who has reached his goal.'

'And if you weren't you, who would you be?'

'I'm happy as I am.'

'Who do you think of as a hard bastard?'

'Mizie Walsh.' I'd never heard the name. Brian saw my blank expression. 'Don't you know him?' I shook my head. 'He runs the north. Blackpool is his home town. He's in his sixties now and he's a pure gentleman. He gives you the utmost respect. He doesn't get in the way of people, but there's no messing with him. He's the man.'

'So this is a guy who stays one step ahead. How do you manage to do this?'

'By believing in the Lord.'

This did surprise me. 'Have you always been a spiritual person?'

'No. Not at all. I never used to give it a second thought. But somehow I found the Lord or the Lord found me – whatever.'

'Do you think that it's changed your life?'

'Definitely. I'm a happier person now. When I found the Lord, I found myself.'

'And has it calmed you down?' I knew that Brian used to have a reputation as a hell-raiser.

'Yes. It's made me able to deal with stress more easily.' Brian seems an exceptionally steady bloke; he is controlled, cagey even. There is just a sense of unswerving determination under that cautious exterior. He wouldn't go at anything face on. If Brian came after you, it would be like a Jack Russell terrier nipping at your heels and never giving up no matter what you did.

'You seem a very calm man.'

He agreed. 'I like to think before I do anything, and have the Lord on my side.'

'Do you think it seems a bit of a contradiction? You live in a violent world, you're a fighter and a bouncer, but at the same time you believe in God, you're a Christian, you have the Lord with you. Is it difficult for you to reconcile these two different scenarios? Or is it more awkward for other people?'

'I just feel confident all the time. I know that whatever happens the Lord is on my side. I believe that whatever I have to face, the Lord is with me.'

In view of Brian's beliefs, I didn't know whether he would want to answer my next question.

'If you could ask a fortune teller about the future and the past, what do you think she'd tell you and what would you like her to tell you?'

There was no hesitation about his answer. 'I'd like her to tell me the truth. But I think she would tell me a mix of good and bad. They want you to believe it, don't they?'

'If you could go back into the past and you were eighteen again, what would you do differently?'

'I'd live a better life. No fighting.'

'So, if you were to give a youngster some advice, say it was someone who you could see was going down the wrong road, what would you say to him?'

Brian thought about this. 'Well, don't get me wrong, boxing is discipline and it's been good for me. It does set you up as a target, though. I'd be more inclined to tell a youngster to look after his relationships, don't let the lifestyle come in the way. It's very hard for a wife or partner to handle the effects of this way of life. Also, I'd tell him to think twice before he got any tattoos.'

'I've heard about an amazing tattoo you have on your back?'

Brian took his jacket off and lifted up his T-shirt. He is covered in tattoos, with a fantastic picture of a man with a bull's head on his back.

'Wow! That must have hurt.'

'It still does in a way. I wish I'd never had them done.' Brian put his jacket back on. Although he is guarded and wary, he has a good sense of humour and he is a geezer with a big heart. He has turned his life around and rediscovered himself. Whatever fate throws at him, he is not going to be weighed down by anything.

'If you had to sum yourself up, what would you say?'

'Simply the best.'

No doubts whatsoever. He is unbeatable for courage and self-assurance.

'Tell me a secret.'

'OK. How would you like to know the result of my next fight?'

'Sounds good. Who are you fighting?'

'Roy Shaw's son, Gary.'

'What's the secret?'

Brian laughed. 'I'm going to win.'

'Tell me a joke.'

He thought for a minute or two.

'OK, here goes. I know a lot of jokes. Did you hear what the famous American boxer had written on his tombstone? "You can stop counting; I'm not getting up!" And what about the crossword puzzle boxer – he entered the ring vertical and left horizontal! And then there was the young boxer who called himself Kid Cousteau – because he took so many dives.'

Brian has a deadpan delivery, which made the jokes all the funnier. 'Pretty good,' I told him when I stopped laughing. There was a ship's siren booming away in the distance and it was getting chilly; the sun had gone in. Brian is a polite man, but he was tapping his fingers. I could see that he was ready for the off.

They say there's no such thing as a free lunch, but I threw the remains of my hot dog to the starlings anyway. I was very impressed by this born-again fighter. He is as honourable and respected as they come. Although he makes up in brawn what he lacks in height, he is truly a giant of a man with a heart of gold and as tough as they come. There was only one thing left to say.

'Brian, can I tell you … hang on a minute …'

But these geezers always like to be in control. He was looking at his watch, saying 'Gotta go, so long' and getting into his car before I got the chance to tell him what was on my mind … there was still a bit of mustard on his chin.

BERNIE DAVIS
'THE TIME-WARP TOUGH GUY'

NAME: Bernie Davis

DATE OF BIRTH: Thirty-something?

OCCUPATION: Security Consultant

STAR SIGN: Capricorn

'On international day I had six fights going at a time. Broke some bones and cracked a lot of heads. It's a different world down here.'

BERNIE DAVIS

'I PLAY A PSYCHOPATHIC MADMAN. IT'S A PART THAT'S
MADE FOR ME'

It was pissing it down with rain and I was parked up
on a lay-by on the main road into Cardiff and
thinking, What the hell am I doing here? The bloke
I had arranged to meet was one of the most sinister
geezers to come out of the Valleys. And he was late.
Unavoidably detained, he'd told me, his lilting
voice making excuses on the mobile phone. I was
wondering exactly what he'd meant by this – maybe
it was a polite way of saying he'd gone on the trot,
or was it an unexpected visit from the Old Bill?
Neither. A few minutes later a blue 4x4 Land Rover
Discovery pulled up alongside me, the automatic
window slid down and a very Welsh voice said,
'Sorry I'm late.' The time-warp tough guy had
turned up after all.

I followed him to an American-style roadside diner. It was

still chucking it down as we dashed inside. Hamburgers, blueberry muffins, hot coffee. Now we were ready to talk.

'Tell me a bit about your background. Where were you born?'

Bernie is a cagey bloke. It was bare bones at first.

'I was brought up in the Valleys. In a little mining town.'

'What was that like?'

'Very strict,' he told me. 'Church on Sundays. No alcohol.'

'What about your family?'

'I come from a big family. We didn't have much money, though. My dad was a miner. That's what everybody did. Leave school at fourteen and down the pit.'

'And did your mum go out to work?'

Bernie smiled at that. 'No, not a chance. My mum stayed home to look after us. Always a struggle, though. But she kept the house very clean, always scrubbing and polishing. The front doorstep always had to be kept spotless, and the front room – for visitors.'

'Was it a happy childhood?'

Bernie nodded.

'Yes, but you don't know when you're happy, do you? I went down the pit when I left school. It was a hard life.'

'Have you always been a tough guy?'

'You had to be tough growing up where I did. I've been a bit of a bad lad since I left school. You didn't have a cat in hell's chance otherwise, did you?'

I noticed that Bernie often ended a sentence with a question. Again, very Welsh. 'Has your life ever been threatened?'

'Loads of times. Too many to think about. It goes with the territory, doesn't it?'

'Have you been stabbed or shot?'

Bernie is cool about his lifestyle. 'Yes, both. I've had a few guns put to my head. And I've been shot at.'

'But you've managed to get out of it?'

'I'm here, aren't I?'

'And the other guys?'

Bernie has eyes as black as the coal he used to mine. They gleamed when he answered this. 'I can't say as what's happened to them.'

Yeah. Right.

'And stabbed?'

'Yes, I've been stabbed. There's been a few blokes wanted to put me away over the years, but they haven't managed to do it.'

Bernie is low key, there is nothing flamboyant about him, but he is one of the most feared men around.

'What's the most violent thing that's ever been done to you?'

'It's when you're looking down the end of a barrel and you don't know what's coming next. It could be all over in seconds. Or you can get the better of the situation. It's happened a couple of times.'

'What happened?'

'I was in France, sorting out some business and the Old Bill came in and one of the young guys pressed a pistol up against my temple.'

'Were you doing something bad?'

Bernie shook his head. 'Mistaken identity, wasn't it?' If you say so. He went on. 'Having a pistol pressed up against your head with someone holding it who's shaking is not too good.'

'Were you scared?'

'I guess so. But the guy who was holding the gun was more scared than I was. He was trembling so much I was a bit worried. I thought he was going to pull the trigger he was frightened so much. It takes a lot to kill someone, but I remember thinking it wouldn't take him much at all

because he was so nervous. He wouldn't have known what he was doing.'

'What's the weapon of your choice?'

'My fists would be my first choice. I can always rely on them. But it's horses for courses, isn't it? I use whatever I need at the time. I'm always up with the modern technology. There are some gadgets that are really useful. Tracking, surveillance, that sort of thing.'

So, this barbarian boyo likes his hi-tech gizmos, but what does he think about people? Is there a soft, sentimental heart beating away inside the tough nut exterior?

'Who do you love most in all the world?'

Bernie wasn't giving anything away.

'It could cause problems if I told you, couldn't it?'

'You tell me.'

Bernie shook his head. His love life was under wraps and obviously it was staying that way.

'What are your happiest and your worst memories?'

'My worst memory is when my father was very ill. He was taken into intensive care and for a while it was touch and go.'

'Did he make it?'

'Yes, he's a tough old boy.'

'And your happiest memory?'

Bernie shrugged. 'There's not too many of them, actually. I suppose when we went to the seaside, when I was a kid. It was getting away from everything, going somewhere different. We all ran about on the sands, and had donkey rides and went in the sea.'

'Sounds pretty good.'

But life changed for Bernie and after twelve tough years as a coal miner he made a vow to escape the dangers and drudgery down the pit.

'You started working as security?'

'Yes, I've done a lot of door work.'

Bernie is supercool. But does he lose his temper easily?

'What makes you see the red mist?'

He nodded. 'Loads of things. It makes you really mad when you've got some slip of an eight-stone soaking wet boy who's gobbing at you and then he's pulling a knife out. It's like they're asking for it.'

'How do you handle the situation?'

'It's difficult, because you've got to stop them, but you don't want to hurt them any more than you have to. Basically, they don't know what they're doing or what they're getting into. As soon as you slap these people or give them a backhander, they're running to the law screaming blue murder. It makes me so mad; they're sorry individuals. The Old Bill should know better than to take any notice.'

'And do they?'

Bernie pulled a face.

'They always follow it up. Goes round in circles. If the blokes behaved themselves none of it would happen.'

'What frightens you and what's the most frightening situation you've ever been in?'

'I've been in a few dodgy situations; it's a bit scary when you're looking down the wrong end of shooters. Nothing really frightens me except ...' Bernie paused. He was going to tell me something, but something made him hold back. He changed his mind. There is something in his past but whatever it is, he doesn't want to talk about it.

'Is there anything that makes you feel guilty?'

Bernie looked out of the window. It was still raining. He nodded to the waitress and she brought two more cups of coffee. Maybe I'd touched a nerve.

'Yes, there is something,' he told me eventually. 'I feel guilty about not being there for my kids, when they needed me.'

There's a lot of men would say the same.

'What about your looks?' Bernie is macho, rugged but a bit sinister. The black goatee beard, the callused hands, the famous tattoo of my former husband Ron Kray and his brother Reg on his leg. Would he want to change anything?

'It's a bit scary when you're looking down the wrong end of a shooter.'

He shook his head. 'No, I'm quite happy with the way I look.'

'What gives you a buzz?'

'It was violence when I was younger. I used to get a kick out of it.'

'Would you turn the other cheek now?'

'No, I'd never back down from anything, but I don't get the buzz from it that I used to get.'

'What makes a man?'

He didn't hesitate.

'Having respect for other people and them having respect for you.'

'If you weren't you, who would you like to be?'

Bernie smiled. 'The champion of the world.'

'Is that the boxing champion?'

'Boxing, unlicensed, whatever. Being top dog, that's what I like. And I'd like to develop my career in films.'

I could easily imagine Bernie as a hard man film star. 'What have you been in so far?'

'I was featured in the book *The Firm* and now I'm in a film. I play a psychopathic madman. It's made for me.'

'Do you like acting?'

'And some. It's a doddle getting paid for easy work and there is nothing like a straight pound note.'

'Who do you think of as a hard bastard?'

'I could name loads.'

'Does anyone stand out?'

'Lenny McLean, and I know that Roy Shaw is well known as the ultimate hard bastard. But to me it's a local guy, up in the Valleys. He used to run the door with me.'

'What's he called?'

'Malcolm Haven. I look up to him. He's a real hard bastard. If he'd come up with a trainer, he'd have gone somewhere big. To the top.'

'How do you stay one step ahead?'

'I think it's instinct. Also modern technology. I find that very useful. It's nice to know what the other side are doing. I've got my finger on the pulse of a lot of things. I know where things are going down and where things are coming from.'

Bernie is a very careful, self-contained individual. But there's more to life than hard facts. What would a crystal ball reveal?

'If you were to see a fortune teller, what would she tell you and what would you like her to tell you?'

Bernie has had a recent unnerving experience in that department. 'It's a funny thing, because the other day I met a girl who is a kind of fortune teller or clairvoyant.'

'Did you go to consult her?'

'No, I met her in a club where I was doing some work. Now this girl has been on TV programmes and done some consultations for the police and she came up to me and started talking to me.'

'What did she tell you?'

'She said that she'd been to the police because she knew someone who had done something wrong and hurt someone. They told her to go away, nothing had happened that they knew of and basically they thought she was making it up.'

'Was she?'

'I don't know, but this same girl, when I was talking to her, said to me suddenly that she knew that I'd done something bad that day. She wasn't going to tell the police or anything, but it chilled me to think that she could look at me and know what was in my mind.'

'Had she hit the nail on the head?'

'Yes. She was right. That was the strange part. It was really weird. She said to me, "It's on your conscience." I thought, How the hell does she know this?'

'Does that frighten you?'

'Yes, it does a bit. Because I'm a person who likes to understand everything. My finger is on the button and when things like that happen, it's something you haven't got control over.'

'Is that something that spooks you? When you can't figure it out?'

'Well, when someone can look into your eyes and see what's in your mind, and you're not telling them, they're reading it telepathically. That's got to be scary.'

'Were there bad things in your mind?'

'Well, I'd just done something that wasn't too good and she knew it.'

'If you were eighteen again, what would you do differently?'

'I wouldn't work underground for a start. Going down the pit was a big mistake.'

'Why?'

'I've seen what it does to people's health. It cripples them up and the dust messes up their lungs. Although there is great comradeship amongst miners. Better friends you could never find. But it's no good working on a coalface and breathing all that dust. It's no good for man or beast.'

'What advice would you give to an eighteen-year-old?'

'I think it would be to get into sport. It's a way to channel aggression and it can lead to a better lifestyle. Fame and fortune without the hassle.'

'Sum yourself up in one word or sentence.'

Bernie had it straight away. 'I'm a nice nasty bastard.'

'What about a secret? You must have loads.'

He shook his head. 'No, I'm sorry to disappoint you. One doesn't come to mind ... except ... Well, there are certain things about my past that I can't release to anyone. People are judgemental and it's not worth it. I could tell you about a bit of bother I was in. It's not really a secret, but it's something not a lot of people know.'

'Go on.'

'It was a fight I was in. On international day. Boy, that was some fight. I had six fights going at a time and I chucked twenty-six blokes out in total. I did a lot of damage.'

'You did?'

'Broke some bones and cracked a lot of heads. It's a different world down here, Kate. Different rules apply. It's not like anywhere else in the world.'

'Tell me how old you are.'

Bernie wouldn't be drawn. 'Thirty-something.'

OK. But had this hard-faced hatchet man lost his sense of humour? He was looking at his watch and jiggling his car keys.

'Tell me a joke.'

He had one ready, but his delivery was deadpan.

'There were two Palestinian women walking down the street. One said to the other, "Does my bomb look big in this?"'

Pretty good. Bernie jumped up, shook my hand and sprinted back to his blue mega-bucks motor. A menacing

man with a violent past but he loves his dad, has more secrets than a spy and is a wannabe film star. I watched him roar away up the motorway, back to his shadowy, dicey and dangerous life.

There was something else I still didn't know. Why do people from Wales finish a question with a question?

HUGH COLLINS
'REALITY HURTS'

NAME: Hugh Collins

DATE OF BIRTH: 17.6.51

OCCUPATION: Sculptor

STAR SIGN: Gemini

'I had a gun inside my coat. And I said to these guys who were coming at me, "If you come any fucking nearer, you'll get some of this." And I just touched it and it went fucking off and blew a hole in the ceiling.'

HUGH COLLINS

'I HAVE TO LEARN TO LIVE WITH WHAT I'VE DONE.'

Edinburgh is a beautiful city. I'd been there once before to be on a live TV show. Another guest on the show was Hugh Collins, the man I was now about to meet. I was thinking about his words as I climbed the stone spiral staircase up to his flat. The show had turned out more exciting than I could have anticipated, with a slanging match between the other guests – it nearly turned to blows. Hugh took the opportunity to have a little chat to me about the Kray twins, Ronnie and Reggie. Apparently they were Hugh's heroes whilst he was in prison. When he discovered that I was Ronnie's ex-wife, he smiled. 'I take my hat off to you, young lady,' he told me with genuine feeling.

As I climbed the stone spiral staircase to his flat I was wondering if he'd still remember me. Hugh lives in the

fashionable avant-garde quarter of Edinburgh — all art galleries, wine bars and Italian restaurants — a far cry from his bare cell at Barlinnie Prison.

The door opened and Hugh welcomed me inside. It was a smashing place with lots of atmosphere, an open fire crackling away in the grate, oriental carpets scattered across the polished wood floor. Huge pot plants in terracotta urns and paintings hanging on the walls. It said style and elegance — the living was good — and had a warm, happy, homely feel.

'Come and sit down, Kate.' Hugh pulled up a couple of chairs in front of the huge plate-glass window overlooking the city. 'What do you think?' he asked me. 'Isn't it fantastic?' The city stretched out to the horizon, rooftops and spires — it was stunning, but it was Hugh himself I was clocking. Denim jeans, cosy fleece, tartan-checked slippers. Glasses perched on the end of his nose. Mr Average. He looked like a middle-class shopkeeper. Was this really the notorious Hugh Collins? I settled down in a huge comfortable armchair and got out my notebook.

'Come on, Hugh. Tell me a bit about yourself.' What was the background to this man who had spent most of his life in prison for murder? Hugh gave me a tiny smile, cleared his throat and we were away.

'My father received a ten-year prison sentence the day I was born. Within a month or so my mother had drifted back into prostitution.'

'You didn't know this when you were growing up, did you?'

Hugh shrugged. 'You always know in a way, even when you're a kid. My grandmother took me in when I was still a little lad and I was well looked after, but she had a big family already. There was always one or other of them in mischief, breaking into shops, that sort of trouble, and one thing led to another.'

'You grew up in a life of crime?'

'Yes, that's all I knew.'

'How long have you done in prison, all together?'

Hugh counted it up. 'It would be about twenty-seven years.'

'You committed murder ...'

His face shadowed briefly. 'Yes.'

'What was the man's name?'

Hugh's eyes dropped to the floor as he answered softly. 'Willie Mooney.'

'Before that, what had you gone down for?'

'Well, when I was in my early twenties, it was for doing protection rackets, mainly in the pubs. At that time they would lose their license if they had three incidents in a row, so me and my mate slashed a couple of bouncers. Word travels fast and Glasgow is quite a small place compared to London. No one wanted any of it, so all we had to do was go the rounds on a Friday night collecting the money.'

'But you fell out with your pal?'

'Yes, I always had my eye on the pubs but he was focused on the money and we finished up going for each other. Then it developed into a tit-for-tat revenge. About this time I started smoking hash, because that was part of the culture I was in. And that was when the conflict started.'

'How did it turn out?'

Hugh adjusted his glasses. 'It ended up with Willie getting killed.'

'Was there much violence when you were inside? Was your life ever threatened?'

Hugh stared out of the window. 'It was all violence, Kate. There was one fella, he was what they call a "pass-man", that's another name for a tea-boy. He was just a bit of a lad, nothing about him, but they've let him into my cell first

thing in the morning and I'm still in bed and he did me with an iron bar.'

'He hit you with it?'

'Oh yes. He did my ankles, my knees, my elbows and my wrists, he knocked me clean out. Look.' Hugh rolled his wrists up and showed me some horrible scars.

'Oh no. Why did he do it?'

'I'd called him a grass and that's the worst thing you can say about anyone in that sort of life. But that's the sort of thing that goes off in prison. Then I didn't see him for ten years. In fact, four or five weeks ago I saw him again. It was at a pal's birthday party and they said he was going to be there and could we let bygones be bygones.'

'And could you?'

'Yes. A lot of water under the bridge since then, Kate. It was like going back in time, stepping back into the sixties. In a way I still thought of him as a pal. But I've moved on. I don't know whether he has. I thought about it, we made terrible enemies in those days and lost good pals. But there was a kind of honesty there ... we had a meal together and squared things up. My wife asked me if I felt any hatred towards any of them.'

'I've been stabbed twice in the leg, twice in the back.'

'And do you?'

'To be quite truthful, I felt quite sad about the whole thing.'

At that moment the door opened and Hugh's wife came in carrying a tray. There was freshly percolated coffee, frothy milk, brown sugar crystals and stoneware mugs. He introduced us and there were the usual pleasantries as Caroline poured the coffee. I felt Caroline thought that this trip down Hugh's memory lane wasn't too good an idea – and who could blame her – but she was polite and friendly

and hides her feeling well. Hugh is a reformed character, though, and that's how he's going to stay.

'What's the most frightening thing that's ever happened to you?'

Hugh thought about this for a moment. 'Nothing that I could pick out, Kate.'

'Have you ever been stabbed or shot?'

'I've been stabbed twice in the leg, twice in the back. I was stabbed with a car aerial in my back. Twice in my arms. Stabbed in the back of the ear. I got stabbed in my face twice, one was a can opener stuck in my eyebrow, the other time I was cut with a razor at the side of my eyes.'

'Two's not your lucky number.'

'Maybe not, although I survived. Then I got hit with a cleaver – that was in my jaw. When I got hit in my back it was the nearest thing I'd come to being crippled. It was a fraction from my spine.'

'Were these all fights?'

Hugh nodded. 'Except the last, which was quite a bizarre situation. I was trying to escape and I said to a guy, "Look, I've broken a mirror." It was one of my pals, I won't mention his name, a bit of a psycho, but he's quite a good guy when you get to know him. And I gave him a bit of the mirror and I said to him, "Stab me. There's somebody in the hospital I know and if I can get in there, I might have a chance to escape." I was hell-bent on getting out of prison – whatever it took.'

'Bit of a crazy plan, wasn't it?'

'Yes, but my mate panicked. He went completely over the top and stabbed me proper I didn't feel anything at the time but I went into shock.'

'I was going to ask you about that. Doesn't it hurt when somebody sticks a knife into you?'

Hugh shook his head. 'No. I don't feel pain. Nothing. I'm desensitised to it.'

'You finished up on a hospital bed, but as a real patient.'

'That's about it.'

'You didn't escape, then?'

'I nearly died.'

'Have you ever been shot?'

'I've had shotguns pointed at me. It was probably in 1975, and it was the first time guns started to be used in Glasgow. I had a gun myself inside my coat. It was a hair trigger but I had no intention of using it. It was a bluff, just to threaten guys. And I said to these guys who were coming at me, "If you come any fucking nearer, you'll get some of this." And I just touched it and it went fucking off and blew a hole in the ceiling. It nearly broke my jaw with the kick-back. Anyway, the guys ran away.'

'As you would.'

'Yes, but a few days later they were back and they grabbed me and put a gun in my mouth, but the gun jammed. I was lucky that day.'

'Is that the most violent thing that's ever happened?'

'No. I got attacked in jail. I'd gone for three screws and they were paying me back. When I look at it now, I think I was trying to get them to kill me.'

'When you say you'd gone for them, what had you done?'

'I'd stabbed them, actually. But they spent a week on me, twice a day, every time the shift changed. Every screw in the jail came down to the dungeon.'

'Is that where you were?'

'Yes. It's underground with just a peephole. They tell the public it's never used, but believe me it is used. I was kept in there in a restraint belt for six days. I was trussed up from head to toe. I ended up with a fractured skull, broken ribs, broken fingers. But you see, what they put on the forms is something else. One black eye and minor bruising.'

Hugh took a careful sip of coffee.

'What did they do, come down and beat you up?'

'Aye, every day. If they had come in one at a time, I wouldn't be here. But they came in groups, scrambling about and they couldn't all get to me. I fought it for three days then my body started swelling up. I was covered in boot polish and the insects were crawling all over me.'

'Boot polish?'

'It was from their boots, they were kicking me every time. There were cockroaches crawling everywhere, they could smell the blood. And these other things, clegs they're called. I've heard other prisoners talking about them. They're the worst, they've got hooks and when you pull them off they leave a bit inside and it makes a scab. I had them all over, in my hair. I reached the

'I ended up with a fractured skull, broken ribs, broken fingers.'

stage when I was de-humanised. I was taking these beatings. But I'd killed a guy. I hated myself. At the time I didn't understand what was going on. It must have been self-loathing. I was ready to die. I wanted to die. Moreover, I wanted them to kill me.

'But I was in such a bad way the screws panicked and eventually took me to hospital. The nurse thought I'd been in a car accident. I told her no, this is Barlinnie Prison. After that I kept re-living it, hearing the boots coming down the stairs. The actual beating isn't the worst – you get knocked out, you don't feel anything after a bit, but the next day you're sore and in agony. You have to show defiance to make sure you get knocked out as quick as possible.'

I was truly shocked. 'This is dreadful.'

Hugh looked at me over the top of his glasses.

'It's how it is. At night when the prison closes, which is about nine o'clock, they used to jag me with this stuff

called paraldehyde, which I found out since is for knocking out horses. You get drunk for days on it, you're helpless, can't do anything. One night I was lying on the floor, I couldn't move, and I heard the door clang.'

'The prison officers?'

'No, this time it was three medics. I thought I was seeing things, that I'd gone off my head and they were going to cart me off to the mental hospital.'

'What did they want?'

'They pulled my head back and stuffed a pair of underpants in my mouth. They were soaked with urine and excrement. They never made a sound, just walked to the door and left me. And I was gagging, choking, but there's always a bit of you wants to survive and I managed to get one of my hands free and I pulled the underpants out. But it finished me, I broke down.

'It was kind of weird. A few days later I thought, Fuck it, and I'm going to go right ahead with these people. It sounds completely insane but there's a kind of freedom when you don't care about anything. The next step is being killed. I didn't mind.'

'Was this just you, or did it happen to anyone else?'

Hugh nodded. 'Yes. They did it to a bloke I knew, a big gentle giant. They drugged him and stuffed a blanket in his mouth. All he wanted was for somebody to sit down and talk to him. But they overpowered him; these screws are brutal. They are having to deal with gangsters, so they think they have to be harder.'

'It's a vicious circle.'

'Some of the prisoners they go for are just young boys; it's not necessary. They go to the PO's social club afterwards and have a celebration, and then they come back and beat you up again. They've got away with it for years.'

'How did you survive?'

'I had support from outside. And they got worried that they were killing me. If that had happened there'd have been publicity, investigations. The balloon would have gone up.'

'You've survived all this. What frightens you now?'

'I've become very aware of death with all this. In jail somebody dies and you don't take much notice, all you think is that he's out of it. But since I've come out it's been different.'

'Life has become more precious?'

'Yes, that's it. My probation officer committed suicide a few weeks ago and it shook me up. He was helping me build bridges with my family. It really got to me.'

'Who do you love most in all the world?'
Hugh answered straight away. 'Caroline. My wife. She's stood by me. I couldn't have done it without her.'

'Are you free now?'

'No, I'm on license. I am on license till I die. But they let me live in the community. They can pull me back whenever they like.'

'Does that scare you?'

'That's my biggest nightmare. It gives me cold sweats just thinking about it. I'm frightened of being set up.'

'You've survived a brutal life and I know you have a lot of bad memories, but do you have any happy ones?'

'My worst memory is the murder. My happiest memory is when Caroline and me had just got married and we were sitting on the docks looking out to sea. It was the first time I felt happy. I felt free and I had someone I loved sitting next to me. It was real good. A friend had lent us a flat and another pal gave us a thousand pounds. We were making plans, to start the gallery so I could do my sculpting. I

looked up at the sky and there was a big red sun, it seemed to be shining on Caroline – she's got beautiful big brown eyes – and it struck me: everything that had gone before, it was finished. Over.'

'Happy ever after.'

Hugh laughed. 'Yes. But real life kicks in.'

'You have to deal with it.'

'A new set of problems. But it's different, it's good.'

'What do you think makes a man?'

'Someone who can look after himself. And his family.'

'If you weren't you, who would you like to be?'

Hugh thought about this, but his answer was worth waiting for.

'Bob Dylan. "Knocking on Heaven's Door".'

'And "Mr Tambourine Man"?'

Hugh smiled. 'Yes. I've listened to a lot of his music over the years.'

It was a brilliant answer. 'What if you went to see a fortune teller, what would you like to hear?'

'I'd like her to tell me that the past is over. And that the future had just begun.'

'If you were eighteen again, what would you do differently?'

'I wish I knew then what I know now. I wish I'd been a bit more mature. I wish I'd been a bit more focused. I wanted to be a painter and decorator. Or an electrician. I thought about the priesthood.'

'Now that would have been different.'

'Yes. But I got sent to Borstal and that mucked everything up.'

'You must have met a lot of hard bastards. If you had to name just one, who would it be?'

'I think I'd have to say Frankie Fraser, because of the

stance he took in the jail. And he was a cheeky cockney – a good sense of humour.'

'What makes you feel guilty?'

'A lot of things deep down, the rest is just layers. I treat people as human beings now. I have to learn to live with what I've done. I've killed somebody and it's a horrible thing. If you start thinking about how they might have had kids and so on, it becomes too much for you. You see the implications. I wish that had never happened in my life.'

'Tell me a secret?'

'The problem is that I've never been able to keep a secret, I blab everything.'

'Tell me a joke.'

'I'm not very good at jokes.'

All right, after what he's been through, and all the angst he still carries around, why would he be? But Hugh has turned his life upside down, from hardened con to famous sculptor, a lifer who has been given his life back, a happily married man who has turned his back on crime and criminals. Hugh saw me to the hallway and I said my goodbyes. Keep in touch; hope all goes well, good luck with the book, etc. etc.

It was a warm day and he left the door ajar. I turned back for one last look. Hugh had strolled back to his armchair by the big window overlooking the beautiful city. He seemed preoccupied, lost in a world of his own. For a while he'd re-lived the past, told his story. I paused for a moment. It was hard to reconcile Hugh Collins, former formidable hard-line criminal, with this chilled-out geezer in his tartan check carpet slippers. But there had been a look in his eyes that I'd seen many times before. It is a look that hardened cons never lose. Had Hugh, like many other lifers, left a big part of himself inside Barlinnie Prison? I watched him roll a

cigarette and light it up. He took a few deep drags. It was a familiar, sweet, consoling smell. I hurried down the spiral staircase and left him to it. Reality hurts.

KIANE SABET

'AN HONOURABLE MAN'

NAME: Kiane Sabet

DATE OF BIRTH: 9.3.73

OCCUPATION: Bodyguard

STAR SIGN: Pisces

'I smashed a few chairs over their heads, cracked a couple of skulls. One guy fell down some stairs. It was soon over. I finished it and then we walked away.'

KIANE SABET

'HE LOOKS LIKE A FILM STAR, BUT HE'S ONE OF THE TOP PERSONAL BODYGUARDS IN THE WORLD.'

The menswear department at Harrods isn't my usual stomping ground, but Kiane Sabet had told me he had to buy clothes. He's a man in a hurry, a man looking for action. When he's not acting as bodyguard for visiting Arab princes and Hollywood superstars, he spends his time reading scripts and lining up auditions. Kiane oozes confidence; he's going to make the bright lights and be the next Jean-Claude Van Damme, so he has places to go and people to see. I saw him as soon as I walked in. He was centre stage and looking at himself in a mirror. Wow! What a hunk. A hungry pack of female shop assistants were ogling every line of the handsome face and muscled-up body. With his French accent, and oozing confidence and sex appeal, Kiane is a

real charmer – and he knows it. Women go wild about him.

Don't be deceived. He may look like a film star but this geezer is one of the top bare-knuckle fighters in the world – this is no-holds-barred slugging it out, no preliminaries, no rules, just two men in a cage beating the life out of each other. Looks are deceptive and Kiane is one real tough guy. But image is everything to him, it is important that he looks the part.

'Hello, Kate.' He held out a hand. 'What do you think?' The blue linen jacket suited him and I told him so. 'Haven't you bought enough?' I asked. Calvin Klein, Yves St Laurent, Gucci – this is a geezer who likes his designer labels.

'You're right.' He sounded a bit resigned.

'Come on,' I told him. 'Let's go and grab something to eat.'

Two avocado, crispy bacon, lettuce and cheese open club sandwiches later and Kiane was in the mood for conversation.

'Where were you brought up?'

'In France when I was a child, then I lived in Paris when I was at university.' He has a very French accent.

'Are you an only child?'

'No. I have two brothers and two sisters. My two older brothers died. I love my family and I had everything I needed as a child. My father had a good job and we had a happy home life.'

'Did you get into trouble?'

Kiane nodded. 'Yes, I was always fighting. I don't know why. When I was at university I started boxing and then I worked as a bouncer in my spare time.'

'Did you go on to be a bodyguard?'

'No. I had to go in the army. Everyone does in France.

You have to serve two years, there's no choice. But it was OK. I wouldn't have liked to do it for much longer, though.'

'Have you ever been to prison?'

'No. I wouldn't want to be locked up, my parents would be upset. I want them to be proud of me.'

'Have you been arrested?'

'Yes. Lots of times. Always for the same thing, violence and fighting. I've never been charged with anything, though. Maybe I've been lucky.'

'Have you ever been hurt? Stabbed or shot?'

There is a tiny line on his cheek; he touched it with his fingers. 'Yes, I've been glassed. I was attacked with a bottle. Here, see.' It was almost a designer scar. James Bond, eat your heart out. 'And I've been stabbed with a knife. I've had a gun put to my head, but the guy thought better of it. I've never been shot.' Kiane moves fast and thinks faster. It gives him an unbeatable edge.

'What's been your most frightening experience?'

'I haven't had one. I don't scare. I'm not that kind of man. Nobody knows what's going to happen in the future. Death is certain. But I'm not going to think about that. It will come when it comes. Nothing can alter fate.'

'Do you think about it, when you're facing a dangerous situation?'

He shook his head. 'No. Sometimes when I'm involved in a situation, people will say, "Aren't you scared?" And I've had a gun put on my head. That's frightening. It's worse when you think about it afterwards. But the adrenaline takes over and I don't even think about it. You do what you have to do.'

'What's the most violent thing that's ever been done to you?'

He thought about this for a moment.

'You know, if you go to the town where I was born, you would hear a lot of talk about me. Even by the time I was sixteen I'd been in a lot of fights. I've fought with gypsies, bare-knuckle fighters, wrestlers, and kick boxers. I had a reputation. I have scars all over my body. There were a lot of fights but I was never badly hurt. I can't pick out one special fight. There's been too many.'

'How do you defend yourself? Is it martial arts? Or weapons? What would be your choice?'

'The best weapon is in the mind. If you know you can do it and if you have no choice, then all that's left is to go for it. Sometimes you are in a situation where you are facing six or eight guys and you are on your own, so what do you do?'

'Run away?'

Kiane ignored me. 'You have to use your brain. Think quickly. The first thing is you want to get out of this in one piece. But I am a man. Even though I am a good person, I have to settle this. I can't back down. If necessary I look for what I can use – it might be a chair or piece of wood, anything I can put my hands on. And it is the look on my face, they know that no matter what they do I will come back at them. That takes a lot of facing.'

'What makes you angry?'

'Disrespect. This makes me very annoyed. Even with people that I used to work for, if they disrespect me, then it is over. I don't care who they are, respect is everything.'

Kiane was getting a bit rattled just thinking about this. I nodded to the waitress and she came across, but her eyes were on him even though she was talking to me. There is no getting away from it. He has presence, style and charisma. They don't quite know who he is, but every female in the room was giving him the eye. 'Another club sandwich, Kiane?'

'OK, why not.'

He uses a lot of energy up, even when he's chatting. His hands and face are expressive, living the moment. And Kiane could eat for France.

'Who do you love most in all the world?'

Kiane didn't hesitate.

'My mum and my dad. Both the same.'

This surprised me because I know that he is a ladies man, with a string of girlfriends. 'Don't you have a special girlfriend?'

Kiane laughed. 'I did have, but we split up last week. I've loved ten other girls since then.'

Ten? All right, this bloke had better stick with loving the family.

'What are your happiest and your worst memories?'

'I have a lot of very good memories, but I remember a family party and dancing with my older sister and dancing with my mother. It was a very happy time.'

'And worst memory?'

This was harder. 'You know, Kate, I don't have many bad memories. But recently, a good friend of mine died while I was on holiday in Marbella. I came straight back to London when I heard the news. It was very sad.'

'What makes you feel guilty?'

'When I do something I know is wrong. Because I always like to be right.'

Kiane is a strong character; there was no doubting that. But what does he consider to be wrong?

'Come on, what do you do bad enough to make you regret it afterwards?'

Kiane looked a bit surprised. 'I don't do anything that's wrong. Well, maybe ...'

'Go on.'

'I suppose when I've been going out with someone,

my girlfriend, and then I've gone with someone else behind her back.'

'You're a single man?'

'Yes. But this still makes me feel a bit guilty.'

'Has your life ever been threatened?'

He shrugged, it was no big deal.

'I had a fight with six big guys. It wasn't my fight; I was just trying to help someone I know. My friend is a teacher, a small guy who doesn't fight, doesn't know anything about trouble. He was getting pushed around by a big body builder, so I just came to try to calm things down, you know, and everything was looking cool and then, wham, these other guys come from nowhere and they all jump on us. So I had to find a way out, and I fought back.'

'There was six of them and just you and a teacher who doesn't know anything about fighting?'

'I pushed my friend out of the way. He was going to get hurt.'

'There was just you and six body builders?'

'But they had made me angry and when I have that feeling inside of me, then anything is possible.'

'What happened?'

'I smashed a few chairs over their heads, cracked a couple of skulls. One guy fell down some stairs. It was soon over. I finished it and then we walked away.'

Kiane is cool and impressive, an understated man, but when his cage is rattled, watch out.

I'd watched him buying clothes so I knew that his appearance was important to him. What about changing his looks, would he go for that?

'What about plastic surgery, Kiane? Would you change anything about yourself if you could?'

He looked fairly stunned. Change what is already fantastic?

'No. Not at all. What is there to change?'

'You're happy with the way you are?'

'I'm not saying that I'm perfect, but I'm very happy with what God has given me. When I look in the mirror I'm satisfied with what I see.'

'What gives you a buzz?'

'This gives me a buzz, knowing that I can do what I have to when I have to.'

He fired up at this. 'Kate, you have to understand that I have a lot of violence in me, but this is my background. If you go into clubs in London and hear people talking about me you will hear my reputation. But I don't look for problems. Sometimes problems come to me. People who know me know that they shouldn't come and give me shit. But I don't believe in violence. I believe only in self-defence. And this gives me a buzz, knowing that I can do what I have to, when I have to.'

'That's the big difference?'

'Yes. I have a lot of fights and it's not because I'm looking for them. I don't believe in violence. I don't drink. I don't smoke. I try to stay out of trouble.'

'You don't drink at all?'

'Maybe in the last six months, I've had two glasses of wine. That's all.'

'What makes a man?'

He thought about this. I poured him another coffee while he finished the last of his third club sandwich.

'You know, a man is someone who can stand on his own. Somebody who always goes forward, no matter what's coming at him. I'll give you an example. Bruce Lee was a man. Have you seen the film *Enter the Dragon*?'

'Yes.'

'This is a man. He does what he has to do and never backs down.'

'If you weren't you, who would you most like to be?'

This made Kiane smile. What an idea. 'Nobody else. Me.'

'Who would you name as a hard man?'

'The Scotsman William Wallace?'

'You have a dangerous life and you're a survivor, how do you manage to stay one step ahead in your profession?'

'By looking ahead. I think about the future and I set myself targets. It's looking good so far.'

'If you were eighteen again, what would you do differently?'

'I would concentrate on one thing. Be more single minded.'

'And what would that be?'

'Boxing. It's good to know how to do several things, but if you concentrate on one sport, you can have a good income and retire early, although a lot of sportsmen retire and have no money, even though they're world champions. They listen to bad advice.'

'But that wouldn't happen to you?'

'No. I wish I'd gone into boxing, because I like it and I do wish I'd thought about this more when I was younger.'

'If you were to see a fortune teller about the future and the past, what would she tell you and what would you like her to tell you?'

'About the past, she would tell me that I've had a happy life and been able to win all my fights! There are two things about the future. I'd like to hear that I was going to live a long time and be healthy, that would be enough for me to hear. But my dream, since I was thirteen, has been to make a martial arts movie, so if she told me that I would be famous in the movie business then I would be very happy too, because this is my aim.

In fact, I am concentrating on this in the future and taking more acting classes.'

'Can you sum yourself up in one word or one sentence?'

'An honourable man.'

Yes, I could go with that. Kiane doesn't bend the rules, doesn't mess about; people know where they stand with him, and what they are up against. Does he have any secrets, though, and will he tell me?

'I can't tell you a secret, Kate.'

'You can, it can be anything. How many girlfriends do you have?'

'No way. You'd think badly of me.'

'It's more than one? Two? Four?'

He shrugged.

'Tell me how many girls you've slept with in your life?'

Kiane was protesting but I had the tiniest feeling that he loved this.

'I can't tell you that, you'll think I'm a gigolo.'

'Go on, tell me.'

'OK, but don't put it in the book.'

'Guide's honour.'

'Between five hundred and a thousand.'

'Oh my. You're a gigolo.'

'I tell you, Kate, that I have between five and ten different girls a month.'

'A month!'

'Every night they come to me, I don't have to do anything. I make love to them in secret. Forbidden fruit taste sweetest. I have a lot of fun.'

'Why do you think you attract so many women?'

'They come up to me and say something like, "I think you're very good looking" and it goes from there. And they've heard about me. I have made love to five girls in

one go. All in bed with me. First one, then another till I'd done five, then I had to run away.'

I guessed that Kiane secretly loves his reputation as the stud of the clubs. I'd said I wouldn't write about this, but I never was a girl guide, and he'd not mentioned any names, so what the hell. He wouldn't be able to remember them all, anyway.

'Do you think that you would be able to find the woman of your dreams in a club?'

He shook his head. 'Not any more, because I meet so many girls since I finished with the girl I loved and each time I meet another I think that maybe she is the one, maybe she is special, then I see them two or three times or even for a month. But it never works out, and there is always something wrong. Sometimes I have five or six going at one time and I see them when I have time.'

'A rota.'

'I have to have a good memory.'

'What do you look for in a woman? Is it purely for beauty?'

'No, not any more. The most important thing is that I'm attracted to the girl. It's the way she manages her life, what's she's doing, the way she is inside. What she wants from the future, if we have things in common. You know, I'm twenty-nine years old now, and I feel that I understand girls. I've had so many girls in my life, so it's going to be very difficult for me to find someone and think, She's the one.'

'Where do you want to live when you do eventually settle down? Will it be England or America? Or will you go back to France?'

'I have no idea. Wherever it would be best for me and my family, if I have one.'

'Do you think that if you were married you would be faithful?'

No hesitation. 'Yes. Yes. Yes. Of course. I'm at the stage, now that I'm getting fed up of all these girls. I'd like to find one special girl.'

'Do you ever spend any nights at home on your own?'

'Oh sure. I love to be alone. When I'm alone I watch TV. I relax, I eat. I need to do this sometimes.'

'Tell me a joke.'

Kiane had to think about this. 'I like to make girls laugh and have a good time, but I don't really have jokes in my head that I can tell everybody.'

'Do you think you're ready for a serious relationship?'

He was sure about this. 'When I meet her, I'll know.'

The waitress came across with the bill. Kiane passed it to me without the slightest hesitation. He got up.

'I must leave you now, Kate.' He looked deep into my eyes and held my hand a bit longer than he needed. It was like dunking Ferrero Rocher into a glass of Cointreau. His voice was low and husky.

'I have a plane to catch. I have a meeting in New York. Then I'm flying on to Quebec to meet a producer. And a little bit of work in Paris on the way back.'

Everyone in the room was watching us. He was leaving and every woman there wanted him to notice her. Kiane has the knack of making a woman feel really special. 'I'll see you again, Kate.' I felt as though I ought to be sad as he turned and walked away.

'I have made love to five girls in one go. All in bed with me.'

But it was OK with me. I had important things of my own to do. Then I saw a familiar face. A handsome face with boyish charm. It was Leo picking me up and I was going home with the man I love, to my reality – walking the dogs and feeding the ponies.

And I felt just fine and dandy.

JOHN DANIELS
'A MAN MOUNTAIN, AN IMMOVABLE OBJECT'

NAME: John Daniels

DATE OF BIRTH: I never reveal my age

OCCUPATION: Enforcer

STAR SIGN: Libra

'Once I get in there I would fight to the death if I had to, it doesn't matter how outnumbered I am. I'll go forward, I'll never go down. They see that in my eyes.'

John Daniels – Big John

'I HAVE A JOB TO DO AND I DO IT.'

The Costa coffee shop on the precinct by the town hall was almost empty. I didn't know whether it was because all the shoppers had gone home and the night-on-the-town people hadn't come yet or because everyone had seen all 6ft 4in of Big John sitting in the window and decided to go on down the road to McDonald's instead.

He was talking away on his mobile phone. John's hands are huge, like the rest of this 30-stone colossal geezer, so why had he got the littlest phone I'd ever seen? Or was it a normal size phone in a monster mitt?

He saw me and waved for me to come over and somehow his massive fingers hit the right button and ended the call. We'd met before, in March 1995, which is a date prominent in my mind because it's when I buried my husband, Ronnie Kray. John was assigned to guard Ronnie's body in the Chapel of Rest at Bethnal Green, east London. We hadn't spoken on that day, but he's a man once seen, never forgotten. John is softly spoken, not loud or brash, but

don't be fooled for a minute. His sheer imposing presence will defuse any situation. He is a man mountain, an immovable object. His work as a celebrity bodyguard for the rich and famous has him flying backwards and forwards to the States on a regular basis. Discretion is his middle name. He never talks about his clients and doesn't give much more away about himself. Maybe he's a bit of a loner, but like it says in the song, he's one with gravel in his guts and spit in his eye. Troublemakers take one look at Big Bad John and think twice.

The coffee machine hissed; there was a lovely smell of Blue Mountain and Danish pastries. John fetched me a cup of latte and a bun drizzled with lemon syrup. What the hell, I couldn't say no, could I?

'Tell me a bit about your background, John. Do you come from a big family?'

John sipped his coffee. 'I have three brothers and a sister. I'm the middle son.'

'Are you close to your family?'

'Yes, they are what really count with me.'

His size is what you notice about him first. There's no missing him – even in a crowd, he is head and shoulders above everybody else.

'Have you always been this big?'

He nodded. 'Since a kid. At thirteen years old I weighed sixteen stone.'

'So you didn't get into many fights at school?'

John smiled. 'No, they usually backed off. I've always been naturally big.'

'Do you train?'

'I keep pretty fit. I go down to the gym every week. My work keeps me on my toes.'

'You're an enforcer. It sounds like something from *Star Wars*. How did you get into this line of business?'

'It started when I left school. I was asked to mind small clubs. They noticed that when I was around they didn't have any trouble. I suppose my reputation just grew. I went on to bigger clubs, then sorting security out. And I was asked to do personal security. When a celebrity is in town I'm asked to look after them. A lot of the time I go over to America, looking after various famous people who need someone to protect them or watch their back, keep their fans at a distance. I spend a lot of my time in Brooklyn, New York now.'

'A transatlantic traveller.'

'That's it, Kate.'

'What about prison? Have you ever been inside?'

He shrugged his massive shoulders. 'I've served time for violence. A bit of debt collecting, sometimes a fan of the star I'm minding might cause a bit of trouble. If trouble comes I can deal with it. But I never go out looking for trouble. It comes with the territory. It's just part and parcel.'

'Have you ever been stabbed or shot?'

John frowned and shook his head. 'One or two have had a go, but nothing really.'

He looks as though blows would bounce straight off him.

'What's the most violent thing you've ever done?'

He thought for a moment. 'Nothing really.'

'Is that nothing you want to talk about?'

'Maybe. I've sorted people out, but only when they've asked for it.'

'Has anything violent ever been done to you?'

'Generally people stay out of my way.'

'What weapon do you use when you're guarding the celebs?'

'My hands are my weapons. They are all I need.'

I looked at his huge fists. Right. John seems cool,

controlled, always in charge. But does he ever lose it? 'What makes you see the red mist?'

'Nothing. What I do is work to me. I'm not going out to challenge anyone or have a fight. I have a job to do and I do it. I evaluate every situation. If there are circumstances where I'm outnumbered, say three to one, then I make a judgement about how to deal with it. Are they going to go away without a fight? If I come to the conclusion that they're not, then I'll lash out first.'

'Do you come out on top?'

'Usually. Once I get in there I would fight to the death if I had to, it doesn't matter how outnumbered I am. I'll go forward, I'll never go down. They see that in my eyes.'

John is a man who never backs off; it's cool, and it's nothing personal. But every tough guy has to have another side. What about his home life? Is there someone out there waiting for him?

'Who do you love most in all the world?'

'My wife.'

'And what is your happiest memory?'

He thought about this for a few moments. 'It was a couple of years ago. I had a holiday in Barbados with my family. There were about thirty-six of us, my kids and the extended family. We all had a wonderful time. Something to remember all our lives.'

'What's your worst memory?'

'When my father died. A part of me went with him.'

John took his sunglasses off and wiped his eyes. 'How long ago was it?'

'Eight years.'

'You were close?'

'Very. He was a fantastic man.'

He took a swig of coffee and put his shades back on. It was OK.

'Does anything frighten you?'

'Not really. I wouldn't like to go inside again.'

'Do you think that prison is a deterrent?'

'It can't be. Look how many prisoners are repeat offenders.'

'What makes you feel guilty?'

'I feel bad if I've not done the right thing.'

Like most men who live by violence, Big John has a strict moral code. His code maybe – not always society's code – but he doesn't stray away from his beliefs and principles. 'What gives you a buzz? Is it fighting?'

'Definitely not.' He thought about this for a few moments. 'I'd have to say that I get a buzz when I'm with my kids. They're your flesh and blood. The future. That's the biggest buzz, watching them grow up.'

'What about your looks, John? Nobody could miss seeing you. Would you like to change your appearance if you could?'

'Not in a million years.'

'If you were eighteen again, is there anything you'd do differently?'

'I would spend more time with my father.'

'You admired him.'

'More than anyone else in the world. He was one of the hardest men I've ever known. I'm not saying that just because he was my father. He was a tough cookie by anybody's standards. But he didn't mess about, he never took advantage of anyone and he was straight. You knew where you were with him. You might not like it, but you knew it.'

'Is that what makes a man?'

'Yes, it's someone who doesn't use violence for violence's sake. Some people are bullies; they take advantage of a situation. Say there's a big guy on the door and a little

weedy bloke is drunk and giving him some grief. It would be easy to bash him. But that would make the big guy a bully. If some-one's drunk, there's no glory in bashing him up.'

'You'd never do that.'

'Never. I don't have to prove anything.'

'If you weren't you, who would you most like to be?'

'It would have to be Martin Luther King. He died for what he believed in.'

'How do you stay one step ahead?'

'By staying calm. Evaluating a situation. When I make a decision, that's it. There's no turning back. My father always said to me, "If you're going forward when you go down, you've won."'

'But you don't go down.'

'No way.'

'Do you ever wonder about the future? Where you'll be in, say, ten years' time? What you'll be doing?'

'Who knows.'

'Would you go to see a fortune teller?'

'I don't think I would ever consult one. What will be will be. If it were something bad, then she wouldn't tell you. And if it was something good, then it'll happen anyway.'

'If you were to sum yourself up in one word, what would it be?'

John didn't have to think for long. 'Big.'

There's no arguing with that.

The coffee bar was filling up with people, mostly teenagers and young couples getting their caffeine kick before the night out. Mostly they wandered towards the empty seats on either side of us, saw this massive geezer with tough guy written in big letters all over him and backed away. John shrugged. He was used to this reaction. He looked at his watch. 'I have to go in five minutes, Kate.'

So did I. Leo was picking me up. We were off to do some filming for my next TV series on Channel 5. There was a world-class kick boxer waiting for us in a pub in Bethnal Green. Hopefully. Time doesn't always mean a lot to some of these geezers.

'Just a couple more questions. Tell me a secret.'

He shook his head. 'Can't do that, I'm afraid. It would go right against my nature.'

I glanced out of the window. Leo had pulled up outside – on a double yellow and he was giving me the hurry-up sign. I stood up to go.

'Before I go, will you tell me a joke?' Big John walked to the door with me.

'I heard a good one the other day, it's a bit long, though.'

'Go on, Leo won't mind hanging on for a minute.'

'All right. Did you hear about the lorry driver who used to amuse himself by running down lawyers?'

'Well, no.'

'Are you wondering how he could tell they were lawyers?'

'Was it the trail of slime they left?'

John's laugh is loud and deep. A woman walking by stopped and stared. 'You have heard it?'

'No, a lucky guess. Go on.'

'Well, one day, this lorry driver was motoring along a country road and he saw a priest walking along the grass verge, so he stopped to see if he wanted a lift. "Where are you going, Father?" he asked him. "To the church five miles down the road," the priest replied. "OK, Father, hop in." So the priest climbed in the passenger seat and they drove on. Suddenly the lorry driver saw a lawyer walking along the pavement and as usual he swerved to get him. But then he remembered he had a priest with him and he

swerved back, narrowly missing the lawyer. But he heard a loud noise – 'THUD!' The lorry driver was a bit puzzled and he glanced in his rear mirror, but he couldn't see anything. "Sorry about that, Father," he said to the priest, "I nearly hit that lawyer." "It's OK, son," said the priest. "I got him with the door."'

I don't know who was laughing more, Big John or me. He waved goodbye and sauntered off down the street. Even the traffic warden who had spotted us edged back against the wall, giving him space. Leo hooted on the horn. 'Come on ...' I climbed into the motor, still chuckling, and we were away. The traffic warden glared at us but I was only watching out for lawyers.

NIGEL
'A GENTLE GIANT'

NAME: Nigel

DATE OF BIRTH: 22.6.62

OCCUPATION: Minder

STAR SIGN: Cancer

'A few years ago I got jumped on by three blokes. I got a battering. I had their boot marks on my back, I was urinating blood and I couldn't lie down for a couple of weeks.'

Nigel – A Gentle Giant

'When I explode, I really go.'

It was 6.30 p.m. and I was looking at my watch, waiting for my lift to arrive. This was going to be a big night out, for me as well as for almost anyone who was anyone in the boxing fraternity. The Champ was in town. The greatest. One of the top licensed boxers in the world and he had agreed to meet me. Yippee! This was my big moment. I was up for an interview with the great man himself and his personal publicist had arranged for me to arrive in style.

Nigel is a minder, but not just any ol' minder. He shadows the best but is reluctant to name names. He is always called upon when someone big is in town and as he was going to be working that night at the same venue, he was coming to pick me up. I thought he might be driving a classy motor, but I didn't expect to see the sort of motor that almost silently pulled up to a gentle halt outside my garden gate. A white stretch limo. Wow! This was the nuts!

Nigel got out and said hello. He looked the business, in dark evening suit, white shirt, and black bow tie. A glimpse of gold watch, diamond stud cufflinks, a faint whisper of Aramis. Only his bashed-in face gave the game away. This bloke has seen action. But tonight we were playing Cinderella and he held the door open for me with a bit of a flourish. An hour before and I'd been in jeans and wellies and fetching the ponies in for the night. But I'd changed into my glad rags – now I was a different person and I was going to the ball. The back of my neck prickled, I could almost feel the curtains twitching all along the street. I guessed that the neighbours were having a nose. But I didn't care. I slid into the deep upholstered seat feeling like a million dollars. It was cream leather. There were tinted windows. In-car entertainment: TV screens in the backs of the seats, even a mini-cocktail bar. It smelled of saddles and much more – money, money, money.

'If it was three against one, I'd want a baseball bat.'

Is this really how the other half live? I couldn't imagine myself going to the supermarket in a motor like this, and I sure as hell didn't know what my dogs would make of it. But tonight I had my posh frock on and my wits about me. It was just right.

My idea was to have a chat to Nigel on the drive into town. Get him to spill the beans. He is a sinister geezer with a reputation for indiscriminate naughtiness and with his fingers in a lot of very sticky pies. He has a story to tell and I wanted to know all about it. The motor purred and I could see his eyes watching me through the rear-view mirror. They were cold and calculating. This might not be as easy as I thought, but still I'd have a go. He put his foot down and we were on our way.

'Tell me a bit about yourself, Nigel. Where were you born and brought up?'

'I've lived in Coventry most of my life.'

'Do you come from a big family?'

'Five brothers and four sisters.'

'What about when you were a kid? Did you have things fairly easy?'

'No way. With that many in the family it was hard times and even harder times. You had to fend for yourself. There was never enough money coming in. But it was the same for everyone in our neighbourhood.'

'Was it a tough area?'

'Yes. You couldn't get out of it. It was like being branded. But we all knew one another and somehow we survived it.'

'What were you like when you were growing up? A little devil or a little angel?'

He thought about this. 'In school days I was a pretty quiet lad, actually.'

'You're still quiet now.' Nigel has this air of mystery about him. It's as though he's trying hard not to give anything away.

'I didn't mind school, but I didn't get the most out of my education.'

'Why was that?'

'I don't know. Maybe it was just the way I was.'

'What age were you when you left school?'

'Sixteen. I'd have liked to go to college, but there was no chance.

'Have you ever been to prison?'

'Yes.'

'What for?'

'Grievous bodily harm.'

'Just the once?'

'Yes, that was enough.'

'How long did you do?'

'Six months.'

'Has your life ever been threatened?'

'I've not had a contract put out on me or anything like that. But in my line of work you're putting yourself up for it every time you go out. There's so many shooters on the street now, you have to be a lot more vigilant than you'd have to, say, a few years ago.'

'Have you ever been stabbed or shot?'

'No, because I make sure I see what's coming.'

'You're cautious?'

'You have to be.'

'What's the most violent thing that's ever happened to you?'

'It's all violence, working the doors. A few years ago I got jumped on by three blokes. I busted them up and got out of it. But I got a battering as well. I had their boot marks on my back, I was urinating blood and I couldn't lie down for a couple of weeks.'

'Did you think you were going to die?'

'I thought they were.' Nigel is understated but full of menace.

'What happened to them?'

'They left the area. No problems.'

'What weapons would you use if you knew you were going to be in a row? What would you rely on?'

'I wouldn't use a weapon if it was one on one.' He held his fists up. His knucklebones stuck out like hardened steel. 'But if it was three against one, I'd want a baseball bat.'

So far, I've found that every hard man has a soft centre. Was this going to be true of Nigel too?

'Who do you love most in all the world?'

'Myself.'

I hadn't seen it so far. But there was still time.

'What is your happiest memory?'

'When I got married. Annette is the best thing that's ever happened to me.'

'Does she keep you on the straight and narrow?'

I could see Nigel's face again in the mirror. He nearly smiled. 'She tries.'

'And what's your worst memory?'

He was looking straight ahead now. His voice was expressionless. 'It was when my dad died. I was in prison at the time.'

'You weren't there?'

He shook his head. 'I should have been. But that's how it goes.'

'What did he die of?'

'It was cancer of the pancreas.'

'Had he been ill for some time?'

Nigel nodded. 'He'd been in and out of hospital all the time I was going to court. He died a week after I'd been sentenced.'

'Did they come and tell you?'

'Sort of. A priest came and took me into a room and told me he was ill and in hospital again. But I knew inside that he was dead.'

'Something told you?'

'Yes, well we'd always been close.'

'Did you get to the funeral?'

'Yes, they let me go. But I was double handcuffed. It was very upsetting for my family.'

'How did you cope with that?'

'I had to sort of switch off. I had to act normal. I never had chance to grieve properly.'

'How old was he?'

'Only fifty-one.'

'What was your dad's name?'

'Andrew.'

'Did this experience change you?'

I could see Nigel's face as he was driving; it was closed, shut down. Being unable to grieve has hardened him.

'At the time. I lost my business, I lost my family for six months. I lost my dad. All because of a stupid mistake.'

'What happened?'

'I was doing the doors and this bloke wanted a row. I didn't want to fight; I talked to him for twenty-five minutes, trying to persuade him out of it. I shook his hand. I thought he'd settled down. He started talking silly talk, like he was going to find me in the street and get me with his brothers, he was going to stab me.'

'What did you say to all this?'

'I thought it was the drink talking. I told him, whatever comes, comes. Then in the end he took his shirt off. I knew that was a bad sign. When a gypsy takes his shirt off, he's going to fight. I felt bitter against him because he could have walked away that night, and I wouldn't have gone to jail. More importantly, I would have been there when my father died'

'Did that make you angry?'

'No. Regretful. I wish it could have been different.'

'When your dad died, did something inside of you die with him?'

'Yes, that's just how I feel. I haven't been up the street where my dad lived since; I can hardly go to his grave. There's too much pain inside of me still. I still want to remember him living.'

'Did you make a vow that nothing like that would ever happen again?'

'Yes. I did. I haven't worked the doors since. I won't put myself in that sort of situation ever again. Losing my dad made me stop and take a long, hard look at myself and my life. '

'Does anything make you see the red mist?' We were in a queue of traffic going onto the ring road. Stop-start. I hoped he wasn't going to say 'Road rage'.

'Being called names is hard for me to deal with. It makes me angry, although I know it shouldn't.'

'Sticks and stones?'

'Yes, that's right. Some people are pathetic, they can't get at you because they know what your reaction would be, so they try it on, see if they can rile you up. It's not worth bothering about. I try to ignore it, but if it happens it rankles. Then I think about it, and that's it, I've lost it.'

'A bit like a simmering volcano.'

'When I explode I really go.'

Nigel is a good driver and he negotiated his way through the traffic with a lot of skill. 'Does anything frighten you?' I expected him to say something about his violent encounters, the risk of having a knife pushed in his ribs or a gun to his head. Nothing like that.

'To tell you the truth, Kate, there is something I've always been scared of – I can't stand spiders. I'm terrified of them.' They say everyone has a weak spot. At least Nigel was prepared to admit his.

'Does anything make you feel guilty?'

He thought hard about this. 'No. Nothing. I have to live with what I do. It's no good if you are going over it. Whatever I do, I take the consequences. There's no place for guilt in my life at present.'

'You're happy with things the way they are?'

'More or less.'

'Would you change your looks if you could?'

Nigel thought about this. 'I suppose I might have a tummy tuck.'

'Would you have plastic surgery?'

'Well, I might. I have been described as a bulldog chewing a wasp, so I might let Harley Street loose on my face one day.'

'What gives you a buzz? Is it violence? I know it's your line of work, but do you like a row, or would you rather keep out of it?'

'I suppose it would give me a buzz. I'm afraid that's the truth. Sometimes I wish it wasn't. It can create more problems than it solves.'

'But you go out there and face it.'

'It's when you enjoy it that the trouble starts.'

'It takes a lot of guts. Is that what makes a man?'

'A man is someone who stands up for himself. A bloke who doesn't back down.'

'If you weren't you, who would you like to be?'

We were weaving in and out of traffic, but Nigel didn't hesitate.

'Kevin Houston.'

'Right. And if you had to name a hard bastard, who would it be?'

Same answer. 'Kevin.' I knew he was going to say that. I asked him why. 'Because he's just got so much respect from everybody and he doesn't stand for anything from anyone. He's the hardest man I've ever known.'

'How do you stay one step ahead?'

Nigel's eyes met mine in the mirror. 'I don't really, I get left behind.' He is so deadpan; it's hard to know when this geezer is having you on.

'If you were to see a fortune teller, what would you ask her about the future and what would she tell you about the past?'

'If she was any good, she'd tell me that I'd been naughty in the past. I'd like her to tell me that I'm going to make loads of money in the future and have a good life with my family.'

'If you were eighteen again, what would you do differently?'

'I wish I'd spent more time with my dad. And I suppose I wouldn't have hit the gypsy.'

'If you had to give advice to an eighteen-year-old kid, and he wanted to go and work on the doors, what would it be?'

'Don't do it. But if you do, don't be a bully. And don't get bullied.'

'If you saw a lad who was going down the wrong road, what piece of advice would you give him?'

'Take stock of your life and look where you're going. Prison is where you will end up – there or dead in an alley.'

'What do you think is the best way to keep out of trouble?'

'I expected him to say something about his violent encounters, the risk of having a knife pushed in his ribs.'

'Getting a good education, without a doubt. And getting out of living in a rough area. If you can talk your way out of trouble, that's the best way. But in some situations you can't do that, you've got to face up to it and go straight in.'

We were nearly at our destination and slowed down in a line of flash motors. 'Sum yourself up in one word or sentence.'

'A gentle giant.'

'Can you tell me a secret?'

'I would do if I had one, but I don't know any.'

I didn't believe a word of it.

'Tell me a joke, then.'

The limo pulled up outside the bright lights. There were crowds pushing and jostling. Nigel got out and held the door open for me. I felt a bit like a film star.

'A joke, Nigel?'

He shook his head. 'I don't do jokes, Kate.' I didn't try to persuade him; his past life is buried inside, shutting him off from his feelings. I hoped that our talk might have helped him in some way.

He got back in the limo and drove off to park it up. Within a few minutes he would be back and in the middle of the action. Saying nothing, seeing it all, his life on the line, if that was what it took. I wondered what he felt like inside, facing the mob, watching somebody else's back, not his own, and not knowing what was coming next or what trouble it might bring him. But the doorman had seen me, I flashed my ticket and he waved me inside. I had butterflies in my tummy. How was I going to get the World Champ to unbutton his lip and tell me some of his dark and deadly secrets? I didn't know. But I flicked my hair back, squared my shoulders and set off across the red carpet. Whatever it took, I was going to have a darn good try.

PAUL KAVANAGH
'A MEAN, KEEN FIGHTING MACHINE'

NAME: Paul Kavanagh

DATE OF BIRTH: 3.3.75

OCCUPATION: Unlicensed Boxer

STAR SIGN: Pisces

'Once I get mad,

I take it out on

everyone. They all

get the end of it.'

Paul Kavanagh

'I MAKE SURE OF THEM. THEY DON'T
GET UP AND THEY DON'T COME BACK.'

It was seven o'clock in the morning and the lake in Chingford Park was wreathed in swirling clouds of mist. It hung in ghostly trails over the water's edge, hiding the empty coke cans, the fag ends and last night's used condoms. The paths were deserted apart from the vague outline of an old man in the distance walking his dog. I was glad I was wearing my quilted jacket because it was cold. Damn cold. I stamped my feet and rubbed my hands together – I must have been mad to arrange to meet any geezer at this time and in this place. Paul Kavanagh is a mean, keen fighting machine – I'd been told that he had a big-money match coming up in a couple of weeks' time. He's a man who's always in a hurry, a prizefighter on a tight leash with a

hard training schedule ahead of him. Ten-mile work-outs at first light, weights, skipping, sparring – these are Paul's daily ticket to fame and fortune. I'd been told that he is a handsome heartthrob and the girls are all nuts about him, so when I saw a well-muscled hunk wearing designer gear pounding the tarmac towards me, it was Chippendales eat your heart out and it had to be him. He held out a fist like iron and shook my hand. Although he was still bouncing and on his toes, thankfully he managed to slow himself down and I could just about keep up with him.

'Tell me a bit about yourself Paul, where do you come from?'

'I was born in Clapton, then we moved to Hackney, which is where I grew up. When I was seventeen we moved to Chingford and I'm still living there, with my mum and step-dad at the moment and my little sister.'

Paul exudes raw energy; he glows with health and energy. I warmed up just by standing next to him.

'All this training you're doing, is it to do with your boxing?'

He nodded.

'Yes. The fight game isn't something you can do half-heartedly. You have to give it everything you've got. When I'm training for a fight, I'm single-minded about it. Nothing else matters. That's all I concentrate on.'

'Is it unlicensed fighting?'

'Yes. It's the same as ordinary boxing really, we have rules and paramedics and doctors. A lot of people think

it's bare knuckle, but all that's different is that it's not licensed by the Boxing Board of Control.'

'No kicking or gouging, then?'

'Nothing like that.'

'Have you been in much trouble? Ever been to prison?'

Paul shook his head.

'Only to visit my dad. He died in Pentonville Prison in 1999.'

We sat down on a bench and watched the ducks on the water. Paul's voice was flat. The emotion was there but well hidden.

'What did he die from?'

'An asthma attack.'

'Good grief.' It didn't seem possible. My own father had died of a heart attack a few years earlier. But asthma? It's very difficult to find the right words. Paul had slumped down a bit. 'That must have been terrible. You can't explain it, can you?'

'I had mates in there at the time. I was working, doing a courier job and I got a phone call. It was my mate, they let him phone me and he broke the news. Then I had to get in touch with everyone else.'

'Didn't he get to see a doctor?'

Paul shrugged. 'Who knows.'

'Do you think if he'd been out, and he'd had better medical attention, then he might have survived?'

'Yes, I think so. A lot of people said this. That he didn't get the treatment he needed.'

Paul has built up a good defence mechanism for coping with his loss. He has the hurt buried deep inside; there is no sign of anything other than cool and calm on the surface.

'Does it make you angry?'

'Yes. Sad and angry.' His eyes were cold and distant.

The rage and pain is there all right. I know that Paul is an unforgiving and relentless fighter. Is this the secret? Is this what drives him?

'There's no doubt about it. Drugs have made people wilder. There's cocaine everywhere in the clubs, it's out of control.'

'Have you ever thought you might go to prison?'

'Never,' he snapped back. Because of what happened to his father, this is a situation he would dread.

'Has your life ever been threatened?'

'No, I couldn't say it has.'

His reputation is unchallenged and he likes to keep it that way.

'Have you ever been stabbed or shot?'

Again, no. Either he gets in first, he's quick or he's lucky.

'What's the most violent thing that's ever happened to you?'

Paul clenched his fists.

'When you're working the doors, so many things happen. It's all violence. Nothing sticks in my mind.'

I found Paul to be almost emotionless when talking about dangerous situations or anything that hurts him or people he cares about. But this is a defence mechanism: on the surface he is calm, but inside I felt that he is still raw and savage. This is a man with deep emotions who finds it hard to talk about his feelings. To be on the receiving end of all this pent-up anger must be awesome. How did he get into this line of work?

'I started off in Bromley and then my business spread out everywhere, all round London. I've been doing the doors for about six years now.'

'Do you think it's more dangerous now than it was, say, a few years ago?'

'Yes, definitely. A lot of people don't hesitate, they shoot first and think afterwards.'

'What's caused this? Do you think that the drug culture has changed the scenes on the clubs?'

Paul was sure about this. 'There's no doubt about it. Drugs have made people wilder. There's cocaine everywhere in the clubs, it's out of control. Some people are OK with it, they're happy taking it and no problems, but others start thinking they're superman and that's trouble. It puts everyone on edge. It's not like the old days; it was bad enough dealing with the wannabe tough guys who'd had too much to drink. But now, you don't know what they're on, they're out of their brains and capable of anything.'

'How many days do you work the door?'

'Normally it's Friday and Saturday.'

'And what about these confrontations? Do you have to face it occasionally or is it every time you go out?'

'I would say fifty per cent of the time there's trouble of one sort or another.'

'How do you cope with this, Paul? You're living in a world where you are facing violence, injury, and death even, as a routine event. This is something that most people don't have to face.'

'That's right.' Paul's face didn't alter. He is a very cool geezer.

'How do you deal with it?'

'Eighty per cent of the job is talking. If you've got the gift of the gab you've a chance of being able to stop almost anything happening. But then it gets to the stage where you can't talk to them, especially if they're pissed out of their head or they're on drugs. There's no way to communicate. That's decision time. Either you have to get them out of the club or you have to sort it. And I'm not a big guy, eleven and a half to twelve stone tops, so sometimes it's any way you can.'

'It's not the dog in the fight, it's the fight in the dog?'

He smiled. 'Something like that. It can be hard to put them in locks.'

'What do you do then?'

'I try telling them first.'

'And if that doesn't work?'

'I give it a good try, tell them the music's too loud or there's a guy wants to speak to them outside.'

'Then what?'

Paul gave me a sly grin. 'That's when I fuck them off.'

'No details?'

He shook his head. 'I make sure of them. They don't get up and they don't come back.' He wasn't saying any more.

'Do you ever feel guilty?'

'Sometimes. If I get carried away and my mouth shoots off a bit. Then afterwards I wish I'd handled it better. Once I get mad, I take it out on everyone. They all get the end of it.'

'Even the people you are close to?'

'Even them.'

'Who do you love most in all the world?'

Paul didn't have to think. 'My family and my girlfriend.'

'What's your happiest memory?'

This did slow him down. 'Possibly it was when I was a kid, and my dad was alive. You know, things like holidays and Christmas. You don't know what you're in for when you're little. Maybe that's a good thing.'

'And your worst memory?'

'Losing my dad. He was only forty-seven.' For a moment the mask slipped and there was an expression of pure grief on Paul's face. It brought a lump to my throat. I knew what he was feeling.

'My own dad died a few years ago. Of a heart attack.' Paul looked directly into my eyes. He is a smashing-looking guy,

and as tough and unflinching as a hungry alligator, but when he lets his guard down he's as susceptible to his feelings as the rest of us. His expression said it all: cut me and I bleed. With him it's not very often, that's all.

'What makes you see the red mist?'

He looked away into the distance. 'So many things. It's become worse over the last couple of years.'

'Since your dad died?'

'I suppose. I don't know what it is. My girlfriend says that I should go on an anger management course. It's the little things trigger me off. I get bad road rage. I have to work hard to keep calm, keep myself in check.'

'What else?'

'The way the country's run. Housing. The way the system works. People don't have chance. It's all these things run into one.'

'What frightens you?'

'Nothing. I've always been the same. I've been in the army and they would tell you that nothing frightens me.'

'What's the most frightening thing that's ever happened to you?'

'Nothing has ever happened that's made me even remotely frightened.'

'No nerves at all?'

'That's right, Kate.'

'Is there anything you'd like to change? Your looks, maybe?'

He shook his head. 'No. But my teeth perhaps. I'd get them straightened.'

'So does fighting get rid of the frustration in your life? Does it give you a buzz?'

'Yes, it does. When I train it helps and when I start sparring I build up a lot of aggression. It's something I can't

get rid of, that's when I need the fight. The buzz is when I win. I can't explain it.'

He's cool, calm, controlled but that's on the surface. The reality is the violence – and reality hurts.

'What makes a man?'

'It's someone who looks after his family, feeds and clothes them. Takes responsibility, really.'

'Sometimes. If I get carried away and my mouth shoots off a bit. Then afterwards I wish I'd handled it better.'

'And if you weren't you, who would you like to be?'

'Nobody. I like being me. I look at people and wish I had their money or their lifestyle, but I don't think I'd turn round and say, "I wish I was him."'

'You're a pretty tough guy yourself, and you must have met a lot of violent men, so who would you call a hard bastard?'

'I personally think that all these so-called hard bastards are bullies. So I wouldn't put them up as hard at all.'

'Wouldn't you put anyone up as a hard man?'

He shook his head. 'It's funny, but when you come from a boxing background, you see the real big guy and then when they lose a fight, they cry. I wouldn't say that I really know any hard bastards. I know a lot of bullies, though.'

'How do you stay one step ahead?'

'My girlfriend keeps me on track. Definitely. Without her, I'd be in a lot of trouble.'

Everybody needs somebody, and this tough guy is no exception. So does he ever think about what's coming next? 'If you were to see a fortune teller about your future and your past, what do you think she'd tell you and what would you like her to tell you?'

'I think she'd tell me that I'd had a lot of grief and that it never goes away, you just learn to hide it. I'd like her

to tell me that I'll get where I want to be and what I'm aiming towards.'

'And that is?'

'A nice house. A good life. For my girlfriend and me to get married, have kids and be happy. I think this is what's going to happen anyway, and this is what she'd tell me.'

'If you were eighteen again, is there anything you'd do differently?'

Paul leaned back and stretched his arms out. The mist had cleared and there were a few more people about. He took his time answering.

'I suppose most people have done things they wish they hadn't. I'm no exception to that. But on the whole, I wouldn't change anything. I am what I am.'

'Is there anything you'd like to have done?'

'Yes.' The answer wasn't what I was expecting from this good-looking young man. It wasn't money, cars or sex, drugs and rock 'n' roll. 'I'd like to have learned sign language. I've always wanted to be able to communicate with deaf people. Help deaf children. I'm partly deaf in my left ear so I have some idea what a difficult time they have. If I'd trod a different path in life, it would have been helping people with hearing difficulties.'

What a nice man! But was this a mistake? Had he given too much away? Paul jumped up and started jogging on the spot. I had to be quick now, he was freaked out and ready for the off.

'Sum yourself up in one word or sentence.' No hesitation. 'Moody.' Yes, I could imagine that. 'Funny.' No, we hadn't got that far yet. 'Very truthful.' Definitely.

The park was filling up with people going to work. I could see Leo walking towards us. Paul had started shadow boxing. Another minute or two and they'd be sparring. 'Tell me a secret.'

No way. 'I don't have secrets.'

'Do you know any jokes?'

He stopped jumping about and thought for a second. 'OK, I'm not very good at remembering them but here's one I heard the other day. There's three ducks and one of them goes into a pub and goes up to the bar. The geezer behind the bar says, "What's your name, mate?" and the duck says, "My name is Dave." So the bartender says, "What have you been up to today, Dave?" The duck says, "I've had a lovely day. I've been in and out of puddles and having a laugh. I'll have a pint of lager please." The next duck walks in, he goes, "My name's Steve." So the bartender says, "How you been, Steve? What you been up to?" And Steve says, "I've had a lovely day, I've been in and out of puddles and all that." The bartender says, "Do you want a drink?" Steve says, "Yeah, I'll have a drink, I'll have a lager." Then the next duck walks in and the barman says to him, "All right, mate. What's your name?" And the duck says "My name's Puddles. Fuck off!"'

Paul didn't look to see if I was laughing or not. His pent-up energy had the better of him and with a wave to Leo, he was away, pounding the tarmac and back to the gruelling training, the fights, the brawls, the violence and laying his life on the line with every night's work. We followed more slowly and by the time we reached the park gates, Paul was almost out of sight. He still had weights and sparring to get through and to get to the peak of fitness for his next fight he had to stick to this strict regime day in, day out. Paul wants a lot more from life than he already has; he is a cool, resourceful fella, single-minded and very determined. I felt certain that he would achieve his aims. As for Leo and me, for the time being we were pitching it a bit lower – something hot to drink and a bacon sarnie, maybe?

SHANE STANTON

'ONE OF THE HARDEST FIGHTERS ON THE UNLICENSED CIRCUIT'

NAME: Shane Stanton

DATE OF BIRTH: 25.7.68

OCCUPATION: Builder and Unlicensed Fighter

STAR SIGN: Leo

'With boxing, it's only you and one other man in there. It's like being a gladiator, you're in face-to-face combat and there's no get out.'

SHANE STANTON

'FIGHTING IS EITHER IN YOU, OR IT'S NOT.'

I met Shane Stanton in a pub just off the Old Kent Road. He'd come up to London to see a guy about arranging his next fight and I was seeing my new agent about some publicity photos. I pushed through the swing doors and went into an old-fashioned London boozer. At least this place hadn't been given a make-over into a trendy wine bar. There was an old-fashioned marble-topped counter, fancy mirrors behind the bar and anaglyptic wallpaper that was fashionably yellowed by the smoke from a zillion ciggies. What made it though, was the clientele. Their pug-ugly faces, wide shoulders and fists like Wall's sausages all gave it away. I was in the right place – wall-to-wall with hard men, fixers,

movers, shakers and naughties. Shane was propped up against the bar in the thick of them, and rabbiting away nineteen to the dozen. Eventually he saw me.

'Be right over, Kate.' He cleared a couple of wannabes out of the way and found us somewhere to sit. 'Can I fetch you a drink?'

There was a thick haze of smoke and conversation. I'd dry up if I didn't have some-thing. 'Tonic water with ice and lemon,' I told him. He came back with two glasses; he was having the same. He sat down opposite me. 'What do you want to know then, Kate?' Shane couldn't be any-thing but a fighter, but he has an engaging personality and is real easy to talk to.

'When it comes to it , you're either a fighter or you're not a fighter.'

'Tell me a bit about your background, where you come from.'

'Romford, Essex.'

'Is that where you've always lived?'

He nodded. 'Never moved. My family are there and it suits me.'

'What were you like when you were little? A bit of a tearaway?'

'Some people might say that. Maybe I was a little git, but I think I was a normal, run-of-the-mill boy.'

'Slugs and snails and puppy dogs' tails?'

'Yes, that's it. I had my fair share of trouble, but nothing too bad.'

'Have you ever been in trouble with the law?'

Shane was all innocence. 'Nothing too serious. I've had my ups and downs, like anybody.'

'Have you ever been to prison?'

He shook his head. 'No, thank God. That's something I would dread.'

'I know that you are a top circuit fighter.'

'And a licensed kick boxer.'

'It's a violent world – has your life ever been threatened?'

'No, nothing to speak about.'

'Have you ever been stabbed or shot?'

'No.'

'Do you work the doors?'

'No, I'm just a fighter.' He took a long gulp of his mineral water. 'You know, Kate, you have to be totally dedicated to get to the top in the fight game. I've been asked to help out with security many times. I could get a little business going any time I wanted. But I'd have to give up my training. Then I'd lose the edge. Then I'd start getting hurt or beat. You can only do one thing or the other. At this stage in my life, it's not worth it.'

'What's the most violent thing that's ever been done to you?'

'I've been bashed up in a fight. To the normal person it would look like "Cor, that's bad", but from a fighter's point of view, you get lumps and bumps and bashes on the head, it's the normal run-of-the-mill. When it comes to it, you're either a fighter or you're not a fighter. You can't be made a fighter. You can be taught how to fight, but it's either in you or it's not.'

'Sheer guts.'

'Yes. It's a natural thing, it's the same as many sports. It's like a racing dog or a horse: either you've not got it or you're a natural. It has to be something inside you. It's how you bring it out, or whoever brings it out, whoever trains you that makes all the difference. That's what

makes a good trainer, someone who can see what you've got and bring it on properly.'

'Is it spotting the talent?'

'That's it.'

'Are you a heavyweight fighter?'

'Yes. I'm heavyweight.'

Shane is built like a tank, solid thick muscles sprouting from his neck, fists like iron and a jaw like steel. But he's not slow and cumbersome; this is a man who is light on his feet, a quick thinker and an even sharper mover.

'Do you go to the gym a lot?'

'I train at a few gyms. I find that different situations are good for me. It gives me an edge, keeps me on my toes.'

'What is the weapon of your choice?'

Shane drummed his fingers on the table.

'You have to adapt to who you're fighting. It would be my head or my fists. The opponent might be straight at you so in boxing terms you've got to be a counter puncher, somebody might go back so you've got to go forward. Some people just walk straightforward, chin down – crash, bang, wallop style. Others go backwards. I always say it's like a game of chess. You've got to be smarter than your opponent. But the best weapon has to be the one you've been given. So it would be my fists.'

'Who do you love most in all the world?'

'My wife.'

'Does she support you?'

He gave a bit of a wry smile. 'Yes and no. She worries about me getting hurt.'

'What is the happiest memory in your life?'

'My happiest time was when I was getting married to my wife. We had a lovely wedding. Top hat and tails.'

'And your worst memory?'

He shook his head. 'I don't have one.'

'Do you lose your rag when you're fighting?'

'Never.'

'What makes you see the red mist?'

'Nothing. I don't get angry. It's a pointless emotion. It doesn't do any harm to the other guy. It just throws you off balance. So I don't go there. I stay calm. I don't see the red mist. Not ever.'

'Don't you? Are you that controlled?'

'Yes. One hundred per cent.'

'You don't ever lose your temper?'

'No. I don't scream, don't shout. Nothing.'

'What frightens you?'

'I don't get frightened when I'm in my professional world. When I walk into that ring I know I've got a job to do. I go in there with the attitude that I've got to keep my head about me.'

'But outside of that?'

'Nothing frightens me, except the normal everyday worries. I see these old fighters and they're wrecked. They've taken too much punishment. I don't want to finish up like them. You've got to know when to quit. Death and taxes are the only frightening certainties.'

'What gives you an adrenaline rush?'

'Not much. I've been there, done it all.'

'Got the T-shirt?'

Shane is the ultimate laid-back geezer. Is there any way to get under his skin?

'Do you actually like fighting?'

'It's not the point that I like fighting. It's the competition. It's like a chess game. When you play you think about your move, then it's their move, you have to destroy the opponent and then see who's going win, who'll be king of the castle.'

'You have to be dedicated.'

Talking about boxing has Shane animated. In spite of what he says, this is something in his blood.

'You have to be one hundred per cent wholehearted about it. It's not like a football match where you can say, "Look you've got to run faster", and there's ten other blokes out there doing it. With boxing, it's only you and one other man in there. It's like being a gladiator, you're in face-to-face combat and there's no get out. If you aren't fit enough you'll be found out. If you haven't trained hard enough you're found out. There's no one to blame but yourself. So, I think you do have to give it total commitment.'

'When I walk into that ring I know I've got a job to do.'

'Are you licensed or unlicensed?'

'In kick boxing I'm licensed. In boxing I'm unlicensed.'

'Which is the most violent.'

'They're the same. To me it's a sport thing.'

'You're out there bashing somebody's head in, inflicting pain. Does it make you feel guilty?'

'No, because he's trying to do the same to me. I feel guilty when I've ate too many cakes and I know I shouldn't have.'

Shane is a good-looking geezer but, like everyone else in the fight game, he bears the reminders of everyone who's cut him. No matter how tough these guys are, they still hurt, they bleed. The marks remain.

'Would you change your looks if you could?'

'No. I think you're born with your looks and your life is written there. You shouldn't change it. You're faking if you do that.'

'Would you have plastic surgery?'

'If I needed it for some medical reason, yes. But not for anything else.'

He is as straight as they come.

'Do you think you need it?' I teased him a little.

Shane gave me a quizzical look. 'I don't know. I'll let somebody else judge that.'

'What gives you a buzz? Is it walking into that ring, is it the violence? What sets you off?'

'It has to be the training. It's a big part of my life, I love it.'

'How often do you train?'

'Four times a week. Coming up to a fight, maybe six times a week, sometimes twice a day.'

'It's a hard life. Is this what makes a man?'

Shane shook his head. 'No, a lot of people have a hard life. I'm choosing to do this. A lot of men have no options. A man is someone who isn't afraid to hold his hand up if he's wrong.'

'Admit his mistakes?'

'Yes, someone who is man enough to say, "Yes, fair enough, I am wrong." It's a person who can say sorry.'

> **'If you haven't trained hard enough, you're found out. There's no one to blame but yourself.'**

'Can you do this?'

'I like to think so. If I'm wrong I'll say sorry. When I look in a mirror no one is ever going to look back but me. I have to face myself, live with my actions.'

'If you weren't you, who would you like to be?'

'I'm quite happy being me.'

'A lot of people would look at you and say that you are a hard bastard. Because of what you do, the fighting. Who would you name as a hard bastard?'

'I can't think of any one name, Kate. It's someone who has problems with his family and gets through it all, or someone who loses the one he loves, like his wife, and survives the loss. I think that makes a hard man. It's a big

responsibility bringing up children on your own if you've been used to being with someone for a long time.'

'Do you have children?'

'Yes.'

'So for their sakes, as a husband and father, you have to juggle your life and stay one step ahead. How do you achieve this?'

'Clear thinking. When your time's up your time's up. You've got to know when to make the right decision and call it a day. And you do know. You know it in the gym before it even happens. I've made mistakes coming up to a fight. No one can stand up and say they haven't, we've all made mistakes. Anyone who says he hasn't is deluding himself. We've over-trained or prepared wrong or anything can happen. You know what I mean. So that's how you stay one step ahead, it's by knowing your limitations and keeping your fitness up.'

'A good answer.'

Shane is a man with a mind of his own and clear goals. So what lies ahead for him? 'If you went to see a fortune teller about your future and your past, what do you think she'd tell you?'

'I'd like her to tell me the truth.'

'What do you think she'd tell you?'

'I don't know. I've been to a couple and they've told me different things, so you have to work it out for yourself. I think a lot of them try to see how you react to what they say.'

'If you were eighteen again what would you do differently?'

'When I was at that age I wouldn't have changed a thing. It isn't an age for taking advice. Eighteen-year-olds think they know everything. It's only when you get a bit older that you realise that you don't know anything.'

BARRINGTON PATTERSON

KEVIN HOUSTON

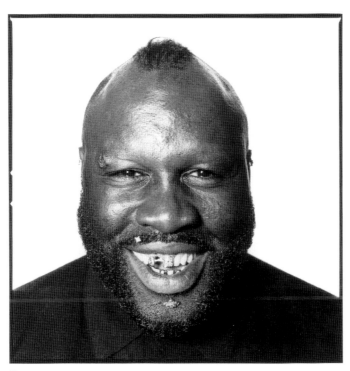

BILL

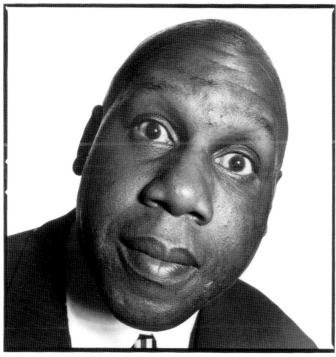

ESMOND KAITELL

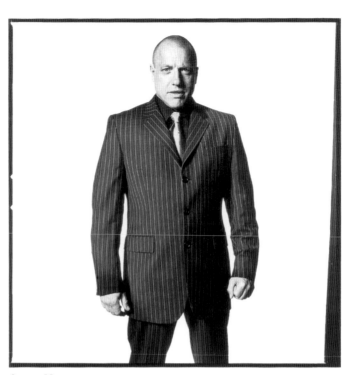

ALAN MORTLOCK

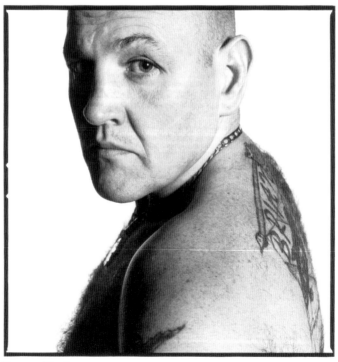

BRIAN MCCUE

BERNIE DAVIS

HUGH COLLINS

Kiane Sabet

Nigel

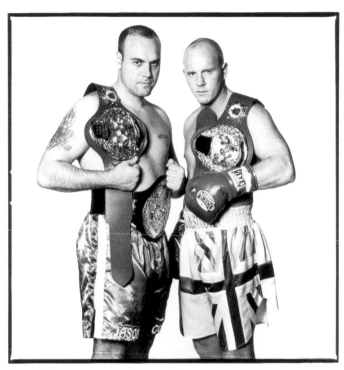

Paul Kavanagh and Jason Guive

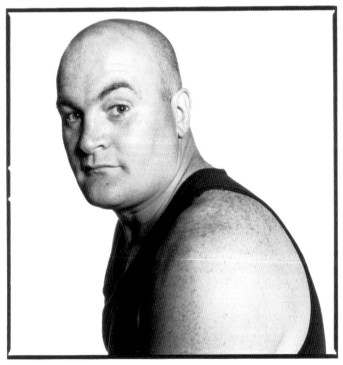

Shane Stanton

Andre Verdu

Stevie Knock

Joe Smith

Chrissy Morris

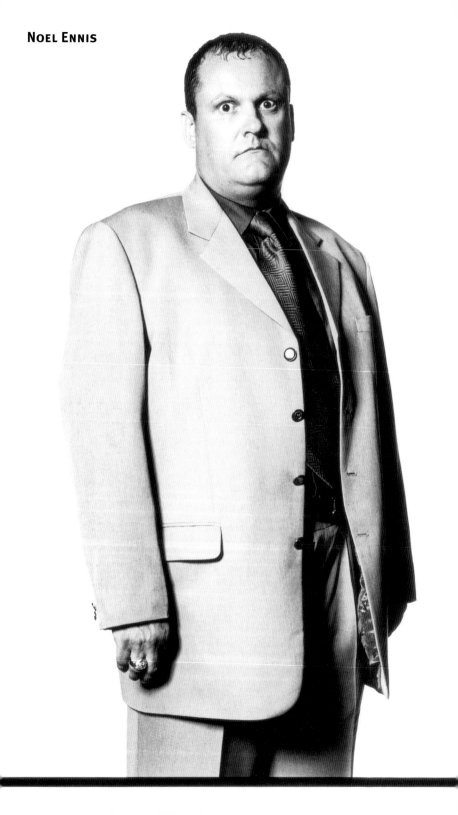

Noel Ennis

'If an eighteen-year-old came to you and asked your advice what would you tell him?'

'The truth. There's no point telling anyone anything but the truth. I would never lie to people. I always tell them the truth. They know exactly where they stand.'

'Sum yourself up in one word or sentence.'

'Honest.'

I couldn't help but like Shane. He is one of the most straightforward geezers around. He may be known as one of the toughest, hardest, meanest fighters on the unlicensed circuit, but he is as straight as a die. There is nothing devious about him whatsoever. What you see is what you get.

'Tell me a secret.'

He shook his head.

'No way. If it was a secret I would never tell you or anybody else.'

'Tell me a joke.'

Shane finished his drink. 'All right, here goes. There was this boxer who had a BMW. And he went out to get in it, when suddenly a car comes roaring along the road, comes too near and hits the door, ripping it off completely. When the police arrive this guy is as mad as hell. He complains bitterly about the damage to his precious BMW. "Officer, look what they've done to my car," he screams. The policeman isn't too sympathetic. "You boxers, you make me sick," retorted the officer. "You're so worried about your BMW that you haven't noticed that your left arm has been ripped off as well!" "Oh my God," replies the boxer, finally noticing his bloody left shoulder.

"Where's my Rolex?"'

I groaned. But there was a little grain of truth in it. A lot of guys do like their macho toys.

It was time to go. Shane left me at the door and disappeared into the crowds. There is a lot of depth to him, more than you would think at first glance. A straight-up guy with his feet firmly on the ground. Is there a conflict between his two different worlds? If so, it

'A man is someone who isn't afraid to hold his hand up when he's wrong .'

doesn't show. Mind you, he didn't give much away and isn't a man who wastes words. I walked to the kerb and put my hand up for a taxi.

But as for his sense of humour ... aaaargh!

Joe Smith
'The Travelling Man – "Joe Stockings"'

NAME: Joe Smith

DATE OF BIRTH: 7.6.71

OCCUPATION: Gypsy; Traveller; Unlicensed Fighter; Golf Professional

STAR SIGN: Cancer

'I was ready for them. I thought, When you lot come, it's smash, smash, smash. I'm going to get it anyway, so I'll take a few of you fuckers with me.'

JOE SMITH

'WHEN THERE'S THREE HUNDRED TRAVELLERS THERE,
YOU'RE FIGHTING FOR YOUR FAMILY'S NAME. YOU HAVE
TO SHOW A BRAVE FACE, EVEN IF YOU DON'T WANT TO.'

A posh Surrey golf course is an unlikely place to meet a true full-blooded Romany. But the geezer I had arranged to meet was no ordinary travelling man. Joe Smith is a top-ranking British professional golfer with hundreds of championship wins to his credit. Joe Stockings is a gypsy fighting man, famous for his bare-knuckle tear-ups at travelling sites, horse fairs and markets throughout England.

Two names, one and the same person. I walked across an immaculate fairway to catch up with a strong-looking blond-haired man on the first green. Would it be Stockings or Smith? There was only one way to find out.

'Hello, Kate, how are you?' We shook hands; he was polite, well spoken, conservatively dressed. I guessed it was Smith. 'Would you like to watch me play?' he asked, belting a straight-as-a-die shot at least three hundred yards. They say that golf is a good walk spoiled, but what the hell. It was a sunny day and I'd tag along.

'What part of the world do you come from, Joe?' Was it Epping Forest? Newmarket Heath? Maybe the horse fair at Appleby?

Joe smiled. He smiles a lot. In fact, he's a proper charmer who could dazzle the eyes right out of your head.

'I was born in west London. We lived in a caravan at Amworth for a while. Then did a bit of travelling round. My grandfather had bought some land at Amworth, so that was our base. Eventually we bought a house there.'

'Are you a gorger now?'

Joe laughed. 'No way. It's a bit like – you can take the boy out of the caravan, but you can't take the caravan out of the boy. That sort of scenario. You are what you are. I'll never change.'

'Are you a proper Romany?'

'Born and bred.'

'Gypsies are known for liking a ruck but being able to look after themselves. Has your life ever been threatened?'

Joe nodded.

'I would say so. I've had blades pulled on me, firms turning up with shooters. You don't want to be a target, but sometimes you can't help it. They try you out. See if you're going to fall.'

'Have you been stabbed or shot?'

'Yes. Both. I've been stabbed, but fortunately it's been flesh wounds. I heal quickly. And I've been shot at, but they've missed. Nothing serious. In two fights, on different occasions, I was stabbed and shot with – thank God – minor consequences. Either they've been poor shots, or it's because I've been too quick for them.'

'Have you ever been in the nick?'

He shook his head. 'No, I've been remanded but I've always managed to get to the other firm. Straighten things out. That's what makes me angry, they put it on you and

then you go give them some of it back and then they go to
the Old Bill. A lot of bullies about.'

'You're a golf professional. Isn't that a strange thing for a
travelling boy to be?'

He agreed. 'I'm the only one out there. Most of the guys
are tarmaccers or roofers or they do a bit of this and that.
Not many play golf.'

'How did you get into it?'

'I started playing along with my dad and granddad.'

'And do you like it?'

'It's a great life.'

'Do you play full time now?'

'Yes and no. I do the fighting as well.'

'Is that unlicensed fighting?'

'Yes, but it's with gloves on. It used to be bare knuckles,
any time, anywhere. It's what travelling boys are famous
for. It's a bit like our national sport. People associate us
with being behind the times. It doesn't happen so much
in London, but if you go down to Kent and places like
that, they're still thirty or forty years behind the rest of
the country.

'Before the turn of the last century, the only real way to
find out what anyone was made of, or to settle a dispute,
was with bare fists. I think we just tended to carry on the
bare-knuckle scene. If you had a difference or a problem,
then that's how you settled it.'

'What do you do? Do you still go to a field and have a bit
of a tear-up?'

'Yes, that's how it happens. That's not a free-for-all –
that's in close quarters, a bar or somewhere similar. An
organised fight will be in a field, but it's man to man and
more than one fight going on at the same time.'

Joe concentrated, gently tapping the ball with the putting

iron. Straight in. It was a long shot but he was good, no doubt about it.

'Is it harder fighting in a field than in a ring with gloves on?'

Joe leaned on the golf club, studying his answer.

'It has two sides to it. You're both fighting. But in a boxing ring, if you get a nasty cut – say ten or twelve stitches – then you have a doctor and a referee to look at it. So then you're assured. The fight won't go on if you're in any danger. You don't get that in bare-knuckle fights. When there's two hundred or three hundred travellers there and you are fighting for your family's name – not only your own name, your family's history as well – and you've got a cut needing twenty stitches in your eye, and your nose is broke and your teeth are out, then you've got no doctor or referee to say "Go back to your corner." You have to show a brave face even if you don't want to. In a boxing ring, you can say "I want to carry on", knowing that the doc and the ref will say, "No son, I'm not letting you." But out in the field you have to make the decision yourself and risk getting killed or losing face.'

'So, you have just got to fight till you stay down?'

'Yes. I've had fourteen stitches and a broken nose just in the one fight. I've lost a lot of blood, two pints once. In a boxing ring it would have been stopped. But in a field I wasn't going to stop no matter what happened. Lesser fighters tend to say, "I'm cut bad, I'll opt out." That's where it tends to sort the men from the boys. Who is the bravest fighter? That's what you're out there to find out. Who is the bravest?'

'Out in the field you have to make the decision yourself and risk getting killed or losing face.'

'What about the woman's role in a gypsy family? Do they go along to watch?'

'Yes, they often do. If it happens at a horse fair or a travellers' site the woman would jump on a wagon and watch it no different to how you'd go to a boxing show. They wouldn't travel in cars to an organised fight.'

'That's men only.'

'More or less. But at a fight in a field you sometimes get two or three women turn up and they say, "Come on, where's your wife?" Or "Where's your sister? Come on get her out, let's have a go."'

It sounded like the women were as tough as the men. Joe agreed.

'They're there to fight as well. I've seen my sisters fight. They've come to watch me fight and they've started something and it's been a proper ruck.'

One thing I wanted to ask Joe was why, in this hi-tech era, travellers still have so many coloured horses.

'What is this thing with horses? Why do you buy them? Do you swap them or sell them? What is it?'

'It's going back to the old days. My people had no transport except the horses, so they were very important to us. Now it's mostly a status thing. They make a bit of money out of it, buying and selling, having a deal. Some of the old travelling boys like their horses so much you couldn't give them a pension to make them give them up. It's their way of life. A hobby, passion, money making.'

Joe is proud of his heritage.

'Who do you love most in all the world?'

He chewed on this for a minute or two.

'I don't want to upset anybody, so I'll say my dad.'

'What's your happiest memory?'

'I've lots of them. Probably when my son was born – he had a flat nose, just like me and the rest of the family. And

my dad was winking his eye to me – that was a good moment, like he was saying, "You've got it made now, son. You're a man now."'

'What's your son's name?'

'Rhymer.'

'That's unusual.' I liked it.

'It's after my grandfather's nickname – he was "Rhymer" John Daley.'

'And what's your worst memory?'

Joe stopped walking, looking down at the grass.

'It was when I lost my grandfather. It was on a golf course. He was watching me play.'

'He died a happy man, though.'

'Yes, but it was very sad.'

Joe took another shot and slammed it nearly to the next green.

'What makes you angry?'

'Apart from the obvious people, like nonces and perverts, I don't know really. I don't like disrespect or when people think they're on a different level. When they don't think you're even Steven.'

'Does anything frighten you?'

'I don't like looking down the end of a barrel.' Does anyone? Joe went on. 'My biggest fear is – and I don't even like to say it – "top hats".'

Hmm. Ascot's out, then. I was a bit puzzled. This seemed irrational even for a traveller. 'What do you mean, Joe?'

'Long tails. Rats.' He shivered. 'There, you've made me say. I'd fight Mike Tyson sooner than face one of them.'

That did surprise me. 'What's the most frightening thing that's ever happened to you?'

Joe shook his head. 'I dunno. There are loads of things. So many times when I've thought, Fucking hell, I wish I was out of this game.'

'Has there ever been a time when you thought you were going to die?'

'Yeah. When you're facing twenty blokes and you've had a cosh on the head and you're on the floor ... your life flashes in front of you. You're thinking, What the fuck am I doing here? There's been a few times like that.'

'Can you tell me about one?'

'I was in Spain, in a bar, and facing the Lithuanian Mafia. They were six handed and crowding me in. I couldn't go anywhere, my mate was making a phone call and he had the car keys. All these guys were coming towards me and they had blades on them. I moved towards two little old German boys sitting at a table – I knew they wouldn't be much use to me but I wanted the company. Then I saw a great big heavy ashtray and I thought, If I go down, I'm going to go down with a bit of something. Then I noticed a mirror and I thought, OK I'll check the mirror – it was like all in slow motion. And I was ready for them, I'd psyched myself up for it and I thought, When you lot come, it's smash, smash, smash. I'm going to get it anyway, so I'll take a few of you fuckers with me ...' Joe positioned himself for another shot.

'And ...' The ball landed smack bang in the middle of the green.

'They weighed it up. They knew I wasn't going to be a pushover. If I went I was taking some of them with me. And I think they just weren't angry enough. My mate came back, they backed off and we legged it for the motor. They were happy to let me go.'

'What makes you feel guilty?'

'I don't ever feel guilty. There's no point. You do what you have to do and that's it. No good crying when it's over. I'm mad at myself if I don't train hard enough or practise at my sport, or when I go on the booze, but that's it.'

Joe doesn't look anything like the traditional image of a dark-haired Romany; he's Viking blond and blue-eyed. Is he happy with his appearance?

'If you could change your looks, would you?'

'No. I wouldn't change anything. No plastic surgery. No way.'

That was definite.

'What makes a man?'

'Giving respect to people, putting yourself in the position that other people are in. Don't do to others what you wouldn't like to be done to yourself.'

His answer to my next question surprised me.

'What gives you a buzz?' I thought it would be something to do with fighting.

'Getting on the first tee in a golf tournament. I've had some real good buzzes playing golf.'

'What about the bare-knuckle fights?'

'Sure, that's a great buzz – when you win. But achieving and doing well at golf is better than anything. Better than any drink or drug. I've dabbled here and there like most people, but I've never had any buzz like the natural buzz of achieving success in sport.'

Brilliant answer.

'Name a hard bastard.'

He came right out with the answer. 'Andy Till is one of the hardest men to hit London town. He's been around for thirty years. There's never been anyone to touch him.'

'Is he still active?'

'Yes. Still young, still active. He's a former British WBC Champion but he was twenty times harder out of the ring than in it. And he was a lunatic in it.'

'You've survived and made it in two absolutely different worlds. How do you stay one step ahead?'

'I have a little half-hour think on my own sometimes. I go

for a walk, go up the fields, and sort things out on my own. I have a look round. Have a look at people, look at situations, weigh things up.'

'Are you more of a thinking man?'

'Definitely. I'm not eighteen any more.'

This led me into the next question. 'And if you were eighteen, what would you do differently?'

'I wouldn't look up to names and faces because they had a fancy reputation. That's what most youngsters do. They're impressed by appearances. I'd say, "Don't go there, don't do it. They only want you to do their dirty work. Just be the nice guy and keep out of trouble. But if anybody starts on you, then do what you have to do."'

'I thought, if I go down, I'm going down with a bit of something.'

Sound advice. 'If you were to see a fortune teller, what do you think she would tell you and what would you like her to tell you?'

'I'd like her to tell me that I was going to be a successful golfer and a successful boxer. That me and my family were going to have a nice healthy life and live to three score and ten or plus.'

'And what do you think she would tell you?'

'A load of bollocks to get my money!'

We both laughed.

'Sum yourself up in one word or one sentence.'

'I'm an easy-going man until somebody wants to try me, then ... then ... Let's just say, I'm a completely different person.'

'If you weren't you, who would you like to be?'

'Dean Martin.' I didn't expect that answer. 'He's not with us any more but I liked him.'

'Why?'

Joe gave me a charming jack-the-lad grin. 'Singing, drinking, boxing, playing golf.'

He'd left something out. 'And a womaniser.'

Joe shrugged. 'Well, I'm a man.'

One hundred per cent alpha male.

'Tell me a secret?'

'Well ...' He thought about it for a minute or two. 'Go on, then. I've got an injury in my right hand and I'm not telling the other fighters in case they take it as a weakness.' Joe has a sense of humour. I didn't believe him for a second.

'Tell me a joke.'

He had one ready. 'This old geezer's lying on his death bed and his old woman comes to visit him. His name is Manny and he says to her, "Gloria, I'm on my death bed and after all these years you've stuck with me." She says, "I have." And he says, "Gloria, I was having it off with that young bird in the village and then she left me and you stuck with me." She says, "I did." And then he says, "Gloria, I made a million pounds in business and then I lost it, and you stuck with me." She says, "That I did." And he says, "I went to war and lost an arm and a leg and you still stuck with me." She says, "I did." "Now, I'm on my death bed, you're still by my side. Why don't you just fuck off, you're a fucking jinx!"' Joe was still laughing as he took the last putt. Straight in. Nine holes. It was enough for me. Joe walked back to the clubhouse with me.

'If anyone starts on you, then you do what you have to do.'

'I didn't think I'd be able to understand you, Joe.'

He nodded. 'Yes, I've been a golfer for ten years and somebody said to me, "Bloody hell, you talk like a gorger." I asked him what he meant. He said, "Good shot, great, well done mate." I told him, I can't say, "Kushti chavvy don't rocker the pooker" when I'm on the next tee, can I?'

Joe can swap between his two worlds at a minute's notice. Black-and-white horses, deals, fist-fights, markets and gypsy gold is one life. As an outsider I would never gain acceptance there. But Joe had successfully made it to the top in the straight-laced, rule-bound, gin-and-tonic world of the nineteenth hole. Well done. After all that walking, I was looking forward to having a sit down with a long drink and maybe a bar snack but when we got to the door, Joe turned to me with a bit of a grin. 'Sorry, Kate, I'll have to leave you here.'

He pointed to the notice. It said 'No Women. Members Only.'

JASON GUIVE
'THE GUVNOR'

NAME: Jason Guive

DATE OF BIRTH: 11.10.72

OCCUPATION: Super Cruiser Weight British Champion and Super Cruiser Weight World Champion – Unlicensed

STAR SIGN: Libra

'When I start something I finish it. If someone's wanting to put me down, they'd better make fucking sure I stay there, because if I get up again, they're gonna have to watch out.'

JASON GUIVE

'I'M NEVER LOOKING FOR A FIGHT, BUT WHEN I GO, I GO'

Using clenched fists in aggression or self-defence is a human activity as old as mankind itself. From the beginning of time men have been proud of their ability to fight and the man I was about to meet wasn't nicknamed 'The Guvnor' – after the late, great Lenny McLean – for nothing. I had arrived early at the gym in north London, so that I could watch Jason Guive sparring. The place smelled of cheesy feet and rubber mats. There were four boxing rings and Jason was already hard at work in the centre one. As I came in, his opponent went to the blue corner, Jason to the red. They both sat down on little stools and started rinsing their mouths, swilling water and spitting into a bucket. Neither of them wore head guards – this is a rugged game and they looked ready for anything. After a few minutes they were back on their feet, weaving

and jabbing again. Jason's sparring partner was a journeyman, an ex-fighter who was there solely to sharpen him up and keep him on his toes. From what I could see, the champ didn't need it.

Five hard, sweaty, vigorous minutes later and it was time for a break. 'That'll do. Out you come,' the trainer growled. They dropped their gloves reluctantly. Jason climbed through the ropes and came over. He held up his fists, 8oz gloves and all. 'Sorry I can't shake hands, Kate.' He still looked fresh and sharp, even though his vest was streaked and his skin damp. Jason is a fast and hard fighter with a lightning right hook and a knock-out punch. As reigning British and world unlicensed super-cruise weight champion, he is the best there is. He nodded across the room and a young lad, the gym gofer, dashed up to unlace his gloves and unwrap his bandages.

'It was like a fucking war zone. They were laid all over the place, blood, guts, broken bones.'

Jason beckoned me across to the drinks machine and handed me a glass of mineral water. 'Shall we sit down?'

Jason sprawled on the bench, I pulled up a stool. I felt a bit out of place. I could almost taste the testosterone in the air, the full-length posing mirrors, punch bags, speed balls – this was macho-man stuff and Jason is one hell of a solid, mean, macho guy. I took a sip of my water, it tasted cold and good. All I had to do was try to suss him out. What makes this 15-stone, suntanned, supercharged bruiser tick?

'What about your nickname, Jason? Why "The Guvnor"?'

He shrugged shoulders that looked as solid as the Rocky Mountains. 'They say I look a bit like Lenny McLean and I fight like him. I take it as a great compliment. Although I think I'm better looking.'

'Tell me a bit about your background, Jason. Where were you brought up?'

'On a council estate in north London.'

'Were you a nice little kid?'

'I don't know about that. I was a real roughy toughy.'

'Did that get you into trouble?'

He nodded. 'Yeah. Lots.'

'Ever been to prison?'

'No, I've managed to stay clear of that experience.'

'What about violence? You can obviously look after yourself, but has anything really dangerous ever happened to you?'

Jason's eyes flickered. So far he seemed to be choosing his words carefully.

'You've got to understand that in my line of work, it's part of everyday life. I've done a lot of door work and that's what it is – sorting out the crap. You either deal with it or you're in the wrong job.'

'Has your life been threatened?'

'Yes. I've faced stabbing and geezers have pulled a gun on me.

'And ...'

He gave me a hard look. 'I'm still here, aren't I?'

'What was the worst moment?'

Jason thought for a moment.

'When I was walking back from a pub one night. You get a certain reputation in this game. It's inevitable that people want to take you on. It's not that you're looking for trouble – it just jumps up and smacks you in the chops. I was with a couple of pals and we'd stopped off to get something to eat.'

'Nothing wrong with that.'

'That's it, Kate. But how it ended up was with us having a fight with fifteen geezers who came up out of nowhere.'

'Three against fifteen?'

'Exactly. It was tough going, even for me.'

'Did you get hurt?'

Jason touched the top of his head.

'I got my skull bashed in with a baseball bat.'

'Did you think you were going to die at that moment?'

'No.' Jason looked at me as though he thought I was mad. 'But he did.'

'You took them all on?'

'I did a bit of damage. When I start something I finish it. If someone's wanting to put me down, they'd better make fucking sure I stay there, because if I get up again, they're gonna have to watch out.'

'Did you go for them?'

'It was like a fucking war zone. They were laid all over the place, blood, guts, broken bones. No kidding, all you could hear was them moaning – the ones that hadn't run away, that is.'

'They didn't come after you again.'

'No. They'd made a mistake the first time and they learned their lesson.'

'What's the weapon of your choice?'

No hesitation. 'My hands. I use them first and think later.'

'Is that an instinctive reaction?'

'Yes. Gut instincts are what you need to keep on top of things in this game.'

'So, what's it all for? You're putting your life on the line; you're risking your neck every time you go to work. Who's the most important person to you, who do you love most in all the world?'

Jason's face lost its gritty expression. He got up and went to a locker and came back with a photo. 'Here.' He held it out. It showed a pretty young woman who was holding up a curly haired little girl. 'My wife and daughter.'

'She looks like you,' I told him. His chest puffed out with

pride. 'What's your happiest memory? Is it from your child-hood or winning a championship?'

Jason shook his head. 'No, I've had some good times but the one that sticks out is when my wife gave birth. Nothing can touch that moment.'

'And the worst?'

He looked down at the floor. '... was when my grandfather died. That's when you know that no matter what you do or what you've won ... how much money you have, or how hard you try, you can't change a damn thing.'

The gym was empty now. I could hear the showers hissing, snatches of conversation and car doors slamming outside. The afternoon session was over. Jason got up to look out of the window. 'Are you wanting to be off?' I asked him.

'No problem,' he said. I looked out as well; there was a brand new Range Rover with personalised number plate parked by the door. I didn't have to ask whose it was – GUV 1, it could only be Jason's. But for the time being he seemed to be in no hurry.

'What makes you see the red mist?'

He pulled a face. 'Ponces.'

'Is there anything out there that frightens you?'

'Nothing, except losing a fight.'

'What's the most frightening thing that's ever happened to you?'

'I dunno, it ain't happened yet.'

Jason is as hard as nails.

'Does anything make you feel guilty?'

'No. I don't do guilt.' He crossed over to one of the full-length mirrors and began shadow boxing, watching his actions.

'Would you change anything about your looks if you could? Would you have plastic surgery?' He stopped for a moment, seeming genuinely puzzled by this. Look at me, what a hunk!

'Change anything? No, why would I? Whatever you changed on the surface, it wouldn't make any difference to what's inside, so why bother? I like being who I am.'

'What gives you a buzz?'

His face cracked into a smile. 'Fighting. That's what I like best. That gives me a real buzz. I'm never looking for a fight but when I go, I go. I think I'm a bit of a shit magnet, I do sort of attract it.'

'Like the last gunfighter?'

'Yeah. People want to take me on. They wish they hadn't afterwards, though.'

This man is supremely confident of his own ability to face anyone and sort any situation.

'What makes a man? Is it this sort of life, fighting, being tough?'

'It is in a way, but what matters most is supporting your family and looking after the people who are important to you. That's what makes you worth something.'

'If you weren't you, is there anyone else you'd like to be?'

He stopped boxing and flexed his muscles.

'My missus, then I could go out with me,' he grinned.

It struck me that Jason was fairly obsessed with himself because he had to be – his fists and his strength are what it's all about. It's how he earns his living, makes a name for himself, gains a reputation. It's not like having a business or a career or a separate lifestyle, there's only one person can do it for Jason and that's Jason himself.

He fetched himself another Styrofoam cup of mineral water and sat down again.

'You must meet a lot of hard bastards. Can you give me a name? Who's the toughest you know?'

There was no hesitation. 'Roy Shaw, it has to be.'

'Why?'

'Because he's fucking brilliant. I saw him a few weeks ago when I was doing a charity show. What a geezer.'

I knew that Roy was involved in raising money for good causes to do with children. 'So you do your bit for the kids as well, do you?' Jason has another side to him, but he keeps it well hidden.

'Yeah. When I'm fighting I make sure that some of the money always goes to help sick children. We had a bit of a do at my pub and Roy came down to support it. It was a good night. We raised £4,000.'

'That's a lot of dosh. Brilliant.'

'It's what it's all about.'

Jason has his life sussed out. He's mean, he's tough, but at the same time there are compensations; he has struck a good balance. But in this game there can be no slip-ups, no second chances. 'How do you stay one step ahead?'

'By being like Roy.'

'What do you mean?'

'I have to get up a bit earlier than the rest of them.'

'Why Roy?'

'Because he's done it. He's got it made. Roy came up the

'What matters most is supporting your family and looking after the people who are important to you.'

hard way. He's made a few quid and he's very respected. You wouldn't mess with him, even now.'

Especially now, I thought to myself. 'If you were to see a fortune teller and you wanted her to tell you what had happened in the past and what was going to happen in the future, what do you think she'd say?'

Jason studied this for a minute or two.

'I think she'd tell me that I'd done what I had to do. Not everything I'm proud of, but at the time I had no choices. I'd like her to tell me that I'm going to be rich. And I think she would tell me that.'

'Is that right?'

'Definitely.'

'Anything else?'

'I'd like her to tell me that I'm not going to do any bird.'

'If you were eighteen again, what would you do differently?'

He shook his head. 'Nothing.'

'Sum yourself up, in one word or sentence.'

'Sad but hard.' I thought this was a bit unusual for a man who appears to have everything going for him.

'Will you tell me a secret?'

His answer snapped back. 'I ain't got none.'

'Would you tell me if you had?'

'Sure.'

Oh yeah. Would I do better with his sense of humour? 'Tell me a joke.'

Jason got up and walked over to the speedball. 'I don't listen to jokes,' he told me. 'I haven't the patience.' He began jabbing at the ball, lightning punches, and non-stop. The door was opening and closing non-stop now too: the gym had begun to fill up again. It was getting crowded with the evening session of sweaty blokes – maybes, wannabes and has-beens. This is a violent and aggressive scene, but all these men seemed to me to be looking for an escape route – it isn't just the money or the fame. Is it to get away from their backgrounds? Or to get rid of all this pent-up aggression? Some just want to learn how to protect themselves and their families. Whatever it was, Jason wasn't going to give me any more.

The air was once more thick with testosterone, noisy, yelling, thumping; it's a tough, hard world. I called out to Jason that I was going. He gave me the briefest nod, without pausing in his jab-jab-jab. That was it. I swung the door open and stepped outside into the fresh air. It felt good.

CHRISSY MORRIS
'A CHARMING ROGUE'

NAME: Chrissy Morris

DATE OF BIRTH: 17.11.74

OCCUPATION: Managing Director
Security Company; Kick Boxer;
Unlicensed Boxer

STAR SIGN: Scorpio

'One time I had a shooter pulled on me. When it actually happens, you just stand there and think, Oh God, why didn't I see this coming?'

CHRISSY MORRIS

'IF TODAY'S FIGHTING MEN HAD BEEN BORN
HUNDREDS OF YEARS AGO, THEY'D HAVE BEEN
GLADIATORS AND SHARPSHOOTERS.'

Southend Pier is all right on a warm, sunny day, but when there's a north-westerly wind blowing, it's not the place to be. Chrissy Morris was there before me, jogging up and down to keep warm. We shook hands and I pulled the collar of my coat up. The sea was churning white foam and crashing against the pillars; the fresh breeze was tingling my cheeks – it was fresh, bracing, invigorating. We headed straight back for the cafe in the amusement arcade.

'That's better.' Chrissy fetched us both a nice hot pot of tea. 'Is this home to you, then?' I asked him.

'I was born in Leytonstone, so I can call myself a cockney. But we moved down to sunny Essex when I was in my teens. I've been here ever since.'

'What about school? Did you enjoy it?'

Chrissy shrugged. 'Not much. I was expelled from three

schools. Mostly for fighting. The teachers called me a rough diamond, which was quite nice.'

I could see what they meant. He is a talkative and likeable fella.

'You started a rough diamond, now you're a diamond geezer.'

He smiles easily. I guessed that Chrissy could charm the birds out of the trees.

I was going to try asking him some serious questions.

'Have you ever been to prison?'

He shook his head. 'No. I spent a little bit of time in local authority care when I was a kiddie. But I sorted myself out quite quickly and I like to think I'm the better for it.'

A positive outlook.

'Have you ever been threatened?'

'Yes, most weekends.' He sounded resigned.

'When you're working the door?'

'That's right. I have my own security firm. If you're not watching out there's someone trying to kill you Friday, Saturday and Sunday.'

'Have you ever been stabbed or shot?'

He shook his head. 'No, I've had a couple of people go for me with blades but I've come out on top. I've had a couple of shooters pulled on me but I've been all right there as well. I've invested in a £500 bullet-proof for when I'm working in dodgy places.'

'Do you wear it when you're on the door?'

'Most times. If I think there's half a chance the local idiots will be carrying, then yes.'

'Whereabouts do you work?'

'The clubs all round Essex and London. I do the doors all through the outskirts and Romford way. The thing is now that little college idiots can come out of school and get a door badge and pretend they can handle it, and the reality

is that they've never done anything in their life. They've had a very protected time of it. They don't understand what it's like to deal with shit people. You see, the door staff are really there for ten per cent of the punters. Most of the people are well behaved. But ten per cent of them don't understand anything but violence, so that's why you're there.'

'What's the most violent thing that's ever happened to you?'

Chrissy rubbed his chin; he has a tough, battered boxer's face.

'Oh, now you're asking. I've been in scrapes that have come straight out of *Braveheart*, everyone getting stabbed all round you, blood and guts all over. A few years ago, working in a club in Romford, we had a running battle with a group of fellas and the bloke standing next to me got slashed and he didn't even know it. I saw the blade go in him, so I spun him out of the way and stood up to the geezer, but lucky for me he headed off on his toes.'

'A lot of men have told me that when they've been stabbed or shot, they didn't know it till afterwards. Do you think that's right?'

'Without a doubt. The adrenaline's flowing. I've been hit with a few heavy weapons. You're aware of a clonk, but other than that you have your mind focused on the job in hand. In a lot of the rumbles on the street, you focus your brain on the fella in front of you and it's basically a bit like tunnel vision. You've got it in your mind that you're not going to get hurt. But you definitely ache the next day. Yeah, I've done all that.'

'What would be the weapon of your choice?'

'Very difficult to say. One of the best little defensive things you can have is gas. Or a gel spray.'

'What's a gel?'

'It's the same as CS gas but it's a little bit more accurate. Whereas the gas goes out in the air, the gel comes out like shaving foam, so you can actually pick your target. Years ago, when there was only gas, if you let it off, the whole room got it. With gel you can hit a specific spot and walk away from it. You can still hit the whole room if you have to, it gives you a little bit more time and you can be a bit more fussy. Gel is a good one, because that way you're cutting down the distance. Obviously you don't want to be too close to people. On the other hand, gas is good because you can get them from six to ten feet away. You don't even have to get near them.'

It was a long way from the pepper pot I used to keep handy when I was living on my own. Chrissy had his strategies for deterrent well sussed out.

'There's an awful lot of cocaine in pubs and clubs and you'd be surprised at what it takes to put an average man away these days. If they've been putting it up their nose all night, you might literally have to break them to put them down. I've bust my hand so many times on these little charlie idiots. You think to yourself, Poor little fucker, because basically you've smashed them right up – even though you've done the minimum you can do without them coming back at you. They don't feel it if they're charlied up. That's it exactly, they just keep coming. A few of them, you have to just keep banging away at. Nothing stops them. You cause them more damage than you need, but on that night they've got to be hurt because they just keep coming back. It's you or them; they don't feel anything.'

Chrissy survives on a tough circuit. I changed the subject.

'Who do you love most in all the world?'

'It's got to be my mum. She's my little washing fairy.'

'What's your happiest and worst memories?'

'Happiest memories are things like having a day out at the seaside. Christmases when I was with my family. And worst memories ... I've got so many that I could fill a book.'

'What makes you see the red mist?'

Chrissy shook his head. 'Nothing much these days. I think you get de-sensitised if you are used to trouble out on the street and on the doors. What will get your blood boiling one year, it'll come round again a bit later and your heart will hardly skip a beat.'

'Does that make you a bit complacent?'

He nodded. 'Yeah. There's great danger in a way, because the average idiot on the street, he'll have one fight a year. So when he does get in a situation that's about to go off, he'll be up for it. While you are working the doors and seeing it every weekend, you get accustomed to it, and the thing is you'll go to grab someone and throw them out one day and you realize that they might be a little bit more of a handful, or they've put a little bit too much of the stuff up their nose. And all of a sudden you think, Oh God, why didn't I take it easy on the guy from the start?'

'Do you think that when people are taking drugs in the club scene, it makes them mellow?'

'If you've got a thousand capacity club, I'd rather see a thousand people smoking puff than drinking beer. The only time the puffies are worth a fight is if they can't get to the front of the queue in the twenty-four-hour petrol station to get their munchies. Whereas the beer boys all want to shout their football songs, kick shop windows in as they go home and have a fight in a kebab shop. The worst drug out there is the cocaine because it's so easily accessible nowadays. Whereas the older lads know what they're doing – they can do a bit, have a good laugh and they're all right on it – the younger boys literally just have it thrust on them. They're

using pubs and clubs that the older boys are in and basically what they do is put a load of the stuff up their nose without realising the consequences of their actions. That's where they come unstuck. Sooner or later they hit reality. Or people like me.'

'What frightens you?' I was expecting Chrissy to say people with guns or knives, but it was an experience on holiday that had made the biggest impression on him.

'Sharks. Great white sharks.'

'Not off Southend Pier?'

'A bit too cold. I went on holiday to South Africa last year and me and a pal went out to see the sharks. We put diving suits on and we went into this old cage and they lowered us into the water and we waited and waited – it was very scary.'

'What happened?'

Chrissy laughed. 'They never showed! And boy, were we pleased. So I went out and did the highest bungee jump in the world. That was something.'

I get dizzy standing on a chair. 'Is that the most frightening thing that's ever happened to you?'

Chrissy shook his head. 'No way. A couple of times I've thought, Oh shit, I'm not going to walk away from this one. One time I had a shooter pulled on me. You think to yourself, I'll do this or I'll do that, but when it happens, you just stand there and think, Oh God, why didn't I see this coming? I never ever let anyone put their hands in their pockets now. If I've got a problem with someone and they go to put their hands in their pockets, I'll have a go at banging them straight out. I remember the time when I looked at the geezer and thought, You ain't gonna have nothing on you. My brain was telling me that – 'course, when he pulled his hand out of his coat I thought, Oh shit. Why did I let him do that?'

I fetched us another pot of tea. These were tense memories.

'Do you think when you've been on the door for a long time, you get a little bit paranoid? Maybe it helps.'

'Yes. Being paranoid isn't a bad thing. There's a good little saying – "just because I'm paranoid doesn't mean they're not after me!" Another saying I like – "some days you're the dog, other days the lamppost!" You know what I mean.'

Most people would have felt the same at one time or another. 'What makes you feel guilty?'

Chrissy stirred the sugar round.

'Not much. As far as violence goes, I'd always say that I've never given anyone more than they deserved. The thing is, when you're working the door, doing it to a professional degree, and also doing security work, a guilty man wouldn't last ten minutes. Basically it's just a cross you have to bear. If I've tried to do my mates a good turn and it hasn't come off, even though it's through no fault of mine, I might feel bad about it.'

'If you could change your looks, would you do so? And would you have plastic surgery?'

Chrissy considered this carefully. His face bears a lot of scars.

'No,' he said, 'I probably wouldn't. I'd get my teeth brightened. I've broken my nose more times than I can remember, but I think it gives me a bit of a roguish charm.'

Roguish charm, eh? 'What gives you a buzz?'

'Fighting. Any man that says that violence doesn't

'Sooner or later they hit reality. Or people like me.'

give him a buzz has got to be lying. I'm not wishing to be violent, because I'm not a violent person. If I feel aggressive

I'll go down to the gym and train, I won't pick a fight with anyone.'

'Does training get rid of your aggression?'

He clenched his fists. 'It doesn't get rid of it, it keeps it manageable. A lot of people look at us and think we're thugs, but you have to remember that this planet is still spinning, and if you think how long men and women have been on this earth, then it's only two minutes on an evolutionary scale since we were bashing each other on the head with mallets. We were cave men. The men who fought were the survivors.'

'Do you think this is in most men?'

'Yes. It definitely is. Some men more than others. Nowadays it's hidden by modern life, manners and nine to five and computers. If today's fighting men had been born hundreds of years ago, they'd have been Roman gladiators and sharpshooters. Violence is a dying trade. It's not acceptable any more. But someone has to do it.'

There is a lot more to Chrissy than you would think at first glance. 'What would you have been if you hadn't been a fighter?'

'Probably an old-fashioned boxer. I wanted to go pro but a few medical problems prevented me. The thing I would say to people is that I've never claimed to be the best fighter on the way out there, but when I'm really up for the fight, I love it. If you ask anyone in unlicensed boxing about me, they'll tell you how nervous I get before a fight. I literally get chilled out before I go in. A little bit of nervous energy doesn't do you any harm. It makes you a better fighter. If you get too relaxed you won't be up for it.'

'What makes a man?'

'Someone who has humility. It's so easy to be a bully. The toughest blokes I know, and the hardest, are complete

gentlemen until they get pissed off. It usually takes them a while. Anyone can shout and rant and rave.'

A brilliant answer.

'If you weren't you, who would you like to be?'

'I'm happy being me.'

'If you were eighteen again, what would you do differently?'

Chrissy didn't have to think for a second. 'Education. I'd get an education. I can't complain about my life right now because I have a lot of good friends around me. My old man used to say that if you could count five friends on your hands you were doing well. I'd have to take my shoes and socks off right now. But I wish I'd had the chance of education. I look around me and see people who have a lot more than me materialistically and they aren't any more intelligent than me and I thinkif I'd done my fighting in my brain, and had put my head down and studied law or medicine, then I'd have been a lot better off.'

'So is that the advice you'd give to an eighteen-year-old?'

'Yes, educate yourself. I have my own gym now and I train a lot of youngsters to box.'

'What's it called?'

'It's called the Champions Gym, in Colchester. What I say to the youngsters is – stay out of trouble. It's real simple. And if you can't stay out of trouble, when you get nicked get a good solicitor!'

'You're a hard man yourself. Who do you look up to, who do you think is a hard bastard?'

'Endless ones. There's always another round the corner. Other people can say someone's a hard fucker. But having said that, if you can get someone's eyes, you've got him. If you got Mike Tyson in front of you and you got his eyeballs out of his skull, he'd be a goner.'

I took a quick gulp of my tea but Chrissy hadn't finished yet.

'By reputation, the hardest man to deal with would be a fella called Chapman. A man mountain, he knows what he's doing and he's done it for years.'

'What does he do?'

'The door at a night club called Cartouche, it's in Ipswich. I've met Lee a few times and worked with him. He's a legend. Another hard bastard would be one of my good friends, Russell Smith. He could hurt any man. For aggression I'd go for a fella called Stewart Easton. There's another man called Gary Mitchell, a wrestling man and he can box a bit as well. I can honestly say that if he took anyone to the floor the fight would be finished, with him on top. He could take down almost any man I've met.'

'How do you stay one step ahead?'

'Treat people how you would like to be treated. Always be fair, always be upfront. Always train ... and try to see what's coming round the corner.'

Good advice.

'If you went to see a fortune teller and asked her about the future and the past, what do you think she would tell you and what would you like her to tell you?'

'I think she'd say that my life has been a struggle but that I've come through. What I'd like her to tell me is the string of numbers to put on the lottery this weekend!'

'Sum yourself up in one word or sentence.'

Chrissy studied this one out. 'Loyal. I always try to look after my friends.'

'Tell me a secret.'

'I've got plenty of secrets, but not any that I'd like to go in a book. I know one – it'll cause a bit of a ruckus, but what the hell. I was having a fight and I knew that the trainer of the bloke I was fighting was having a side bet on me. He won a bob or two as well!'

'Tell me a joke.'

'Freddie Mercury dies and the Angel Gabriel goes to Freddie and says, "Freddie I loved your music so much I want you to go back downstairs. Obviously you can't go back as Freddie Mercury or else you'll be missed in heaven, so you've got to pick someone else and I'll put you down as him." So Freddie has a think and he says, "Angel Gabriel, I would like to be the Arsenal goalkeeper." The Angel Gabriel turns round and says, "What a strange choice, you could have been anyone – Brad Pitt maybe or any one of the top male models, why the fuck do you want to be David Seaman?" And Freddie says, "It's quite simple. I'll have eleven arseholes in front of me and thousands of dicks behind me!"' Chrissy roared with laughter. 'But I don't want to be a goalkeeper, trust me.'

Chrissy is a fantastic character, a real old-fashioned toughie who could fight his way out of any situation. They broke the mould when they made Chrissy Morris. But is he as sensitive as he might be? I buttoned up my coat; I'd had enough of stewed tea and smoke gets in your eyes. I was ready to brave the fresh Southend air. Chrissy went over to one of the slot machines on the way out. He put a two-pound coin in and pulled the handle. He was touched with luck. Three cherries in a row. Bingo. A heap of coins poured out. He shoved them into his pockets, looking as pleased as if he'd broken the bank. 'Come on, Kate,' he grabbed my arm. 'This is on me. I'll treat you to a big plate of cockles and mussels.' I felt my stomach churning again. Eyeballs, gouging, stabbing, slashing ... No way, no way, no way.

ANDRE VERDU
'THE ICEMAN'

NAME: Andre Verdu

DATE OF BIRTH: 8.12.64

OCCUPATION: Security

STAR SIGN: Sagittarius

'If they want to see blood, they can, so long as they understand one thing: it's going to be theirs.'

ANDRE VERDU

'IF I WIN I WIN, IF I LOSE, I LOSE.'

It was Saturday night and Manchester's biggest boxing venue was buzzing, wall-to-wall punters looking forward to the blood and guts of the top-of-the-bill fight between Dean Pithie and Isacc Sabaeuca. I was there to meet one of the Midlands' top fighters – but this was a man who made his living out of the ring and without gloves. I'd heard a lot about Andre Verdu, and none of it was good: don't get him upset; be careful what you say to him; you mustn't get him rattled; so long as he doesn't flip. Was this a wind-up, or is Andre Verdu really Britain's most cold, temperamental and vicious geezer?

Our appointment was at 7.30 p.m. and exactly on the dot the crowds parted like the Red Sea and a huge Greek god appeared out of the shadows and walked towards me. His handshake was cool and hard. 'You must be Kate,

pleased to meet you.' We went through to the bar and he pointed towards a table in the corner. 'Shall we sit down? I can give you half an hour.'

So far I hadn't said a word. I was a bit overawed by his physical presence; this man is so cool he's unreal. He's a big bloke, over six feet tall and with the physique of a Mr Universe, broad shoulders, narrow hips, his jet black hair slicked back, olive skin and dark Valentino eyes. He was wearing a very sharp suit, dark grey and with a crisp white shirt opened at the neck; a discreet gold ring and a Rolex rounded it off.

Andre is a dramatic and imposing figure with an air of impenetrable mystery about him. His presence spoke for him: men moved out of his way and every woman in the place had clocked him. They were all looking him over and melting like Wall's ice cream. I might have been with a film star except for one thing. His eyes. They're deep black pits of menace, cold, hard and expressionless. The atmosphere around Andre seemed as though it was charged with electricity; he was absolutely focused and in control. I felt as though I had touched him – not that I would have dared – there would have been sparks. I couldn't read him at all. How the hell was I going to get anywhere with this iceman?

Andre ordered a sparkling water and lime for me and a glass of water for himself.

'You don't drink?'

He shook his head. 'Never. I used to, but drink and me aren't suited.'

'Why? Don't you like the hangover?'

'No it's not that. When I've had a drink, I have an urge to pull the head off anyone who irritates me.'

I noticed he was clenching his knuckles. OK. 'That's a

good enough reason.' I could just visualise him doing it. I took a deep breath and went on.

'Tell me a bit about yourself, your background. Where were you brought up?'

'I was born in Birmingham, over my dad's corner shop. My family are Greek Cypriots.'

'You've still got close ties with your family?'

'Yes, I was brought up to believe that the family is the one of the most important bonds in your life.'

Loyalty. I admired him for that.

'Where did you go to school?'

'We moved to Coventry when I was six. That's where I was brought up.'

'Did you like school?'

'I was always getting into trouble.'

'A bit of a tearaway?'

'I think it's fair to say that they were pleased when I left.'

'What did you do then?'

Andre sipped his drink; so far his expression hadn't changed. Sometimes when you're talking about home and family and childhood, even the toughest hard man will melt a little. But not this one.

'I went into engineering. Then property developing.'

'What's your present line of work? Still buying houses?'

Andre nodded.

'And other things. I'm mainly in the security business now.'

'What does that entail?'

'I've been working the doors for sixteen years.'

'A dangerous life.'

'You never know what's coming next or what you'll have to face. If you say that you're never scared or that you think you're never going to die, then you're a liar. I've been

attacked with a bottle. I've had a gun pointed in my face, and I was frightened, up to a point. I'm not ashamed to admit that I was frightened. But I think it's either you face it or you run. And I just haven't got that run-away syndrome in me. I'd rather just face it.'

'You don't back off?'

Andre leaned towards me, with an air of menace.

'Never. I've just looked them in the eye and took it.'

'Well, you must always have won then.' I noticed from the first moment I met Andre that he had an air about him – I couldn't tell whether it was confidence or menace, it was just the look of the man. 'I think that if someone wanted to come and have a row with you, they'd think twice just by looking at you. Not because of your size. I recognise a certain look in people's eyes and you have that look.' Andre seemed pleased. 'Do you like that feeling?'

'I do. Yes.'

'Because you know you've got it, you get respect.'

'My wife once said to me that the first time she met me and looked into my eyes, she thought I looked evil. Psychopathic.'

'I'd say very controlled and dangerous.'

'I've been told by other people that they've seen me watch someone who's arguing and when they notice me looking, that's it – nine out of ten times, they stop.'

'This I can believe.' I'd turn into a statue if Andre gave me so much as a cool sideways glance. 'You don't have to raise your voice?'

'No. It works well on the kids as well.' For a second Andre's manner changed – there was just a glimpse of a family man. 'I don't need to say

> **'I've been attacked with a bottle. I've had a gun pointed in my face'**

anything to them, I've only to turn round and look at them and they stop.'

'You'd never step down if anyone got in your face?'

'No way. But most people don't want to fight you. If you embarrass them and they can't save face, then they've no choice. I always give somebody the opportunity.'

'A get out?'

'Yes. There's an escape route if they want to take it. If they want to go, they can go. But if they don't, and they come into my zone ...'

'What happens then?'

'They're having it. I see a red mist and I'm going for it and that's that.'

'Is there anybody or anything that could stop you when you're having a tear-up?'

'The guy I'm working with now, my partner. He could. And he'd probably tell you that I'm the only guy that can stop him. I know I'm like a mad bull when I go for it. When I've lost it, I've lost it. I want to hurt somebody then.'

I could tell that Andre had a sense of pride in himself because of this, but when I asked him the next question, I was surprised by his answer. There was more to him than I'd discovered so far.

'You're obviously a very brave man, but what frightens you? What's the worst scenario you think about?'

'What frightens me is that I could take somebody's life in a second, without any intention to do this. You only need to hit a bloke and he falls wrong, bounces off a table and it's all over. It scares me a lot.'

'You're a thinker as well as a fighter.'

'I try to deal with things in a different scenario now, instead of being a Neanderthal and taking people's heads off.'

'That was in the old days.'

Andre nodded. 'Now we do a lot of grappling and tend to manhandle people instead of just trying to annihilate them.'

Well, that's reassuring. I still wanted to know more about what made this man tick. 'But what frightens you personally? Is it taking someone's life? Or is it losing your own? In your line of work, that must be at the back of your mind all the time.'

Andre thought carefully. 'If I said it frightens me, Kate, then I wouldn't do the job I do, and I can't say that I don't sometimes think about it, because I do. But if I came to the point where I was frightened of having my life taken, that would be time to pack it in. I wouldn't do this any more. My wife sometimes asks me about this. She worries I won't come home one night. That she'll have to go to the hospital or fetch what's left of me home in a coffin.'

Gulp. I could understand her fears. Like the last gunfighter, Andre is always going to be a target. If he can't stay ahead, he's finished.

'What do you say to her?'

'There's nothing much I can say, except that the day I admit to being worried about it, that's the day I give up.'

'Have you ever been stabbed or shot?

Andre shook his head.

'I've been glassed and I've had guys come at me with a knife and a gun. That's as close as I've come to being done for. There's many occasions when I've come close to it, but I've dealt with the situation.'

'How do you know what's coming?'

'I watch people when I'm working. I read them, suss out their body language and see what they're doing. I think through years of experience working on the door, I can sense what they're going to do before they know it themselves. I can tell when a situation's going to go off just

by looking across a room. You see two lads squaring up and you get to the point where you go over there and nip it in the bud straight away.'

Andre was super controlled; I wanted to know what happened if or when he lost it.

'How can you tell when they're going to back off. Or if they won't?'

He almost smiled.

'The hairs on the back of my neck usually ... I feel the adrenaline kicking in. But I always give everybody the opportunity of escape. It's either fight or fly. If they want to see blood, they can, so long as they understand one thing: it's going to be theirs.'

'Have you stabbed or shot anyone?'

'No.'

A flat no. Definite. If he had, he wasn't going to tell me.

'OK. What's the most violent thing that you've had done to you?'

'Being glassed. Seeing the bloke coming at you with a smashed-off beer bottle and knowing he was crazed out of his head and didn't know what he was doing. Being in that scenario you don't know what's going to happen next. I couldn't take my eyes off his hand, I knew that one mistake and I was going to be slashed up.'

'What happened?'

'I just flipped. I wanted to kill the bastard. It took six doormen to pull me off him. I was going to have him.'

'Have you ever been to prison?'

'A near thing. I had a suspended sentence. Two years.'

'And what was that for?'

'It was an aggravated wounding charge. I was lucky, I had a good brief and he got me off.'

'Are you going to tell me what happened?' I had to drag

everything out of Andre. He was one of the most careful blokes I'd come across. Maybe telling me about a row would get him to open up.

'I was working on the door at a club and I had a problem with one guy. It was all going all right and I was leading him out, when his pal waded in and I got it, Judas-style, from the side. I had two of them coming at me now, one of them pulled out a knife and got me in the mouth.'

I winced. 'Was it really bad?'

Andre nodded, involuntarily touching a very faint scar running down his chin. 'It bled a bit.'

'You mean a lot.'

'You could say it was messy, but at that particular time I was foaming at the mouth, which made it look worse. How dare these fuckers do this? I wanted to kill the both of them. I was going to kill the both of them. But the first guy ran away and my partner pulled me off the one who glassed me.'

'Just in time.'

'I rearranged his features a bit.'

'Have you ever gone too far?'

Andre was weighing it up, tapping his fingers on the table. I didn't know whether he was getting a bit rattled at me for asking all these questions.

'Nearly,' he told me reluctantly. 'It was when I was out with my mates. I wasn't working and we were having a quiet game of pool. Then this guy started on my mate without any reason.'

'He didn't know you were with him?'

'Obviously not. So, I went to deal with it and stop it, but the guy went mad and hit me with a pool cue. He was a biggish bloke, thought he was the business and he had a weapon in his hand; he took a chance.'

'Did he hurt you?'

'Fractured my arm. I didn't feel it at the time. Basically I saw the red mist, I flipped and I just annihilated him. The pub was smashed up, there were people screaming, I chased after him out into the street and when the police came I was still kicking his head against the kerb. Boot prints all over his face. Obviously I was arrested.'

'Had you been drinking?'

'Yes. That's what made me lose it. Drink doesn't agree with me. It makes me say things to people I wish I hadn't afterwards. I never drink now and I don't have a problem.'

'Do you ever think of giving up working the door? Not being in this business?'

'Never. It is a violent life, but it's a great life as well. I have a lot of mates, I know a lot of people, and I love it. It gives me opportunities I couldn't get in any other way.'

'And if you could change your life?'

'I'd go back and do it again. Even knowing all the things that I do.'

'When you're fighting – and you must think about this possibility every day of your life – and guys are coming at you, if you were to carry some form of defence, what would it be? What's the weapon of your choice?'

Andre weighed it up. He knew all right, but was he going to tell me?

'If I had to pick a weapon to use, I'd probably choose a duster.'

He was tense at the line I was taking. Maybe I could lighten it up a bit. 'A duster? A yellow fluffy one?' My joke hit the rocks.

Could I get through to him by asking him more personal questions?

'Come on Andre, tell me who you love most in all the world. Is it your mum, your work, your family?'

He replied without hesitation. 'My wife Tina – and the kids, of course.'

That was nice. 'And your happiest memory?' Again, he was straight there.

'Seeing my children being born.

'And your worst memory?' He closed his eyes for a second.

'Hearing that one of my friends, who was a doorman, had been stabbed outside a night club in Coventry.'

'How did you feel?'

'When I heard, it just hit me like a sledgehammer.'

'Did he die?'

'Yes. He died. Yes.'

'And that's always in the back of your mind. It could happen to you?'

'It's made me more of a thinking guy now. I used to be actually off the rails, but now I realise it's a lot more than just wading in there and taking people's heads off.'

'I chased after him out into the street and when the police came I was still kicking his head against the kerb.'

'What makes a tough guy?'

'A tough guy has to have more than just going in like a Neanderthal and thrashing people and taking their heads off. It's a thinking game as well.'

'What makes a man?'

Andre reflected on this, fidgeting with his hands, twisting the chunky gold wedding band on his finger.

'Personally, I think that a man has to be controlled in everything he does. You can be the toughest guy in the world, like Roy Shaw or the late Lenny McLean, but you still

have to keep everything under wraps. I mean, don't get me wrong, Kate, I'll have a row with anybody, and I don't claim to be as tough as Roy or Lenny. But if any guy comes in front of me and wants to have a row, I'll have the row, whether I win, lose or draw.'

'You'd never step down if someone came face to face?'

Andre's lips twisted, his look of menace was the worst I had ever seen.

'I ain't stepping down for nobody. My partner is one of the toughest guys around and when he first came to the Midlands, we had a problem. There were issues between us, basically because I was acting as a go-between for him and another tough guy. But we resolved our differences. I wasn't backing off. If I win I win, if I lose, I lose.'

'If you had to name a hard bastard, who would it be?'

'Without a doubt, Lenny McLean.'

'Why?'

'Because of his background, how he grew up, how he put up with being beaten as a kid, all of those things. I have his book and I'm really intrigued by the guy.'

'Did you ever meet him?'

'No, but I wish I had.'

'You're at the stage where a lot of people respect you, you're well known now. Everybody wants you to work for them. You seem to be in demand.'

'That's right. I've set up a company with my partner. We haven't had to go looking for work. It means that I can take more of a back seat now. We go round checking on the lads, going to all the contracts and clubs, showing our faces.'

'Collecting the money?' Bingo! That actually made the man smile.

'As you do.'

'It's the security business?'

'The firm's called Jab UK.'

'That says it all.'

He began looking at his watch. I'd been lucky and had had more than half an hour.

'Just one or two final things, Andre. If you could change something about yourself, what would it be?'

'Nothing.'

Mr Perfect, eh? 'All right. Would you like to change your looks?'

No hesitation. 'I'm happy as I am, Kate. I might change my attitude sometimes, though.'

I liked that. 'And if you weren't you, who would you like to be?'

Silence.

'It's a hard question.' I guessed that Andre couldn't think of anyone he liked better than himself – and who could blame him? He has looks, guts and an impressive air of confidence. I wanted to prompt him but decided against it.

He spoke at last. 'Maybe someone who was minted so that I wouldn't have to do the things I do. I could sit back all day and let other people fetch things to me.'

Hmm. Did this mean that there is a tiny bit of him that would like to change? But the hard-jawed film star face had shut down again. I had to move on.

'Is there anything that makes you feel guilty?'

'If I've had to deal with someone and I've felt it could perhaps have gone another way. They could have walked, or maybe they've been pushed into a situation by their mates and they couldn't save face, then there's no way out for them. Sometimes they come into my zone without knowing what they're getting themselves in to and they want to fight you. And you know they've no chance, they're going to get annihilated and then I feel guilty.'

'Always?'

'Sometimes.'

Andre smiled but I could tell he was edging to go.

'Last questions. If you went to see a fortune teller, what would you like her to tell you about the future, and what would she tell you about the past?'

'I'd hope that she'd say I'm going to live a long life and be happy and do all of the things I want to do.

'And the past?'

Andre shrugged those super-broad muscled-up shoulders. 'I've no doubt the fortune teller would be talking about all the bad things I've done. But that's all behind me now.'

'Have you done loads of bad things?'

Andre gave me a hard stare. No reply. 'Baddish?'

He pushed his chair back and stood up. He'd clammed up. We could hear the crowd roaring, the fights were starting.

'One last thing, Andre.' The room had emptied and I had to follow him to the door. 'Come on, tell me a joke.'

He paused, trying hard.

'You must know one.'

'I'm trying to think of a clean one, Kate.'

'Doesn't matter, so long as it hasn't got swearing in it. Tell me a rude joke if you like.'

He shook his head. I could see it in his eyes. No way. That wasn't going to happen.

'Sum yourself up in one word.'

This was easy.

'Controlled.'

I agreed one hundred per cent.

'Last question. Tell me a secret. One that nobody else knows.'

He looked almost shocked.

'Go on.' I tried to persuade him, but even the thought of spilling the beans was more than he could stomach. 'A little one ...?'

'All I'll say is ... ask my partner.'

'OK. I will and do you mind if I ...' But it was too late. I'd had my chance, it was seconds out and Andre Verdu was out of the corner and away.

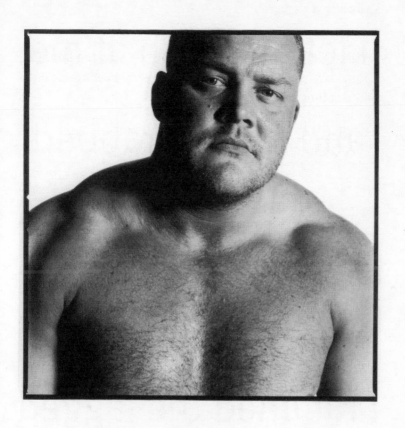

STEVIE KNOCK
'KNOCK-OUT KNOCK'

NAME: Stevie Knock

DATE OF BIRTH: 18.4.67

OCCUPATION: Former Doorman

STAR SIGN: Aries

'I let him rush at me, and then I grabbed the cue from him and broke it in half. I rammed the jagged edge straight in his head. Three inches. At least.'

STEVIE KNOCK

'I KNOW WHAT I'M CAPABLE OF AND THE OTHER
SIDE OF ME TELLS ITS OWN TALE.'

The house on Foxcroft Lane looked just like all the others. Cottage style, neat and tidy, a pretty garden. The village I'd just driven through was green and leafy, one pub, two shops and a post office, Morris Minors parked outside the school, little children riding bikes on the village green and elderly ladies taking fat little poodles for a walk. It was time-warp Miss Marple country, respectable and sedate and a million miles from the shadowy world of the man I was about to meet.

Stevie Knock spends most nights working the door at the Gin Palace. It's the Old Kent Road, where shifty-looking geezers cruise past in rag-top motor status symbols, pounding rap and smoking spliffs, all owning girls who hang round street corners looking for punters and calling: 'Rub your tummy, guv?' The curtains twitched

as I walked up the drive and Stevie opened the door before I could ring the bell.

'Hello Kate, come in.' Stevie Knock is a big man. Bloody big. An immovable object with a face as craggy and hard as the Grand Canyon and no neck; his bullet head sprouts straight from his shoulders. He was wearing a baggy tracksuit and trainers, comfy clothes for a bloke relaxing at home. This was no macho man's gaff, it was pastel and chintz, huge comfy armchairs and pictures of him and his newlywed hung all over the walls. Julia came in carrying a tray with tea; his eyes were watching her all the time. Was I seeing a new side to one of the hardest bastards going? Had she tamed him at last?

'You're happily married, looking relaxed, in business with your dad. Is it all over now?' I asked him. 'The fights, the rucks, the violence?'

Steve frowned, rubbing a jaw as hard as rock. When he talks to you, he looks you straight in the eye. He has a direct manner that's impressive because it never alters. 'I never invite violence, but when you're working the doors, it goes with the territory. I'm very straight, very sensible. I have my temper under control.'

'I've heard that you can be a little bit vengeful?' Stevie has a reputation for finishing every fight. He doesn't let anyone off.

'I never invite violence, but when you're working the doors it goes with the territory.'

'I mean to come out on top,' he growled. 'That's all it is. I don't follow it up. When I've put a man down he can stay there, but if he gets up again ...' he shrugged, '... he knows what's coming.'

Over the years Stevie has been involved in stabbings, shootings, brutal encounters and violence of every kind.

He's been in every ruck going. A training and fitness-mad karate king and fist fighter. What he doesn't know about dishing out pain and grief isn't worth knowing. Yet there he was, surrounded by suburbia, rose-covered cushions and sipping Ceylon tea from a china cup.

'Tell me a bit about your background, Stevie.'

'I was born and brought up in London. We lived down the Old Kent Road, so you could say I was streetwise as soon as I could walk. It's what you had to be. There was no money, my dad wasn't around much, and so my mum had a struggle to bring us up.'

'Was it just you and your sister?'

'Yes. She was ill for a long time with a progressive brain tumour. We were inseparable until she died.' His face changed, softened. 'She was only a little kid.'

'Did you look after her?'

'My mum had to work to get us enough money to live on, so most of the time it was only me and her. I thought the world of her.'

'That must have hit you hard?'

'It freaked me out totally; I was still only a kid myself. You can't cope with it at that age. You don't know how.'

'Do you think that it affected you? Made you a bit of hard bastard?'

'Undoubtedly. I had to protect her; the other kids were sometimes cruel. Her illness made her a target. I took a few knocks and then I learned how to dish it out. And when she'd died I didn't care much about getting hurt. It didn't matter. Knock-out Knock – that's what they called me.'

'You were good with your fists?'

'Always fighting, always in trouble.'

'Did you get in trouble with the law?'

'I looked like a little angel, but I was very, very aggressive. And if I wanted something I made sure I got it. I was always in trouble. But we all were. That was the world I lived in, even as a kid.'

'Did you have any idea how your life would turn out?'

'No. I imagined it would be a lot easier than it has been.'

'What did you want to be?'

Stevie walked up and down. 'I suppose I wanted success in life, all the material things we didn't have – and I could see that other people had them. But without education it's very difficult to get the breaks. Now I'm not so bothered about material possessions. Happiness is the main thing.' He glanced at a large photo of his Julia. The love of his life. At least that had turned out right in the end. 'I would have liked to have been a professional boxer, though.'

'Couldn't you have done that?' Stevie has the guts and a knockout punch. 'Why didn't you go for it?'

'It was finding the time that beat me. I had my living to make. I had to look after my mum. I was having one ruckus after another in my work. Try running five miles and sparring when you're up till three in the morning.'

'You were working as a doorman?'

'Yes. There didn't seem to be enough time to train to the standard I needed to be a boxer. If you go professional you've got to give it one hundred per cent. I was giving that to my job.'

'You've got an awesome reputation as a doorman. Have you ever been threatened?'

'Yes, quite a few times.'

'Was this when you were working on the doors?'

'Yes. And before. But nothing that ever bothered me. Just your average idiot, really. They've had a drink or

they're a bit high and they're just spouting off, really. They don't know what they're doing or who they're up against. I can be a bit vengeful, that's maybe my fault, but when a guy's down I never follow it through. They don't always see sense. Know what they're up against. There's usually a gang of them and only one of you.'

'Have you ever thought you'd be killed?'

'There's always a possibility, but it's never bothered me. I've always been laid-back about it. What will be will be. The more volatile the situation, the more calm I become. When the adrenaline's flowing, I seem to see it a lot clearer. I always think that the punters have more of a struggle than the doorman. They're mostly a bit naive, blokes who're having a night out with their girl; they don't fight from one year to the next. Then if they get in a ruck, they take more stick than the doorman ever does. There's inevitably the other type, who think they're hard or they're showing off and they want to take a pop at you because of who you are.'

'How do you deal with them?'

'Make sure they regret it!'

'How? Do you have a quiet word with them? Perhaps reason with them, tell them what's going to happen?'

That made Stevie smile, but not with his eyes, they were as cold as peas from a frozen bag of Bird's-Eye petits pois. He shook his head. 'No, it's a waste of breath trying to talk to them. When they're full of themselves, they don't listen no matter what. I once had a kid in his twenties come in and I knew he was trouble from the start. He was with a gang of his mates, they'd come down from Newcastle, thought they were the business. The ringleader was a big lad, a weight trainer, and he had this fantasy that he was a bit of a boxer. A big fish in a little pond. I tried to be reasonable but he wasn't having it.'

'What happened?'

'They thought they were having me because there were a lot of them going to rush me together. The first lad came at me with a pool cue and that got me riled up.'

'You're in a pub filled with people ...' He nodded. 'And there's a gang coming at you, and the one in front has a broken pool cue he's trying to get you with?'

'There was a some cursing and hollering. There were chairs smashing and tables upturned. It was a right old tear-up.'

'What did you do?'

'I stood my ground. The cheeky bastard. I thought, I'm not having this.'

'And ...?'

'I let him rush at me, and then I grabbed the cue from him and broke it in half. I rammed the jagged edge straight in his head. Three inches. At least. They stopped dead in their tracks and the rest of them melted away like butter on a hot potato. They don't really have the bottle for it. Most of them are just football hooligans.'

Stevie told me this in a matter-of-fact way; in this world of vicious hooligans, they get what's coming to them. 'Have you ever been stabbed or shot?'

'Yes, I've been shot in the head, and with a sawn-off shotgun – there were about 25 pellets went in. I've been stabbed twice. Slashed a few times.'

'No big deal?'

'I'm here, aren't I?' He was as cool as the iceberg that sank the Titanic when he was telling me this, and letting about as much show above the surface.

A survivor. A hard guy to crack. This savage barbarian can take it as well as give it out. When he's wearing his black overcoat, with the inside pockets that can

hide anything, and he's on the door, he's the man. He decides who's coming in and, more importantly, who's going out. No arguments.

It's all about power. The price is that he puts himself up as a target, with no back-ups, no guarantees.

'Even when I got shot I think I was the calmest bloke in the place. They were all screaming and shouting. I thought, What's the use, it doesn't make it

'The first lad came at me with a pool cue and that got me riled up.'

go away. I even had a woman copper looking for the wound, asking me where it went in. She even went round the other side looking for the exit wound.'

Stevie's had so many hard knocks in his life, they just bounce off him. 'What's the most violent thing that's ever been done to you?'

'The most violent thing? Well, obviously, the shooting thing stands out, there's other things that have been very nasty encounters, but what I've mentioned to you is just what's happened on the door. I've had confrontations where I've been lucky – one thing's led to another and fate's been on my side. I once had a guy standing right in front of me, not six feet away, with a gun pointing at me and he fired and he missed. He hit the windscreen of the car behind. Stupid bastard.'

'What happened?'

'If they take a chance and it doesn't come off, then basically, they have to face the consequences.' He asked Julia to make us another cup of tea, not wanting to be drawn any further. All right.

'That leads me to the next question. What's the most violent thing that you've ever done?

'Christ!'

'Tell me.'

'I couldn't, could I? There's too many, to be honest. I've done lots of things I'm not too proud of. There's nothing I can say on this subject, Kate.'

It was obvious he wasn't going to talk about this aspect of his past. His life had led him down paths not of his choosing. He'd done what he had to do, what he thought was right at the time. There's a survival instinct that takes over. It was keenly developed in Stevie Knock. I was beginning to know why. Now I wanted to know how he fights.

'What's the weapon of your choice? Hands, head, feet, guns, knife?'

'I'd say through the years I've used all weapons – and all is underlined.'

'We'll leave it at that.' There was no point pressing him.

'I've used all weapons, but if it was bodily weapons, I suppose head, elbows, fists in that order. I hold all the belts in martial arts.'

'Kung Fu, that sort of thing?'

'I started tae kwon do about fifteen years ago. I've fought numerous kick-boxing bouts, I've trained in Thai boxing, and I've done a lot of unlicensed fights, trophy matches, that sort of stuff.'

'Why do you do this? You don't have to – it's not work, not making your living.'

'No, but this is my world, being with the lads, around tough men. It's a man thing. For the fame not the fortune, if you like.'

It must be hard on his family. When he goes out, will he come back in one piece?

'Who do you love most in all the world?'

'Let me think.' Stevie paused, knowing that his wife was listening. He is a bit of tease when he wants to be.

'Come on, I thought you were going to say Julia.'

'Well, I was, but I was trying to find a clever way to get round to it. Yes, it's Julia. Obviously it's Julia. She comes under a special type of love, that's a wifely love. Then there's other loves, you know, family.'

'What makes you see the red mist?'

'I think that still comes down to the disrespect some people have. It's like having a complete plank in front of you who thinks he's a cardboard cut-out, a phoney gangster and he's telling you how tough he is. People always know me as a happy-go-lucky bloke; I've got a smile on my face if I don't get messed about. But I know what I'm capable of and the other side of me tells its own tale. I don't like having idiots coming up to me who, at the end of the day, will always be made to look what they are.'

'What's that?'

'Doughnuts.' Stevie flicked his fingers. He could brush anyone away like a fly. 'Yeah, it's disrespect fires me up and that will always be the main one. I have my own respect for a straight-up fella; it doesn't matter whether he's a hard man or not. I've just got a lot more regard for genuine nice people.'

Was there anything that would get through to this man? I didn't think so. So far he'd been like the immovable mountain.

'What frightens you and what's the most frightening thing that's ever happened to you?'

'Literally what I can't control, that's what frightens me.'

What he said fitted my impression of him. It wasn't the fighting and the risk of getting hurt himself that scared him, it was the thought of any danger to his loved ones. I noticed that he was drumming his fingers on the chair arm.

'If my Julia is out somewhere, in a club, and I know the local mugs are down there, that's when I'm thinking about

it. Fear is when you lose someone you love. When I'm not there to keep an eye on things and keep her safe. Or my family, for that matter. Also, recently I've been trying to regain contact with my children. That bugs me, I'm sort of cracking on through life without seeing them.'

I knew that Stevie's first marriage had ended in a contentious divorce and that he hadn't been able to keep in touch with his kids.

'What makes you feel guilty?'

'Not any of the confrontations, not even the violent ones. I've never, never had any remorse about that. I'm quite callous when it comes to what I've done, whether I've left someone in a pool of blood or broken bones or smashed up, whatever, I've never regretted that, but I suppose if I could do things over again, I might have approached things differently. I feel bad about that. But then, I can't speak for anyone else's actions. Like the scenario with the children: I can't talk for the ex's actions because like most ex's she's a law unto herself. You know, some normal run-of-the-mill people, i.e. women in divorce cases, they're more deserving to be in one of your books than people like me.'

Stevie has a good sense of humour; a bit warped, maybe.

'If you could change your looks, would you like to and would you have plastic surgery?'

Julia came in to clear the tea tray away. She is a lovely looking girl with a smile ear to ear. Stevie caught hold of her hand.

'Julia says she wants me to have a willie extension!'

His wife took the teasing well, laughed and shook her head and retreated to the kitchen. I thought she was a good sport.

'I'd have bits of my ear sewn back on,' he told me.

'Did they get bitten off when you were fighting?' He

shook his head. 'Actually they got crushed when I was born – forceps – but they always look like they've been bitten off. My nose has been re-straightened, I've just had that re-done to help me breathe a bit better. The snoring was driving Julia mad. I first broke it when I was fifteen and it's been compounded a lot of times since then. And I've just had my cartilage re-done. Apart from that, I think I'm all right.'

'What gives you a buzz? Is it violence?'

'Normally I would say that's a wally's attitude. To say you get a kick out of violence is stupid, but I must admit that once I have seen the red mist, I'm away. But it's always justified, I've never taken a liberty and I've never taken the piss out of someone. So, yes, I do start to get a buzz when I'm on full spurt. Yes I do. But then actually it's because I'm in the right. If I knew I was doing something out of hand, then I'd know that inside as well. It is a buzz; it's the power and everything that comes with it. You see everything go flying. I suppose the main thing is the geezer I'm giving it to is a complete prat or he's a piss-taker, because he deserves everything he is getting.'

'Is it because you know you're right, then?'

'Yes. I get respect from people because they know what I'm capable of doing. No, I've never taken advantage over anybody. They've all got their own stories about to back it up, whether it's their brother who's had the encounter or their cousin or their mate, someone's always been there to say, "Yeah, Stevie Knock's never took the piss."'

'They've always deserved it?'

'Yes. I could always hold my head up. And that's why I've got so many mates and so much respect. That goes with it.'

'So what makes a man?'

'I think decency as a human being makes a man. I like

to see good manners; it doesn't hurt to be polite. It's no good to man nor beast to be a growler in the world.'

Too true.

'You don't want to go round biting everyone's head off. Not everyone's a fighter. So you shouldn't treat everyone as though they're your next victim, so to speak.'

Stevie has a lot of good opinions and is not shy to speak out; he is his own man, with plenty to say.

'If you weren't you, who would you be?'

'Elvis Presley, no doubt about it.'

'You ain't nothing but a hound dog?'

'Crying all the time ...'

He has a good voice.

'Name a hard bastard and why.'

'Right. I like Roy Shaw's story and everything about him, because it's exactly what I'm saying. He's someone who's led a violent life; he's gone down the path with no regrets. He's not flash about it, that's what I admire about him; he's actually a nice guy. There's a lot of history there and it's not made up. He's had to put up with a lot of tough things and he's had to be hard in a lot of situations and he's always come through.'

'How do you stay one step ahead?'

'My brain ticks over at a million miles an hour. It always does, whether I'm in a pub situation, whether I'm on the door, whether I'm earning my money in bits and pieces, even if I'm at work, my brain's always working and I'm two steps in front. And that's in everything I do in life.'

'If you were to see a fortune teller about the future and the past, what do you think she would tell you and what would you like her to tell you?'

'Bloody hell. First off, my personal view on fortune tellers: I've never felt comfortable going to one. It's just something that freaks me out and I wouldn't do it. But if I

did see one I think she would tell me that I've had a rough-and-tumble life and she would say that I've had it hard, but that I'm a decent guy who's made the best of anything that's come my way.'

'If you were eighteen again, what would you do different?'

'I would definitely try to slow down from what I was like at eighteen. I'd put down a lot of things that were in my hands at eighteen. I mean, yeah, I would do the complete opposite of what I was like. I've been arrested numerous times and I've been lucky. I have never been put away. But I can only look back now in hindsight, and wish I'd had a really good education. That is something I've missed. It would have changed my life. It's to do with where you're brought up as well. Now I live out in the sticks, a quiet part of the world, but when I was growing up, my main influence came from where I was living in Bermondsey and all the people I was mixing with and the things I was getting up to, it was just part and parcel. There

'It's a man thing. For the fame, not the fortune, if you like.'

was no way you could keep out of it. So I think that if I was eighteen again, I'd get out and live in a nice quiet area where no one led me astray. It wasn't that they did, but that I buzzed in that atmosphere. I was charging at a million miles an hour. And going in the wrong direction.'

'You took up the challenge.'

'Yes.'

'That small word ... "if".'

'Right.'

'Sum yourself up in one word or sentence.'

'A toughie but a very nice guy too.'

Lovely. 'Tell me a secret.'

'I immediately get images of policemen asking me that question. I've stood in front of them and they've asked me that.'

'Can't you think of one you can tell me?'

'That's got me stumped.'

'You can't, can you?'

'I can't. My make up won't let me say it.'

'Tell me a joke.'

'What's pink and hard?'

'I dunno.'

'A pig with a flick knife.' He has a deep, infectious laugh. 'That's perfect, innit?'

Stevie looked at his watch and jumped to his feet. It was getting late and the Old Kent Road would be filling up with another night's dregs of good, bad and downright ugly. He walked with me to the bottom of the garden, looking up and down the street as he opened the gate. The man towered over me – solid, immovable, impossible to predict. He lets you see a little bit, and then it's shut down. He reminded me of someone. Yes, the Terminator. A remorseless, automatic fighting machine.

'See you again, Kate,' he called out to me, cool, polite, remote. I wanted to say, 'I'll be back'. But what I actually said was, 'Bye Stevie, thanks for the tea. See you, mate.'

TIGER
'ONE HUNDRED PER CENT'

NAME: Tiger

DATE OF BIRTH: 25.10.71

OCCUPATION: Fighter

STAR SIGN: Scorpio

'Within seconds Tiger's face had changed and with a yell he was out there, fists flying and baring his teeth. This fearsome geezer is a gladiator from the gates of hell.'

TIGER

'I WAS THE YOUNGEST PERSON EVER TO BE CHARGED
WITH GRIEVOUS BODILY HARM.'

Bright lights, hunks in evening suits, pretty girls, flashlights popping at the arrival of celebrities. A special occasion, opening night or a film festival? No, the usual crowd trying to get into The Manhattan club, one of the East End's trendiest nightspots. I pushed my way to the front, hoping that I'd be spotted. It worked. The guy running the door, a Lord Greystoke look-alike with hair down to his waist and jungle muscles to match, saw me and hauled me inside. 'Hello Kate, glad you could make it.' With a wild man growl at the punters, he cleared the way through the club to a room at the back. 'Is it always this hectic?' I'd never met Tiger before. I wished I'd worn my fake leopard jacket. 'It's always like this at weekends,' he told me. 'Look, I can only spare half an hour.'

I nodded. 'That's all right.' I sat down on a squashy sofa. The room was 70s plush, with a well-stocked drinks cabinet, signed photos of the rich and famous plastered over the walls and a massive combination-lock safe. Tiger offered me a drink. We both settled on water. He was like a jungle animal: confident, cool, on the prowl.

'Tell me a bit about yourself, what about the name? How did you get to be called Tiger?' Maybe it was to do with his ferocity in the ring.

'Put that down to my mum. She was in labour for a week when she had me. I was premature, two months early, and I only weighed 2lb when I was born. When the nurse saw me she said I'd have to be a fighter to survive. They didn't think I'd make it to start with, and my mum said I was a real tiger, the way I held on to life. The name stuck.'

'What was it like when you were growing up?'

His eyes narrowed. 'I was always in trouble. Went with the territory, I suppose. In and out of fights, I was always in trouble with the police while I was still a kid.'

'Why was that?'

'A guy beat up my sister, so I had to sort it. I wasn't having that. I ended up with being the youngest person ever to be charged with grievous bodily harm.'

'How old were you at the time?'

'Ten.' He must have been one hell of a tear-up.

'They gave me a suspended sentence and my old man a five-grand fine.'

'I bet he wasn't too pleased.'

'No.' Tiger had a pained expression; it looked as though the experience was still fresh in his mind.

'Tell me about the fighting. Do you do anything else?'

'The doors. And unlicensed boxing. I go all over the world. I started boxing sixteen years ago. I've fought all over the world, but mostly I've boxed a lot in America.'

'Who's your trainer?'

'My old trainer used to look after the Krays. Dave Payne?' I'd heard my ex-husband Ronnie mention the name. 'Well, Dave used to box under the name Dave Robinson, and then he became a trainer and I was with him until he moved out of the country and went to live abroad. Then I went to the States and I started boxing out there. That's where I'd really like to live, to be honest.'

'How did you start boxing unlicensed?'

'When I came back from New York my mate had been having a go. I went to see him and I thought: I'll have some of that. And that's how it started.'

'Has your life ever been threatened?'

'Yes, it goes with the job. I don't bother about it. I don't run from anything.'

'Have you been stabbed or shot?'

'Six times.' Tiger opened his white shirt to show me a zigzag purple scar on his chest. It made me cringe. Then he rolled up his sleeve to show me a three-inch gash on his arm. And that one was still red.

'That's only two,' I said.

'Do you want to see the others?' He started unfastening his shirt.

I shook my head. No way. 'I believe you.' This guy is one tough individual. 'Is getting stabbed the most violent thing that's ever happened to you?'

He shrugged. 'Not really. I had a fight with an American in Las Vegas and that was really something. I think it would be shocking for me to tell you about it.'

'Do you see the red mist when you start fighting?'

'No, not really. Fighting's my job and when I go for it there's no backing off. I can be a bit of a wild man.' With the long hair and sinewy build, he certainly looks the part. 'But I'm not the kind of guy who's going to get fired up. A few

years ago I had three policemen come for me all at the same time and they ended up nicking me for GBH. The Old Bill with guns and all the rest of it, and I suppose I lost it then because I was saying, "Come on man." That made me see the red mist because I had my kids in the house

'With the long hair and sinewy build, he certainly looks the part.'

and I hadn't done anything wrong. Anyone taking liberties would get me riled up.'

'What frightens you and what's the most frightening thing that's ever happened to you?'

Tiger thought about this for a moment. 'A little while ago I was lying on my bed and suddenly everything flashed before me. I felt as though I was going to die and my life was spinning past. I don't know what it was but that was frightening.'

'Did you go to hospital?'

'Yes, but they couldn't find any explanation. I've had it happen before a few years earlier. I had a period with some trauma in my life, my house burnt down and I was due to have a big fight. Well, I had appendicitis, in fact my appendix burst. One minute I'm at home watching telly, the next I'm having an emergency operation in hospital. I was due to have this fight the next week and so I got out of hospital and went ahead with it.'

'What, straight after the op?'

'I said I was gonna have the fight and I wasn't going to let anyone down.'

'What happened?'

'It was the quickest knockout in the country. I won with an eight-second KO. It made the headlines.'

'What makes you feel guilty, Tiger?'

'Lots of things. If only the old could and the young would.'

'I like that.'

'Sometimes I regret making excuses. A man shouldn't make excuses.'

'Would you change your looks if you could? Would you ever have plastic surgery?'

'You should talk to my wife about this,' he kidded. 'But seriously, I wouldn't want to change my looks but I would have surgery for health reasons. I've broken my nose eight times and I've had three operations on it already. If it would improve my breathing, then I would do it.'

'What gives you a buzz? Is it fighting?'

He shook his head.

'No, it's not fighting. I've had millions of fights in my life. I've had more fights than other people have ever dreamed of. It isn't fighting. Maybe it's the concept of the match between two fit, tough men.'

'A bit like gladiators?'

Tiger's face was animated. He said it didn't give him a buzz but he certainly loved talking about the fight game.

'Yes, that's right, Kate. The thing I love about boxing is that it's the only fair fight you're ever gonna get. I've had plenty of fights with people who just want to put you away; I shouldn't even be here today. It's no big deal, though. I've fought blokes who're drunk, or off their head on whatever. But that's not a fair fight. Boxing is good because in there you get in the ring and there's only the two of you. It's a fair fight. There's no hiding, no running, just a proper straightener.'

'What is the weapon of your choice?'

'I'd say that my fists are the answer to everything. That and thinking about how a fight needs to go.'

'What makes a man?'

Tiger topped up my Perrier, ice and lemon and poured himself a drink from the jug of mineral water on the table. His answer showed me that he is a thinking man who has thought long and hard about his life.

'A man isn't made by fighting or not fighting. A man is not a hypocrite. A man deals with whatever gets thrown at him. Whatever comes your way, you have to get on with it and that makes you a man.'

'If you weren't you, who would you like to be?'

'I could tell you a lot of people I wouldn't like to be. I wouldn't want to be a lawyer or a politician. That would be worst. I particularly don't like politicians.' He thought for a minute. 'No, nobody else, I'm happy as I am.'

'Name a hard bastard and why.'

'I've met Mike Tyson. He is a hard man. And I'd have to say Roy Shaw. I look at him and what his life's been and I have to respect the man. You don't see him moaning. I don't know who number one would be. Maybe my dad, he's one of the hardest men I've known.'

'Why is your dad so tough?'

'It was his upbringing. He was brought up in Ireland. They were good Catholics and he went to a school run by priests. The stories he told me about the kids that were abused were chilling. Some of them were raped, they died. My dad was made to eat grass in the morning. He used to be pretty tough on me and I moaned about it but now it's all come out. I used to want to leave my dinner and he'd hit me with it if I complained. But I never realised till now how hard it was for him.'

'You've survived a lot, and you're in a dangerous business, so how do you stay one step ahead?'

'Fitness. I train a lot. But lately I've not been able to do as much because I've ripped my shoulder clean out of its socket, so I have to take it easy for a while.'

'How did that happen?'

Doors were opening and closing, people were coming in asking questions, the club was packed and the pressure was building. Tiger looked at his watch. 'We're OK for another five or ten minutes,' he told me. 'My shoulder. Yes. It was in America a few weeks ago. I was in a club in Florida and I got into an argument with three men. I was with a pal and his girl, and he'd gone outside for something. Now in America they've got a different brain on them. They think they can go up to a girl, no matter who she's with,

'A man is not a hypocrite. A man deals with whatever is thrown at him.'

and do whatever they want to do. So these three geezers go up to her and get a bit saucy and she doesn't like it. So I say, "What's up?" And it finished with me taking the three of them on, but the next minute there's a whole football team. It was mayhem and we all spent the night in a downtown jail.'

'You and the football team.'

Tiger laughed. 'Yeah. I'd only gone out for a quiet drink and a game of pool.' He worked his injured shoulder; it was still painful and he winced. 'But that's all behind me now, I'm getting it back in shape. And it's taught me something.'

'What?'

'Before I run headlong into things, I stop now. It's, "Let me have a look at it first."'

If only we could predict what was coming. 'If you were to see a fortune teller, what do you think she'd tell you and what would you like her to tell you?'

Tiger looked fairly serious. 'She'd tell me that I'd made mistakes. But I'll not make them again. She'd tell me that a lot of bad things have happened. I think that if a lot of events in your life aren't too good, you tend to be

apprehensive at times. Your mind can play games with you. What I'd like her to tell me is that it would be smooth from now on.'

'If you were eighteen again, what would you do differently?'

'Nothing. I wouldn't change my life. I am what I am.'

A controlled fighting machine with no fear.

'If you were to see a young kid, about eighteen, and you knew he was going down the wrong path, what would you tell him in order to straighten him out?'

'Get a good lawyer! Seriously, I'd tell him that there's nothing worse than a wasted life. I'd do my best to make him see the right path. I think that setting the right example for your kids is half the battle.'

'Sum yourself up in one word or sentence.'

'One hundred per cent.'

Absolutely.

'Tell me a secret.'

I was used by now to guys saying I don't know any, or I can't, but Tiger's answer was spot on.

'The secret to life is to be real, don't be a bullshitter.'

'If you weren't you, who would you want to be?'

'Nobody.'

'Tell me a joke.'

That fazed him. But then he came up with a good one. 'One morning a blind bunny rabbit was hopping down the bunny trail when he tripped over a large snake. "Oh please excuse me," said the little bunny. "I didn't mean to trip over you, but I'm blind and can't see where I'm going." "That's perfectly all right," says the snake. "It was my fault. I didn't mean to trip you, but I'm blind too and I didn't see you coming. By the way, what kind of animal are you?"

'"Well, I really don't know," replied the bunny. "I've never seen myself. Maybe you could examine me and find out."

'So the snake felt the rabbit all over and he said, "Well, you're soft and cuddly, and you have long silky ears and a little fluffy tail, you must be a bunny rabbit."

'Then the rabbit said, "I can't thank you enough. But by the way, what kind of animal are you?"

'The snake replied that he didn't know, and the bunny agreed to examine him. When he was finished the snake said, "Well, what kind of an animal am I?"

'And the bunny, who had felt him all over, replied, "You're hard, you're cold, you're slimy and you haven't got any balls – you must be a lawyer!"'

I was still splitting my sides over that one as Tiger escorted me to the front of the club.

'Sorry I've had to cut it short, Kate.'

A guy came up, pushing and shoving. Within seconds Tiger's face had changed and with a yell he was out there, fists flying and baring his teeth. This fearsome geezer is a gladiator from the gates of hell. He isn't made for these times. There were screams and yells, chairs smashing, the sound of bones cracking.

NOEL ENNIS
'THE EX-KING OF MEAN'

NAME: Noel Stephen Ennis

DATE OF BIRTH: 25.12.58

OCCUPATION: General Manager

STAR SIGN: Capricorn

'The point of the knife stuck in my rib, just over my heart. A fraction either way and I'd have been dead.'

NOEL ENNIS

'THE POLICE WERE SHOOTING AT ME ON A BEACH
IN MARBELLA.'

The international departure lounge at Heathrow
Airport was packed with holidaymakers, business-
men, backpackers and travellers. It was all hustle and
bustle and noise. Security guards were packing guns,
looking menacing and guarding exits. They didn't do
anything for the holiday atmosphere. I'd been trying
to meet up with Noel Ennis for the past three or four
weeks. Either he was busy with work, or I was. I'd
been filming a new series, which meant early
mornings and late nights and no time for chatting
with roughie toughies. And boy, in his time this guy
has been the king of mean.

We'd arranged to meet in the bookshop, but he had been
delayed, so I was spending my spare time re-arranging a few
of my books. Some cheeky sod had put *Hard Bastards* 1 and 2
and *Killers* on the second shelf down. The sales assistants
were too busy to interfere and I was getting them back to full

prominence in the centre spot on the top shelf when Noel tapped me on the shoulder.

'At last we meet.' He shook my hand. Noel is a smart-looking guy with a ready smile. We were getting pushed and jostled so it seemed a good idea to adjourn to the snack bar on the first floor. We could watch the planes take off and land as we talked.

Five minutes and two overpriced cups of cappuccino later and we were settled. 'Tell me a bit about your background, Noel. Where were you born and brought up?'

'Willenhall, in Coventry. I was born at home in my mother's house.'

'Is that a bit unusual?'

'Not in those days, it's what most people did. Coventry had to be re-built after the war and they were still at it in the late fifties.'

'What sort of a place was it?'

'We lived in a very rough area, so I was dragged up rather than brought up. No Mothercare, no childcare psychology I'm afraid.'

'Do you come from a big family?'

He nodded. 'Yes, I am the youngest of six boys.'

'That is something. Your poor mum! No, I didn't mean that ...'

Noel has a good sense of humour, he takes it all with a laugh and twinkle in his eye.

'I expect she had her hands full with us.'

'Were you all little scoundrels?'

'That's putting it mildly. We were little scoundrels who turned into even bigger scoundrels.'

'Have you ever been to prison?'

''Fraid so. Me and the Old Bill are well acquainted.'

'How many times have you been inside?'

'It's about eight I think.'

'Eight?'

'I'll have to watch it, Kate, I'm losing track.'

'Tell me about the time you were locked up in Spain.'

'Right. Well, I was having a phase where I was a bit of a naughty lad. My misspent youth. I was a fraudster over here.'

'What does that mean?'

'I used to go into banks and withdraw cash. Other people's cash! And I had a load of warrants out for my arrest, so I went to live in Spain to get away from it all. That's why they call it the Costa Del Crime, I guess. There might be a few of your old mates out there, Kate!' Cheeky sod!

'Anyway, while I was out there, I got into the old cannabis trade. I wasn't shipping it back here, but people did used to come to me and buy it. I used to do the transport, shift it for them. One day I was well caught by the Old Bill. They stopped me in a road block and I had a hundred kilo in the back.'

'As much as that? Good grief – Puff Daddy!'

If there is a funny side to any situation, Noel will see it. 'I told them it was for personal use, but they wouldn't have any of it.'

'That must have been some joint!'

'Yes. But they carted me away.'

'How long did you get in prison?'

'Three and a half years. I did three.'

'In a Spanish prison?'

'Yes.'

'What's it like?'

Noel still shuddered at the memory. 'Cor blimey! It wasn't too bad at the end, but at the beginning I was sent to Granada, to one of the oldest prisons in the country. There were six of us in a cell and these cells were the same size as a two-man cell in Winsome Green. But they were really high. The bunks went upwards. If you were on the top bunk you got a nose bleed.'

What a comic.

'I'm joking now, but it was dead rough. There were no toilets as such. It was a hole in the floor with a footplate either side and you had to squat over it and make sure you hit the target.'

'It sounds dreadful.'

'It was absolutely disgusting. Really revolting.'

'Were you wary when you were there? I don't suppose there were any British people you knew.'

'I didn't know anybody. And to be honest, I didn't want to know anybody, they were all heroin addicts, smackheads, and there were drugs everywhere, it was rife in the prison. There were needles lying about all over the place.

'The doctor pushed the needle up through my cheekbone, into my head.'

If you went into the showers you had to be careful where you were standing or else you'd get one stuck in your foot. It was terrible. And if you ever upset any of them, they all had syringes on them, they were going round stabbing each other. It was out of control, absolutely.'

'Were you able to make friends, or did you get into rows?'

'It was hard. The few English people in there were the biggest bunch of wankers I've ever come across in my life. I ended up getting pally with a load of French geezers. They were all right. Sound blokes, spot on. I tried to learn Spanish and learn French at the same time, so I could half communicate with them.'

'Was it worse being in prison there, or over here?'

'Oh Spain, definitely. No doubt about it. When I went in there I couldn't speak the language. And they certainly wouldn't communicate with me in English even if they could; they wouldn't speak it, even in the canteen. They refused to, so if you wanted anything, you had to ask them in Spanish. So the only way you were ever going to get anything was to learn the language.'

'Didn't they try to get on with you?'

'No, the authorities hated me. They hate the English, they can't stand us. About fifty per cent of the inmates weren't too bad. But the people running the prison didn't care what happened, they didn't want anything to do with us.'

'Have you seen the film *Midnight Express*? Was it as bad as that?'

Noel nodded. 'Yes, it was on the same sort of lines. Maybe not quite as bad.'

'But it was close?'

'Yes.' Noel took a long drink of coffee. It was something he wouldn't forget easily.

'How long were you in that jail?'

'About a year. They were actually building a new prison and we were moved into that eventually. So we went from the slummiest prison to the most up to date.'

'And that was all right?'

'It was all brand new. Two to a cell. We had showers in the cell.'

'Would you go back to Spain again?'

'Yes, I would go back. But I wouldn't do anything wrong.'

'Has your life ever been threatened?'

'Yes. I've been threatened with shootings. I've had geezers say they were going to stab me and kill me.'

'What happened? Did they change their minds or did you sort it?'

'You could say that I've usually managed to defuse the situation. I did get stabbed, though. It was a row at a party, it turned into a free-for-all and somebody stuck an arm through the crowd and stabbed me in the chest with a stiletto. I'll show you the scar.'

Quite a few heads turned when Noel took his T-shirt off. There was a scar across his pecs.

'The point of the knife stuck in my rib, just over my heart.

A fraction either way and I'd have been dead. It cracked my rib instead.'

'Did you know that you'd been stabbed?'

He shook his head. 'Not at the time. I'd had a bit to drink. It was only when I turned round and somebody said, "Look at that." There was all this blood, you know how you see it on a comedy film, and it was spraying out of my chest. It went all over and people were dodging it. It was like one of those joke cameras that Tommy Cooper might have as a prop. It sounds hilarious but I suppose it was touch and go at the time.'

'I was going to ask you to tell me about the most violent thing that's ever happened to you, but I don't think anything could top that.'

Noel thought this was quite a joke. He has a wonderful, infectious laugh. No matter what happens, life's a breeze. A good attitude. But he could recall another incident even more violent than the stabbing. This wasn't to do with crime, though.

'It was at a football match a few years ago. A gang of about fifteen football fans stomped on me. Millwall supporters. They kicked me and battered me all over. Booted me and completely pounded me stupid for about twenty minutes.'

'What were you doing there in the middle of Millwall fans?'

Noel laughed. 'One of life's mistakes. It was a cup match against Coventry. I was there on my own and Millwall lost.'

'Have you had a lot of support from your family?'

'Yes. They've always been there for me.'

'Who do you love most in all the world?'

'At this moment in time, it would have to be my little granddaughter, Charlie Jade Chaplin.'

'Is that really her name?'

'It is.' I guessed that Noel had a hand in that.

There was a loudspeaker announcement, but I couldn't catch the words. 'Hang on, Noel, I'd better check the screen.'

He came with me; we were catching different flights. His trip to Budapest was delayed by fifteen minutes. Mine, to the sun, was on time. But we were OK to keep talking. 'What's your happiest memory?'

He thought for a moment. 'It would have to be the birth of my two daughters and the birth of Charlie Jade.'

'And your worst memory?'

'It would be being shot at by the police on Marbella beach at three o'clock in the morning.'

'It sounds like something out of a film.'

'They were shooting at me and when I went to run away, my foot got caught in a hole and I twisted my ankle and I ripped all the ligaments and tendons in my foot and it just went all floppy, like a flipper. And I ran about five kilometres with it like that.'

'You got away?'

'I did that time.'

'What gives me a buzz now is doing something for somebody. Helping them. That's the best feeling in the world.'

Noel can look back and have a laugh at all these bad experiences. Is there anything that makes him lose his rag?

'What makes you angry, Noel?'

'I have the patience of a saint now. I used to have a temper problem a few years ago. I had a temper and a half, but I've sorted myself out. What would make me a bit angry was people who let you down. I try not to let anything get to me now.'

'How did you sort yourself out?'

'Basically, I've done it myself. At one point I was getting seen by psychiatrists, they were trying to find out why I was so wild. But one day I just sat down and took stock of my life. I thought about it, what was going on. It wasn't getting me anywhere. I gave myself a good talking to; I didn't need to be doing any of this. I used to fight every weekend. There were

ten of us and that was what we did. We went out looking for a fight. It was mindless violence. That was what we were into. We were doing it to please the crowd.'

'Did you find it easy to stop?'

'I had to get away from it. I stopped going round with them. I'd had enough. Then when I started being nice to people, I found out that I liked it. I realised that I liked being nice more than I liked not being nice. It was better than having people frightened of me. And that did it. I've never looked back.'

'Yes. I've been threatened with shootings. I've had geezers say they were going to stab me and kill me.'

'What frightens you?'

'Not a lot frightens me personally. But thinking that anything might happen to members of my family is always there. It's things that I wouldn't have any control over.'

'Does anything make you feel guilty?'

He shook his head. 'Nothing.'

'Would you change anything if you could? What about your looks?'

'Definitely. I've taken a bit of hammer over the years.'

'Would you have plastic surgery?'

'Yes, I'd have a bit of eyebrow suction and a couple of the chins removed.'

His appearance still matters to him, then. But what gives this guy a buzz?

Noel thought about this.

'It used to be violence. I used to feed on it. Really got off on it. Now it wouldn't be the same. It makes me feel sick now. What gives me a buzz now is doing something for somebody. Helping them. That's the best feeling in the world. I don't know why it took me so long to find this out.'

'What makes a man?'

'There's only one thing – a woman!'

Good answer.

'If you could change places with anyone, who would you like to be?'

'I like being me, but if it was anyone it'd be Tom Cruise. But don't put that, because I'll sound like a wanker. Hang on, let me think of somebody real cool ... Ray Winstone the actor, that's it. He's a dude.'

'What about all the hard geezers you've known – who's the hardest?'

No hesitation. 'Kevin Houston. He's the hardest man I've ever met.'

'How do you stay one step ahead?'

'Nowadays, it's using my brain and my intelligence. Before it was my fists.'

'If you were to look ahead to the future, if you consulted a fortune teller, what would you like her to tell you?'

'I'd like her to say that I'm on the road to success. That I'm a hard worker and that I'll get the Golden Fleece in the future. I think that's what she would tell me.'

'What would she say about the past?'

'She'd say that it's all behind me. I don't think she'd want to look too hard when she saw my past.' He laughed out loud.

'If you were eighteen again, what would you do differently?'

'Women. I was too quick before.'

'Tangled relationships?'

'A few.'

All right. 'Can you sum yourself up in one word or sentence?'

'Honest, reliable, loyal.'

'Tell me a secret.'

'Will this be going in the book?'

'Yes.'

'I'm not telling you, then.'

'Go on, there must be something.'

For the first time since I'd met him, Noel stopped laughing. His face hardened.

'I'll tell you, then.' He stared out of the plate glass window. 'I was abused as a child.'

I didn't know what to say. 'I've never told anyone that before, Kate.'

Some things never go away. But in spite of everything that's happened to him, Noel has turned his life around big style. A rough, tough upbringing, fighting for survival, drugs, crime, the lot – he's had it. But he's come through and learned life's most important lessons – violence only pays in hard times and dirty money. It's taken him more than a few years and a lot of hard knocks to find out that the best things in life have no price tag. Noel has paid his debt to society – he's survived and he's kept his brilliant sense of humour.

'Tell me a joke.'

'All right, then. A man walks into a pub with a frog on his head, and the barman said, "Where did you get that from?" And the frog said, "It started off as a wart on my arse!"'

When we both stopped laughing Noel said that he always tells himself that joke when he's feeling down. It hits the spot.

Leo came to find me. Our flight was at the top of the screen and ready for boarding at Gate 5. We both shook hands with Noel and said our goodbyes. He was on a business trip – and he had to find a phone and make a few last calls. Leo and I were off on holiday. No more hard men, tough guys or bad, mad, sad stories. Sun, sea, sand and getting away from it all – for a little while, anyway.

I picked up my mags and my Gucci sunglasses and got my passport and boarding ticket ready. Puerto Banus here we come.